D040967

2008

BADLANDS: NEW HORIZONS IN LANDSCAPE

Edited by Denise Markonish

Texts by Denise Markonish, Ginger Strand, Gregory Volk, and Tensie Whelan

Foreword by Joseph Thompson

Interviews conducted by Denise Markonish

Art Center College of Design
Library
1700 Lida Street
Pasadena, Calif. 91103

MASS MoCA

NORTH ADAMS, MASSACHUSETTS

ART CENTER COLLEGE OF DESIGN

3 3220 00273 0138

ROBERT ADAMS

VAUGHN BELL

BOYLE FAMILY

MELISSA BROWN

CENTER FOR LAND
USE INTERPRETATION

LEILA DAW

GREGORY EUCLIDE

J. HENRY FAIR

MIKE GLIER

ANTHONY GOICOLEA

MARINE HUGONNIER

PAUL JACOBSEN

NINA KATCHADOURIAN

JANE D. MARSCHING AND TERREFORM

ALEXIS ROCKMAN

ED RUSCHA

JOSEPH SMOLINSKI

YUTAKA SONE

JENNIFER STEINKAMP

MARY TEMPLE

Art Center College of Design
Library
1700 Lida Street
Pasadena, Calif. 91103

© 2008 Massachusetts Institute of Technology and
Massachusetts Museum of Contemporary Art

All rights reserved. No part of this book may be
reproduced in any form by any electronic or mechanical
means (including photocopying, recording, or information
storage and retrieval) without permission in writing from
the publisher.

MIT Press books may be purchased at special quantity
discounts for business or sales promotional use. For
information, please email special_sales@mitpress.mit.edu
or write to Special Sales Department, The MIT Press,
55 Hayward Street, Cambridge, MA 02142.

Principal typefaces
Gotham, Caslon 224

Printed and bound in Canada by Westcan

Library of Congress Cataloging-in-Publication Data

Badlands : new horizons in landscape /
edited by Denise Markonish.
 p. cm.
Catalog of an exhibition at the
Massachusetts Museum of Contemporary Art.
Includes bibliographical references.
ISBN 978-0-262-63366-6 (pbk. : alk. paper)
1. Landscape in art—Exhibitions.
2. Art, American—20th century—Exhibitions.
3. Art, American—21st century—Exhibitions.
I. Markonish, Denise.
II. Massachusetts Museum of Contemporary Art.

N8213.B33 2008
704.9'436730747444—dc22

2008013791

10 9 8 7 6 5 4 3 2 1

Published on the occasion of
Badlands: New Horizons in Landscape
Curated by Denise Markonish

MASS MoCA
1040 MASS MoCA Way
North Adams, MA 01247
413.MoCA.111
www.massmoca.org
May 25, 2008–April 12, 2009

Made possible with support from the LEF Foundation;
the Elizabeth Firestone Graham Foundation; Mixed Greens;
The University of New Haven College of Arts and Sciences;
the Tagliatela College of Engineering; National Endowment for
the Arts, Massachusetts Cultural Council; Harace W. Goldsmith
Foundation; the Artist's Resource Trust, a fund of the Berkshire
Taconic Community Foundation; Berkshire Hills Development
Company; and The Porches Inn.

Designer
Dan McKinley

Copy Editor
Steve Van Natta

Mixed Sources

Product group from well-managed
forests, controlled sources and
recycled wood or fiber
www.fsc.org Cert no. SW-COC-002520
© 1996 Forest Stewardship Council

COVER
Anthony Goicolea *Tree Dwellers* (detail) 2004

CONTENTS

Art Center College of Design
Library
1700 Lida Street
Pasadena, Calif. 91103

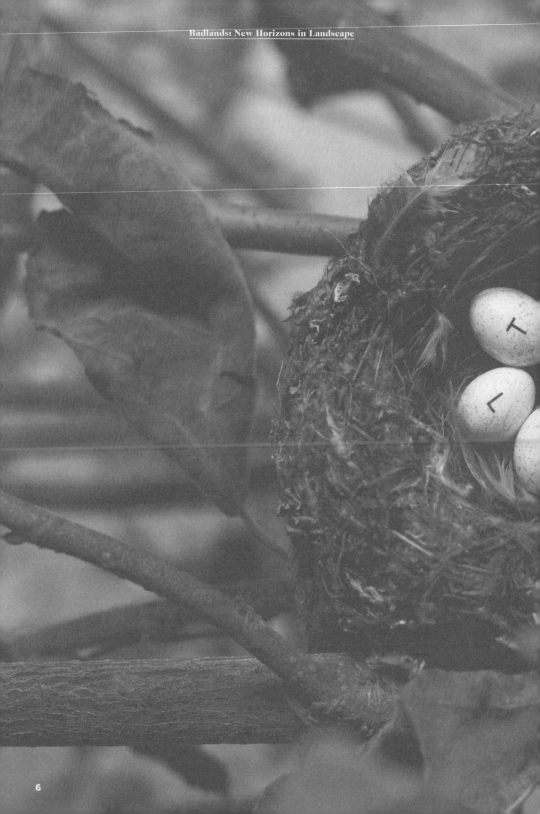

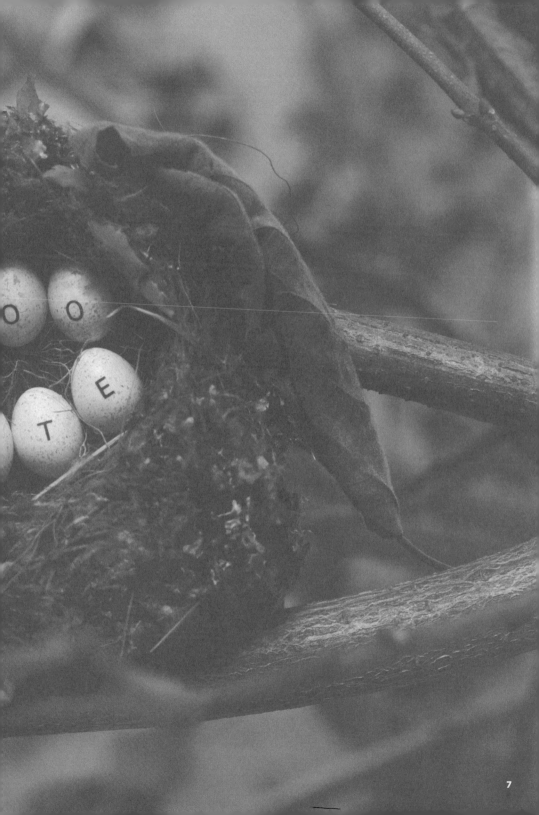

FOREWORD

Joseph Thompson, Director, MASS MoCA

Landscape is personal.

For me, there are far too many trees in New England—especially in the valleys and on the gentle slopes that make our Berkshires so distinctive. Over the past century we've allowed shaggy, second-growth, second-rate woodlands to encroach upon fields hard-won by eighteenth- and nineteenth-century farmers, stump by stump. Eerie stone walls deep in the woods are often the only remainders of the pastures they once defined. In nearby south Williamstown, drivers stop by the side of Route 7 to take in an otherwise unremarkable local vista made exceptional by several large meadows still maintained in the fore and middle ground.

From most roads and even from many hiking trails, what you usually see is a dense, shadow-casting flora partition, much of it comprised of choking non-native underbrush and light-starved saplings that will never reach specimen dimension. Yet whenever I point out that the desultory reforestation of New England has actually diminished the beauty of our landscape, most people just look at me dumbfounded. Trees are so widely associated with nature itself—so iconically coupled to the corrected

PREVIOUS PAGE
Nina Katchadourian *Too Late* 2003

environment for which we yearn—that it has become almost sacrilegious to utter a word against them, much less to propose a little strategic clear-cutting. I'm with Robert Adams (see his interview on page 36) that our relationship to individual trees matters, but in my view, some wooded fields we could do without.

The art in this exhibition, and essays gathered in this book, remind us in many ways—both subtle and chest-thumping—that landscape is a construct of the mind, memory and political will, as much as a physical configuration of the natural and built environments. This confluence of nature and human intervention can be both glorious and pro-foundly dispir-iting, and it's that range of possibility which is at the heart of *Badlands*. For this exhibition and book, curator Denise Markonish has gathered wonderfully nuanced and wide-ranging art and inter-pretive mate-

rials to help us reconsider the essential character of the landscape today. This is Denise's first major exhibition at MASS MoCA, and I join our staff and board in welcoming her, and applauding this wonderful first outing. I also join Denise in thanking the artists; whose excellent work, thought, and craft are featured here. The LEF Foundation and the Elizabeth Firestone Graham Foundation provided key funding for the show, and we thank them.

MASS MoCA is an interesting foil for *Badlands*, since our museum occupies such a beautiful piece of post-industrial brownfields. Our own approach to landscaping has been to celebrate the hardscape of this historic mill compound, occasionally juxtaposing the prevailing masonry and macadam surfaces against small copses of volunteer birch and sumac, more formally placed locust trees, and, in our clocktower courtyard, one elegant blaze maple. A bit further afield, the entrance courtyard features six trademark flame maples, suspended upside-down in a startling work of landscape sculpture, *Tree Logic*, by the Australian artist Natalie Jeremijenko.

Tree Logic refers to both a decision making tool utilized by computer programmers and game theorists, but also to the iconic standing of trees themselves. It's interesting to note, in the context of this exhibition, that at least half of our visitors arrive at the box office inside the museum having not noticed the inverted and suspended trees they just passed beneath. This perceptual slippage makes me think that when something so fundamental to our human existence as trees is presented so radically out of context—green side down, trunk rising to the sky—our brains simply fail as a result of a base building block of our natural environment having been so radically shifted. We hope that after enjoying *Badlands*, our visitors may then see on the way out what they may have missed on the way in.

THAT'S GREAT, IT STARTS WITH AN EARTHQUAKE, BIRDS AND SNAKES, AN AEROPLANE— LENNY BRUCE IS NOT AFRAID. EYE OF A HURRICANE, LISTEN TO YOUR- SELF CHURN— WORLD SERVES ITS OWN NEEDS, DON'T MISS-SERVE YOUR OWN NEEDS

REM It's The End Of The World As We Know It (And I Feel Fine) 1987

INTRODUCTION

Denise Markonish, Curator

When the pop band REM released the song "It's The End Of The World As We Know It (And I Feel Fine)," it was said to be a stream of conscious rambling written after singer Michael Stipe awoke from a dream, but it is hard not to see its opening stanza as an anxious reflection or maybe prediction about the current state of the environment. The song evokes "natural" disaster but also a kind of relationship of need between man and the world. The more I think about earthquakes and hurricanes the more I realize that it *is* the end of the world as we know it and... I don't feel fine. Every time I turn on the news, look in a newspaper or read something online I am confronted with new facts ranging from the decline of the planet through global warming, to the disappearance of bees and the continued destruction of various ecosystems. This past year I even noticed that the leaves started to change to their fall colors at the end of August. Now, that cannot be right!

With all of this doom and gloom, how then do we negotiate a landscape that seems to be literally melting away before our eyes? For me, the landscape has always served as a tool to understand place, and so when I moved to

the Berkshires of Massachusetts in July 2007, I instantly became immersed in a kind of bucolic landscape of picturesque mountains and rolling green hills, a landscape in the tradition of the pictorial sublime. This is somewhat new for me, for nearly all my life, I was a "city girl." There was a brief two year stint in graduate school when I resided in the Hudson River Valley, though I was more in my books than in the landscape. I was always more accustomed to concrete than grass, more used to hearing cars than birds. Like most city folk, I had both fantasized and feared the landscape, while secretly wondering about the great outdoors. As a result

I have spent a good part of my curatorial practice deeply enmeshed in issues around the culture of nature, working with artists who use the systems of the natural world as their medium. I would never claim to fully

understand the landscape, but as a result of this repeated investigation I do *feel* it in a different way, both through art and place.

With the awareness spurred on by a new environment, I started to think, once again, about the ways in which artists have depicted this thing we call landscape. One could say that the artistic love affair with the outdoors began in earnest in the United States with the mid-nineteenth-century Hudson River School. At this time, landscape became a *thing*; our National Parks System was developing, and more and more cultural caché was placed into the wilderness. This history has continued through art. A brief, and by no means exhaustive, post-Hudson

River School lesson might go as follows: skipping ahead to the twentieth century, we had the great nature photographers of the turn of the century who brought the magnificent vistas of the American West into view, then we had the Earth Art movement of the 1960s which took the emphasis away from the pristine beauty of nature and instead focused on its natural systems and entropy, then there were the New Topographics, photographers in the 1970s who turned their backs on the sublime in order to concentrate on the scarred and manned earth, and in the 1990s, Eco-Artists collaborated with scientists and environmentalists on projects dealing with hot topics such as sustainability, ecosystems, and politics. Today, a whole new generation of artists, represented here in *Badlands* continues to merge together and build upon this legacy.

Badlands serves as an extension of an art historic lineage, but also as a document of the current ecological crisis and how, as a culture, we are dealing with the decline of our natural environment. Thus the title *Badlands* has a dual meaning: it stems from the Badlands, the place itself in the Dakotas, an area filled with both inhospitable conditions and immense beauty, but the phrase "Badlands" generates its own meaning; for our land is in bad shape. I recently heard the artist Mark Dion make a startling statement (I shall paraphrase it here): that if the earth was some kind of test for mankind, then we surely are failing. But the test need not be over. For in *Badlands*, the artists tread a dichotomous line,

one evident in both the phrase itself and the current environmental situation, by showing both the aesthetics of decline as well as a renewable belief in beauty, while at the same time thinking about possible solutions for ecological sustainability.

This publication, like the exhibition it exists alongside, takes a multi-disciplinary approach to looking at art, stemming from history, culture and science. There are four sections into which this book is broken down, each with artists and texts corresponding to certain topics and offering diverse perspectives. The journey through the land starts with the Historians, a group of artists looking at and recontextualizing the history of landscape depiction, this section is accompanied by my essay about the participants in the exhibition and the new genre of landscape art that emerges from their work; next come the Explorers; artists who go out into the environment and examine our place with in it, here Ginger Strand examines the landscape as a cultural construct;

the next group are the Activists and Pragmatists, artists who alert us to the problems of the natural world and provide possible solutions, which features an essay by Tensie Whelan that deals with environmental science, sustainability and climate change; and lastly we end with the Aestheticists, artists investigating the relative beauty found in nature, accompanied by Gregory Volk's essay which deals with both historic and contemporary landscape art through the lens of Transcendentalism. With this multi-faceted approach, we get art, history, science and culture... all the things that make up this complex construction we call the landscape.

I recently saw Terrene Malick's 1973 film *Badlands*, and while it is based loosely on the Starkweather/Fugate killing spree of 1957, it is as much about love and murder as it is about the landscape, specifically the Dakota Badlands. The two main characters, Kit and Holly, are on the lam, traveling across the Badlands which Malick films with a stark twilight beauty that nearly takes your breath away. You almost

Stills from Terrence Malick's 1973 film *Badlands*, starring Martin Sheen and Sissy Spacek.

forget the killing, you almost forget the story, but you never forget the landscape. Just like the film, this exhibition and publication will create an indelible link to the Badlands… a place where the landscape beyond life itself, is simply, imbued beauty.

——————

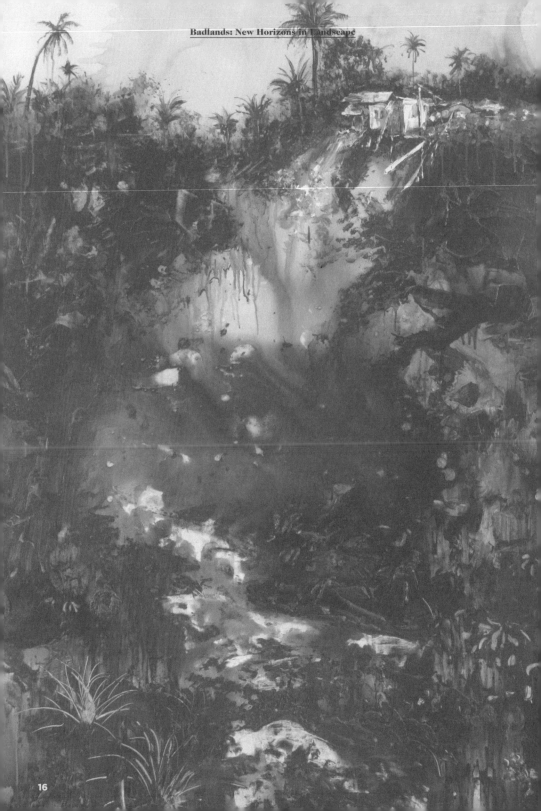

Manifest Destiny to Global Warming: A Pre-Apocalyptic View of the Landscape

Denise Markonish

There's always a period of curious fear between the first sweet-smelling breeze and the time when the rain comes cracking down.
Don DeLillo[1]

On the far side of the river valley the road passed through a stark black burn. Charred and limbless trunks of trees stretching away on every side. Ash moving over the road and the sagging hands of blind wire strung from the blackened lightpoles whining thinly in the wind. A burned house in a clearing and beyond that a reach of meadowlands stark and gray and a raw red mudbank where a roadworks lay abandoned.
Cormac McCarthy[2]

Two views of a landscape, bleak, cold, ruinous and unfortunately not so far out of our imagination. Given the daily news with its reports of our planet in peril, it is not surprising that there is a current cultural trend towards an inevitable doomsday. It is seen in movies like *The Day After Tomorrow* (2004) and *I Am Legend* (2007) and in fiction from Chris Adrian's *Children's Hospital* (2006) to Matthew Sharpe's *Jamestown* (2007), but two authors whose works have been aligned with the horrors of civilization over the past twenty-five years, whose works are imbued with fear and impending (and post) doom, are Don DeLillo and Cormac McCarthy. Right now we seem to be in DeLillo's moment of the breeze before the rain hits, but we can see in our sites McCarthy's heartbreaking "road," the point of no return for civilization. How then do these apocalyptic visions relate to the genre of landscape art? These literary accounts of "The End" are a cultural barometer for the ways in which society feels the crushing weight of a planet, a civilization, in decline. Art, like

literature, provides a voice, an image, to these concerns, and in some cases provides a solution. Art about the landscape also presents a cinemascope or larger than life vision of the world around us, presenting vistas complete with beauty and impending doom, literally freezing a moment in full panoramic sweep. It is impossible for contemporary artists to continue representing the landscape without looking at the past, through art, film, and literature, as well as the current environmental crisis, and the not too sunny future it represents, or more likely, it is a future so sunny as to become dangerous.

What results from this link between history and the present is a new phase of landscape art, one that is ecologically aware and verging on the pre-apocalyptic but one that also holds on to the sublime beauty of the past, to preserve a history while pushing it forward into new terrain. *Badlands: New Horizons in Landscape*, the title for both this exhibition and publication, has many meanings: it at once references the Dakota Badlands, that beautiful yet inhospitable land that is one of the fastest eroding landscapes on Earth. The title also references the 1973 Terrence Malick film of the same name, which presents a landscape of heartbreaking sumptuousness alongside human atrocity and survival. Most importantly, *Badlands* is a metaphor for the decline of the landscape around us, the ecological peril that we are responsible

for. The landscape genre continues with this lineage in mind, building upon the past of the Hudson River School and Earth Art, to produce a next wave; from Manifest Destiny to global warming, indeed.

Perhaps the defining moments of landscape painting are that of the nineteenth-century Hudson River School coupled with European Romanticism. At this time, the sublime meets Manifest Destiny as artists like Thomas Cole, father of the Hudson River School and English Romanticist J.M.W. Turner go out into the landscape to explore and depict changes in land ownership, geological sciences and advances in technology all through the lens of God's Divine Creation. It is here that nature and the landscape are put on a pedestal, turned into sacred icons for worship; a cultural misstep that leads to seeing the landscape as an untouchable, unspoiled part of the planet. Landscape then becomes a cultural rather than natural phenomenon. Simon Schama states in *Landscape and Memory*: "Landscapes are culture before they are nature, constructs of the imagination projected onto wood and rock."[3] For these early landscape painters, escaping the trappings of progress meant retreating to the "wilderness," but with this came the naïve thought that what they were observing was actually untamed. In fact, many of the Hudson River School painters, rather than depict pure scenes of landscape vistas, sketched on site

and then painted final images that were composites of many idealized views collapsed into one. What results from this idealization of the landscape, along with a reinforcement of Schama's notion of landscape as a cultural construction, are some of the greatest and most troubling paintings on the subject, ones that depict the sublime landscape, with all its religiosity, teeming with Manifest Destiny and white European notions of progress.

Alexis Rockman adopts an aesthetic similar to the early landscape painters. Rather than retreat to nature to avoid civilization, Rockman goes out into the landscape to expose the sublime beauty of a world in decline. In 2002 Rockman created an epic work called *Manifest Destiny*, which imagined Brooklyn, New York, in the year 5000. It is a scene of post-global warming and post-apocalypse where creatures go back to the pre-historic and man-made civilization is in ruin; it is indeed our destiny made manifest. This depiction of anti- or perhaps hyper-progress shows the trappings of mankind and the results of our carelessness with the planet, a message similar to what Cole and his Hudson River School counterparts were saying centuries before as they tried to push aside progress for faith in nature. For *Badlands*, Rockman's travels in the landscape continue with a trip to Antarctica (in the spirit of Hudson River School painter Frederick Edwin Church), to capture its glacial landscape. Artists in the past journeyed to such locations in search of awe-inspiring vistas, but also to brave the treacherous unmanned landscape. For Rockman, the heroism of exploration has shifted and is replaced with an urgency to capture the landscape before global warming melts it away. The impulse for travel is still there but the results are vastly different. Rockman's large-scale work, like his Hudson River School forefathers, comes from the sublime, of which

Brian Wallis, channeling eighteenth-century British philosopher Edmund Burke, says: "Burke suggested that the sublime, a mood prompted by some overwhelming or awe-inspiring natural feature, would create in the viewer an unsettling fear or astonishment, similar to what Sigmund Freud later called 'the uncanny.'"[4] This sense of fear in the face of beauty runs through all of Rockman's Antarctic works, with their crashing images of ice lost among vast seas and ominous clouds above. Rockman need not paint disaster or even talk about it, as it is part of the sad beauty inherent in his work.

Paul Jacobsen alludes to German theologian Albert Schweitzer more than he does Burke. Schweitzer states: "Man has lost the capacity to foresee and to forestall. He will end by destroying the Earth."[5] Destruction is indeed what Jacobsen depicts, however, unlike Rockman's unmanned landscapes, in Jacobsen's work, the figure is present, whether metaphorically or in actuality. Jacobsen's undoing of civilization is a controlled rather than chaotic apocalypse, one in which a group of humans know that change is needed for survival and force collapse in order to pick up the pieces and begin again. In Jacobsen's *Post-Industrial Collapse* (2005) the landscape is still bucolic, coming right from the Hudson River School, with its rolling hills and beautiful never ending vistas. Jacobsen adds among the green a new mountain, a kind of effigy to the past, comprised of detritus from society, piles of trash including airplane fuselage: a monument to a world now gone. Around this lost techno-mountain are the survivors, young hip looking people wandering about the new world, ready to start the beauty over. In another painting, *The Final Record of the Last Moment of History* (2008), Jacobsen paints a similar scene but without the survivors. One has to

wonder if in this case the humans made the same mistake again rather than having the "capacity to foresee and to forestall." Jacobsen's critique on the trappings of civilizations echoes the past, specifically Thomas Cole's *The Course of Empire* (1835–6) in which Cole depicted the impact of the industrial revolution and the subsequent ruin of civilization and the landscape. In contrast, Jacobsen's world contains an element of choice, his controlled collapse offers an opportunity for man to rethink and retrace his actions, before, perhaps, an inevitable end. Jacobsen is placing in front of us the possibility of renewal rather than the inevitability of decay.

Ed Ruscha also took note of Cole's *The Course of Empire* when he appropriated the tile

for his own series in 2006 in which, like Cole, he was dealing with the path of progress. For Ruscha progress is not the dramatic ruinous landscape, rather he went back to his iconic *Blue Collar* (1992) series that depicted five non-heroic buildings of the industrial landscape. Ruscha then exhibited these original paintings alongside five new representations of how the same buildings looked in 2006. The notion of "progress" here may be as simple as the erecting of a chain link fence, a gesture of ironic ruin and blockage that counters Cole's emotion with Ruscha's detached irony. Ruscha's work for *Badlands* however, deals more with ideas of the American West and the picturesque quality of that vast landscape mixed with a cultural exaggeration of

a "Western" style of speech. In his *Country Cityscapes* (2001) Ruscha starts with typical images of the American West, tumbleweeds, mountain vistas, and sweeping deserts. Each one of the six images almost looks like it could have been taken straight from a calendar. Ruscha is not happy with the nature of the image alone so he adds an ironic twist to the depiction of the Wild West (and a nod to the cinematic genre of Western movies) with a series of texts. Ruscha whites out blocks of the images, with each section standing for one word of text, which he then places below. With this act of carving up the picture surface he infuses his words into the environment, making them one with the space so that, in effect, the landscape seems to be speaking rather than the artist. In Ruscha's hands the landscape doesn't just speak, it screams: "You will eat hot lead," "Do as told or suffer," "Your [sic] a dead man," etc. Finally the landscape has the last word and with its Wild West twang it shouts at us to leave it alone.

Robert Adams is also known for depicting the America West. Unlike other artists, Adams is not interested in cool irony or cultural stereotypes nor is he interested in sweeping landscape vistas, rather Adams is mesmerized by the minute detail; the landscape as anti-hero. There is another Adams that usually comes to mind when thinking about the American West and that is Ansel Adams. Ansel Adams was photographing at a time when the landscape

was just starting to become a cultural phenom-
enon. The National Parks System had begun
to take shape in the late 1800s and a visit to
Yosemite in 1916 was for Adams a turning
point. Like Hudson River School paintings,
Adams' photographs were about untouched
sublime vistas with perfect lighting, composi-
tion and contrast. It is here, at this point of
heroics, that the two Adams' diverge, Robert
Adams taking the metaphorical "road less trav-
eled" in order to concentrate on the beauty
of the everyday while also documenting the
landscape's devastating decline. Robert Adams
was part of the 1970s New Topographics move-
ment which was the antithesis to past land-
scape genres in that it addressed: "…the end of
romantic nature and the erasure of boundaries
between the human and the natural…"[6] These
photographers were revolting against the cul-
tural construct of the unmanned landscape by
showing the convergence of man and nature,
depicting tract housing and dirt roads, sewer
pipes and cut down trees. In Robert Adams'
more recent work, he moved away from the
tract housing but still retains the dirt road. In
his series *Listening to the River* (1987), Adams
concentrates on the quiet details of the land-
scape, the way a tree sways in the breeze or
the highway intersects a grassy knoll. Counter
to the ordinariness of his images Adams still
brings a sense of the sublime to his work, not
the heroic vista but the ability to look beyond
the obvious and feel the landscape in his pho-
tographs as if you were there beside him. This
is a poetic sublime that touches the human
soul in a way that a perfect picture of Yosemite
never would.

Much of the art history of the landscape
is tied up in two-dimensional representation,
this would change in the 1960s and 1970s
with the Earth artists who went out into the
landscape and moved dirt around, created

sculptural interventions, and allowed the land
to consume their work with its natural forces.
Robert Smithson's *Spiral Jetty* (1970), Michael
Heizer's *Double Negative* (1969), or James
Turrell's ongoing *Roden Crater*, are all in and
of the landscape, they leave their mark. Earth
art took artists out of the museum and placed
them and their audience in the environment in
a one on one dialogue with the world around
them (this genre would later be subsumed into
the gallery system but that is a discussion for
another essay). Two artists in *Badlands* work
alongside this Earth art tradition but do so with
an anti-heroic, or ironic, take on what it means
to depict the fluctuating state of the Earth,
more in line with Smithson's *Site/Non-Sites*
of the late 1960s and early 1970s, which dis-
placed rocks and soils from the landscape into
the gallery setting, filling the pristine museum
with earth.

Boyle Family are not your average artists,
they work as a family unit (Mark and Joan are
the parents and Sebastian and Georgia their
children) and they travel the globe making var-
ious paintings of the Earth's surface. Prior to
collaborating as a family, Mark Boyle and Joan
Hills started to make work in the 1960s, along-
side the Fluxus and Earth artists of the time,
highlighting chance encounters with the world
around them. These early works mostly took
the form of collage and performance. In 1964
the couple invited friends over to help begin
their next series called *Journey to the Surface
of the Earth*. The performance started with
each participant being blindfolded and handed
a dart, which they threw at a world map. Boyle
Family then recorded these points and began
their life-long quest, which still continues to
this day, to travel to each randomly chosen
spot and create a "painting" of the area as they
found it. What results from these investigations
are a series of works that look almost exactly

like pieces of the terrain ripped from their sur-
roundings, however upon closer inspection,
they are revealed to be meticulously construct-
ed sculptural paintings. Just as the Earth art-
ists went out into the world, so do the Boyles,
but rather than altering what they see, they
capture the encounter. Boyle Family highlights
the flux of a landscape in their *Tidal Series*
(1969), which depicts the sandy beach pat-
terns that are continuously wiped away by the
tide, disappearing the moment they emerge.
The resulting paintings are then imbued with
a sense of capturing the fleeting quality of na-
ture. All of their works, though mammoth in
size and astounding in execution, are so ordi-
nary; though they are made of mixed media
and resin they are perfect embodiments of
clumps of dirt, swaths of sand and bits of side-
walk. They truly are slices of the surface but
their meaning goes to the center of how we re-
late to the landscape.

Vaughn Bell also works within the his-
tory of Earth art, and like Boyle Family she
provides an alternative view of the landscape
that is about a close look at the world rather
than a heroic attempt to master nature. Like
her predecessors, Bell starts with a performa-
tive gesture which includes the viewer as well.
Upon entering the gallery space viewers are
presented with a series of hanging domes, each
mimicking the rolling hills of the Berkshires
in Massachusetts. Inside the clear domes are
native plant species, existing in their own
little biospheres. But just like the biosphere
of Earth, humans are allowed to infiltrate the
small universes by placing their heads inside
the domes through holes in the biosphere un-
dersides. Once inside the domes you feel like
Gulliver, a giant in a Lilliputian world. Rather
than a feeling of mastery over the environ-
ment, the enclosure allows you to feel an inti-
mate part of it, you can see things at eye level,

feel the oxygen the plants emit and smell their
freshness. This is an intimate way of being in
the landscape that one would never experi-
ence in the outdoors. For Bell there is a sense
of protection here, a sense of being able to
escape from the world into your own personal
biosphere. Since these works are also specific
to the environment in which they are placed
it also allows locals to see their landscape with
fresh eyes, while providing visitors with the
chance to experience a unique environment.
While comforting and protective, Bell's domes
also channel an underlying sense of threat
in the face of our disappearing biodiversity.
Bell's project calls to mind not just Earth as
biosphere but the failed Biosphere 2 experi-
ment of the early 1990s, and pre-dating that,
Douglas Trumbull's 1972 film *Silent Running*,
which posits a future in which the last surviv-
ing plants are sent in a dome into space to be
kept alive until Earth can be repopulated and
replenished. The film was science fiction, but
in experiencing the protective quality of Bell's
work, this future seems almost likely.

H istory does not start or stop with
the above artists; all of the artists in
Badlands are indebted to the art historical
lineage of landscape depiction. Whereas the
artists just discussed relate to distinct histo-
ries, the next group deal less specifically with
art movements and more so with the historic
impulse to go out into the world and explore
it first hand. The explorations of these artists
range from the macro to the micro, from the
North Pole to their own backyard, all the while
they are looking closely at the landscape and
examining the idea of what it means to be an
explorer of such terrain.

There is so much myth surrounding the
North Pole and these stories are so prevalent,

that the very "idea" of the North Pole far out-weighs its reality. However, this geographic region is moving into the forefront of thought for reasons other than its unfathomable nature; it is the hotbed of discussions currently surrounding the issue of global warming. As we are inundated with images of melting ice caps and stranded polar bears, we still know little about what kind of place the Arctic is, instead our science fiction is just blended with some science fact, while truth continues to fall by the wayside. This nexus of fact and fiction is exactly what interests Jane D. Marching in the North Pole. There is a vast history of Arctic exploration starting with William Edward Parry's 1827 attempt to Roald Amundsen's 1926 first flight over the North Pole. Most of the knowledge we have of the North Pole though is second hand. Marsching exploits this in her project *Arctic Listening Post* (2005–8), in which she explores the North Pole through information rather than actuality, navigating with her computer via the Internet instead of a boat. The core of this project lies in the question: "what is the North Pole?" So like all good research missions, Marsching's project began with her seeking out like minds. As a result, Marsching and collaborator Matthew Shanely created the web project *Deep North: A Virtual Expedition to the North Pole* (2005) which, through an open source blog, invited people to enter a dialogue about the North Pole. Marsching continues her virtual Arctic explorations with the series *Future North*, where she worked with the architecture studio Terreform, along with science fiction illustrators, and climatologists to imagine what the North Pole will look like in

one hundred years, a time frame beyond true scientific fathoming. By bringing together the scientific and the artistic, Marsching strips bare the creative process and the concept of presenting information by showing that where there is fact, there is also fiction. She also shows us that we can never truly know a place, yet the imagination, or the computer in this case, can always take us there.

Unlike Marsching's virtual journey, Marine Hugonnier went to Afghanistan, Switzerland and Brazil to shoot a trilogy of films. Just because her travels were actual does not mean she got any closer to the truth of the landscape. *Ariana* (2003), *The Last Tour* (2004), and *Traveling Amazonia* (2006) deal with the idea of a politicized vision, one that is mediated through cultural and political perspectives but also by the lens of the camera. Each part of the trilogy presents a different take on the experience of the landscape through travel and exploration. *Ariana* begins with the simple task of wanting to shoot a panorama from the Panjshêr Valley in Afghanistan; however only Afghani Government officials have access to this site, rendering Hugonnier's journey an impotent one. Within this failure, Hugonnier realizes that the idea of the panorama is enough in and of itself; that it is a cultural construct, so instead she leaves us to ponder the importance of the vista replaced now with the military gaze. For *The Last Tour*, the subject shifts from the military to the tourist gaze as Hugonnier concentrates on the Matterhorn in the Swiss Alps, in a fictional future when it will be closed to the public, ending the idea of the tourist experience. The film eerily depicts a

Boyle Family in their studio, Greenwich, London 2003
Left to right: Georgia Boyle, Joan Hills, Mark Boyle, Sebastian Boyle

23

dystopian vision of the future when tourism of the landscape is just memory. Lastly, *Traveling Amazonia* looks at Brazil's Trans-Amazonian highway, a government project begun in the 1970s and still incomplete today. Hugonnier depicts the failed utopia of the project as she tries to construct her own visually straight line, by having a camera dolly on stationary tracks built, which then serves as a stand-in for the road. This is yet another attempt to construct and capture a landscape that does not exist in these particular cultural terms. Overall the series hints at the attempts of exploration and the futility inherent in the act itself.

Gregory Euclide and Mike Glier depict a more humble type of travel but one that is no less rich. Euclide begins his exploration with the idea of walking. In the tradition of the early natural history explorers, the act of walking is one that is rich with discovery, whether it is of a new plant species below your feet or the very nature of the landscape around you. Walking is an intense kind of concentrated exploration. Frederich Nietzsche once stated: "All truly great thoughts are conceived by walking." Rebecca Solnit sums it up best though when she states: "The rhythm of walking generates a kind of rhythm of thinking, and the passage through a landscape echoes or stimulates the passage through a series of thoughts. This creates an odd consonance between internal and external passage, one that suggests that the mind is also a landscape of sorts and that walking is one way to traverse it. A new thought often seems like a feature of the landscape that was there all along, as though thinking were traveling rather than making."[7] This convergence between thinking, walking and creation is at the heart of Euclide's work, which takes the form of sculptural drawings that trace his meanderings of both mind and feet. Not unlike literary theorist Walter Benjamin's strolls

through the nineteenth-century Paris arcades to get a sense of the life and culture of the city through the act of walking and observation, Euclide also sets out into the world to explore and elucidate meaning through the environment around him. However, in his work, Euclide concentrates on the pasture rather than the Parisian, the sylvan rather than urban landscape. Euclide's work begins with delicate depictions of the landscape that are at once lost in the past, and at the same time immediate, open fields pool with drips of ink and woodlands bound with delicate calligraphic lines. These images are then destroyed, crumpled and left as discards. Euclide goes further and picks up these drawings and recontextualizes them, creating sculptural environments from bits of dirt and leaf matter from his walks and placing them among the crumpled folds of the drawings. By bringing these two moments of the walk together Euclide is collapsing time and allowing the rhythm of nature and thought to merge with the act of the walk. What results is a type of evidence, a trace or memory of exploration. Here the picture plane is not merely a window into the world; it is a manifestation of the mind.

Like Euclide, Mike Glier stays close to home, however, Glier doesn't intend to remain there; rather it is just part of one long exploration into the world as a whole called *Latitude*, *Longitude*, and *Antipodes*. Like all good explorers Glier starts in his backyard with *Latitude* (2006–7), a series of plein air investigations into how this space changes through the seasons, or more specifically, as the Earth tilts on its axis over the course of the year. Plein air painting is part of a long tradition, made popular by impressionists like Claude Monet. Glier's paintings are similarly imbued with the slight changes of light and color that infiltrate the environment over time. In Glier's

work there is also a nod towards abstraction, an immediacy of gesture that captures the fleeting nature of a well-known landscape in order to understand the changes that are taking place. Glier's paintings are full of motion, with sweeps of paint rustling before you just as wind would blow through the trees. After finishing this series, Glier embarked on a longer, more arduous journey with *Longitude* (2007–8), which brought him along one line of longitude starting in the Arctic Circle, down to the Equator, and eventually ending up back in the United States, all the while recording through plein air paintings the changes in the environment along his path. The series will end with *Antipodes*, which will compare two opposite points on the globe. Throughout all three investigations, Glier gets to the heart of why we as humans are interested in exploration and (in a sense) interested in the landscape at all. It is about finding a place and understanding that particular location as it relates to the self. Glier's travels allow him to look closely at the whole and present to us the abstracted sum of its parts.

N ow that we have traveled the landscape, seen it from the macro and micro, what do we do about it? How do we negotiate the fact that this thing, this cultural construct that is so important to us, is in severe decline? Do we sit back and wait for Armageddon? Or do we take action? Since *Badlands* presents landscape artists from those reinterpreting history to those dealing with aesthetics and beauty, the picture would be incomplete without artists who are working with and in the landscape from the point of view of our current and future ecological crisis. This next group of artists peels back the veil of the landscape and looks inside to reveal what we can do next.

Solutions or ideas can only arise once disaster is recognized and that is exactly what Melissa Brown and Leila Daw do: they place disaster, real and imagined, right in front of our faces, like a tornado that cannot be avoided. Brown's work has an eerie calm to it, a cartoon-like sense of stylized color that makes her juxtapositions even more frightening, it is akin to the beauty and terror of Burke's sublime. What imbues these works with such edge is that Brown is interested in the moment just prior to or well after disaster has struck. We don't see an oil spill happening in *New Valdez* (2007), instead we see a beautiful landscape with birds flying above the mountains and then, almost hidden by vegetation, an oil slick on the surface of the water appears as a constant reminder of ecological crisis. The Don DeLillo quote that opens this essay is an ideal metaphor for Brown's work as DeLillo speaks of that momentary space of calm, the energy in the air before the storm strikes that is felt but not quite understood. This is exactly the mood in Brown's paintings, an underlying electricity in counterbalance with an almost out of place cheerfulness. In *Forest Fire* (2004) the charred remains of the landscape are depicted in brilliant reds, pinks and oranges, even though the fire is barely evident, the landscape is forever colored by its destruction. The composition here is also significant, as the trees on either side of the frame seem to part, leaving a swath of barren landscape in the middle, almost like a platform, setting the stage for some sort of happening or explanation to take place. There is theatricality inherent in all of Brown's work that comes from both contemporary disaster movies, where Armageddon is a series of computer generated effects, and from nineteenth-century panoramic paintings that were set up as spectacles. The panoramas were the movies of their time, and were rolled out and traveled

from town to town, telling tales of great battles and history. Just like both her predecessors and contemporaries, Brown places her viewers in the audience, to ponder the effects and history of disaster.

Leila Daw also provides a platform for the contemplation of destruction, however, unlike the frozen action of Brown's paintings, for Daw the lava flows and the tidewater rises until both wipe away the landscape along with all of civilization. In her two works for *Badlands* Daw depicts opposing, yet equally destructive, forces at work: a flood and a volcano. Both works are long and vertical, which allows the action existing within them to flow down like it would in real life. The size of each work also mimics the proportions of the human frame which places us as giants among the action, as if we are flying above the landscape peering below. We soon realize though that there is no escape. This shifting scale and merging of macro and microcosm calls to mind Hermes Trismegistus, the mythical father of Western Occultism, Magic and Alchemy, who stated: "That which is above is like to that which is below, and that which is below is like to that which is above."[8] The floodwaters and lava are everywhere, there is nowhere to run. *Volcano to the Sea* (2006) depicts a spew of lava that flows down the landscape, burning out the aerial view of the town below. The work, however, signals its own illusion by ending in a woven series of overlapping colors, like it is an ancient scroll, a warning from the past, which has been unfurled to show modern man, "Look, this can happen again." For *Wiping the Slate* (2008) Daw gets even more destructive as an overflowing waterway takes homes and boulders careening down its path until everything is covered in watery effigy. It is impossible not to think back to Hurricane Katrina, another avoidable disaster. In the end, Daw's work (like Brown) cautions

us against our own complacency and asks us to think about the fact that the end could be right around the corner. So how will you be prepared?

Like Daw and Brown, J. Henry Fair also shows us disaster; however his depictions of vastly polluted sites across the United States could not be more real. Fair takes a bird's-eye view, flying in planes over toxic sites, using a kind of stealth not possible from the ground, where, as you can imagine, it is not easy to gain access to these areas with camera in hand. This aerial approach allows for an abstraction of the landscape: erasing all ideas of horizon. Upon first glance, Fair's photographs read like abstract expressionism, like Jackson Pollock meets Robert Smithson. It takes a moment to reorient oneself to the landscape until perhaps you see a bulldozer pushing coal up a mountain, or recognize fertilizer aeration tanks amidst Technicolor blue-green water. These are not paintings, they are not digitally manipulated, they are real... and that is what makes their beauty so startling. Looking at these images results in immediate seduction through color, form, and composition, and this is exactly Fair's intent: to draw you in before hitting you over the head for not realizing that the environment is being polluted not just by big companies, but also by you, the viewer (and accomplice). Everything is connected and we are all part of the problem, but this being so, Fair gives viewers a chance to be part of the solution, to see these images and then think about how we use nature's resources. Fair doesn't get at this realization by presenting viewers a long list of ecological texts, rather, he titles the works simply as *Paintbox, Coal Fired Power Plant, Niagara Falls* (2002); *Dividing Line, Aeration tanks at sugar mill, Gramercy, LA* (2005); or *Expectoration, Bauxite waste from aluminum processing, Darrow, LA*

(2005). By presenting the facts of what and where the polluting industry is, Fair allows the viewer to assume responsibility and this becomes a powerful realization.

As Fair travels the country by plane, the Center for Land Use Interpretation (CLUI) takes to the ground. Founded in 1994, CLUI states that they are "…a research organization interested in understanding the nature and extent of human interaction with the Earth's surface. The Center embraces a multidisciplinary approach to fulfilling the stated mission, employing conventional research and information processing methodology as well as nontraditional interpretive tools."[9] CLUI achieves this mission through work done at various outposts across the country (Wendover, Utah; Los Angeles and Mojave Desert, California; and Troy, New York) as well as by providing a residency program and an online Land Use Database. All of these activities come together in the form of newsletters, writings, lectures, and exhibitions dealing with different topics of land use in the United States. CLUI presents facts rather than opinions. By blurring the lines between art and activism CLUI are able to draw in diverse communities and get them to collectively think about the ways in which the land is being used and abused, stressing the cultural implications of such misuse. CLUI's exhibitions delve into different communities, and their work for *Badlands* is no exception. Here the exhibit titled *Massachusetts Monuments: Images of Points of Interest in the Bay State from the Center for Land Use Interpretation* (2008) explores various sites throughout Massachusetts. These locations and monuments are as varied as a granite tower/war memorial housed on top of Mount Greylock in the Berkshires, or Lincoln Lab, a massive electromagnetic communications and research and development center operated by

the Massachusetts Institute of Technology located at the edge of Hanscom Air Force Base in Bedford. By concentrating on the local, this exhibition gives visitors a different perspective of the state that they are in, allowing them to look anew at the landscape and its occupation.

Yutaka Sone's work, in a sense, is also about land use, however his is a more metaphorical pondering rather than a factual pursuit. Entering into one of Sone's installations involves a suspension of disbelief, one moment you are in a gallery and then suddenly you walk into a jungle and are transported beyond the white walls into a world of tropical plants. There is a sensory shift that takes place, the ground beneath your feet softens, the smell in the air is more earthy and natural, and the sterility of the white walled museum slips away. After meandering through the paths the artist has laid out for you, you come upon a series of monoliths, reminders of the museum, in the form of large marble sculptures placed low on pedestals. The sculptures present a microscopic view of Los Angeles complete with tiny, densely packed buildings, and intersecting highway junctions. The highways, which are so essential to the city of Los Angeles, take center stage. The inversion of scale is what is most remarkable in Sone's installation. The highway, an ultimate symbol of industrial progress, is miniaturized, and instead the landscape engulfs it to the point of consuming its function and rendering it as mere decoration within the wilds of the jungle, albeit an artificial jungle, with mix-matched plants and no real sense of order. This is an imaginary world, a past (or perhaps a future) where we don't need to get anywhere fast, but rather, can take a moment to stop and be a part of the landscape. Sone's work is not a snapshot in which viewers can see everything all at once, rather it is an experiential viewing of the landscape, where you

move through space and encounter what it brings to you.

Joseph Smolinski's work provides a kind of solution to one of our ecological woes. In his pragmatic yet ironic response to alternative energy, Smolinski has created *Tree Turbine* (2008): a functioning wind turbine disguised as a fake pine tree. Here we get a sculpture that can actually generate electricity. Smolinski's Turbine came out of the fact that there is a debate over the visual blight that some think wind turbines create in the environment (particularly in the Berkshires where they are said to interrupt scenic views). A similar conundrum occurred when the proliferation of cell phone towers began to dot the landscape. The question became how to provide modern convenience in the form of enhanced cell phone reception with sensitivity to the look of the landscape? The result... Frankentrees, or cell phone towers disguised to look like pine trees. The illusion is amazing at first but then the structures immediately stand out as fake. These cell phone trees are in fact predated by the 1965 creation of a series of islands off the coast of Long Beach, California, complete with uninhabited high-rise building structures and palm trees that cleverly hide oil rigs, while retaining a charming beachfront view, an exercise in artifice worthy of the California coast. With his oil rig and cell phone tree cohorts in mind, Smolinski came back to turbines and thought, that to appease those interested in the view, he should make a wind turbine that can blend into the landscape. The irony of such a gesture is that some nature lovers don't accept turbines even though they provide clean energy for the environment. Those who claim to reside with nature should not want artifice mucking it up, but many believe that artifice is okay as long as it doesn't ruin the view. However, throughout history, we know that the idea of a pristine nature, one not infiltrated by culture, is all but impossible to achieve, so it only makes sense that Smolinski continues the tradition of constructing the landscape, sticking with a sense of human, rather than natural, beauty. Smolinski then provides energy while enhancing the view; however, he never tries to hide the fact that the gesture of creating a fake tree in a landscape full of real ones is anything but absurd. Smolinski's work is a sculpture, one with a purpose, one with a message, and one with a twist.

In the end it seems to be all about the trees, quite natural when considering the landscape. For the final group of artists in *Badlands*, trees reign supreme in all their beauty. These artists do not endorse beauty for beauty's sake; rather, their work is about the idea that the landscape contains beauty even in its decline; a latent sense of push and pull between preserving the sublime while allowing nature to take its course. Aristotle stated that: "In all things of nature, there is something of the marvelous," and the artists in the final section of this essay adhere to this idea, finding beauty in the mundane, horrific and even in the idea of beauty itself. Like all of the artists in *Badlands*, this last group is also looking to history; they are bringing back Romanticism and its belief in the emotional power of the aesthetic experience. Just as the eighteenth- and nineteenth-century European Romanticists celebrated the tension between suffering and beauty, so do the artists in *Badlands*. Instead of Caspar David Friedrich's precarious glaciers, here we get leafy artifice that speaks to both ecological imbalance and immense beauty.

Anthony Goicolea's striking large-scale photographs are pregnant with the possibility of action. Goicolea started by taking photographs

of himself, but these were not merely self-portraits, instead, he would multiply his image and use himself to enact various boyhood activities with twinges of adolescent misbehavior and sexual exploration. In these images Goicolea also picked up on the tree theme with *Tree Dwellers* (2004): a series of images that posit him as a modern day, yet oddly threatening, kind of Robinson Crusoe, set to live in the ultimate tree house. Goicolea became so interested in the scenarios he set up in the landscape that he began to photograph the sets he would construct after his initially staged action. He then created digital composites of these sites, a technologically contemporary version of the Hudson River School's paintings drawn from various site sketches. The landscapes in the nineteenth-century paintings didn't exist in actuality, nor do they in Goicolea's photographs, but here, rather than trying to construct a utopian image, he is more interested in a kind of dystopian action that takes place upon the landscape with only the trace of the human left behind. In these images there is a sense of loss, of loneliness and the discard that pulls viewers right into creating their own narrative. For instance, in Goicolea's monumental 24-foot long panoramic *Snowscape* (2002) it is impossible for the viewer to take in the image all at once, instead he/she must walk along the photograph as one would travel the landscape to encounter the entire image, full of icy crevasses and traces of human activity, from a pile of snowballs to fur pelts hanging from a makeshift rack. Aesthetically, the barren ice calls to mind Friedrich's sublime painting *Polar Sea (The Destroyed Hope)* (1833–4), however, like Melissa Brown; Goicolea is more in tune with the history of the panorama and its theatrics of viewing. In the end, Goicolea's photographs are about combining these two histories, resulting in the actual experience of viewing alongside the vast constructed beauty and mystery that is beholden to the landscape. One can see the allure of the landscape for Goicolea, as a place where twisted fairy tales come to the surface either with or without action.

Jennifer Steinkamp's trees contain a similar eerie quality to them as is evident in Goicolea's photographs. However, here the uneasiness comes not from a post-event landscape but rather through the simplest movement. Steinkamp's trees are enchanted, almost like the Wicked Witch's forest in *The Wizard of Oz* (1939). Rather than being filled with the possibility of action, Steinkamp brings her trees to life by projecting large scale computer generated images on the walls of the museum. Each one of the 12-foot tall trees looks *almost* realistic, moves *almost* naturalistically, but there is something about these trees that is not quite right: something a bit synthetic that adds to their enchantment, like these are images that have been consciously brought to life rather than depictions of something previously living. The result is that one feels as if he/she is in a fairy tale, not knowing whether danger or beauty is right around the corner. Will we meet the good witch or the bad witch… or perhaps not a witch at all. With these projections Steinkamp is creating automaton trees that are ripe with a surrealistic quality that allows them to transcend the fairy tale and become all the more sinister. However, at the same time, Steinkamp's trees have a sense of whimsy, with their synthetic stage set quality; they balance the uncanny with childlike celebration. Steinkamp's trees shimmy and shake, they drop their leaves and sprout new ones, and they are filled with a magical beauty that takes over your whole visual field allowing you to experience the "treeness" of the object. Steinkamp infuses her work with the ultimate exaggerated qualities of a thing that can only

cause you to go outside and imagine the real trees wiggling before your eyes.

Just as Steinkamp's work provides a kind of "slight of the senses" so does Nina Katchadourian's. Katchadourian is interested in infusing humor into the world, all the while pointing out just how absurd nature really is. For instance, while walking along the Finnish archipelago her family hails from, Katchadourian noticed that the lichen growing on the rocks resembled the outlines of different countries. This realization led to *Moss Maps* (1993), where Katchadourian used rub-on letters and affixed the names of countries—the United Kingdom, Taiwan, etc.—right onto the lichen. In *Animal Crossdressing* (2002), Katchadourian dressed a rat as a snake and a snake as a rat, and in yet another series she went around and mended spiderwebs with red string. Throughout all of these projects the absurd is highly evident, but so is the futile idea that humans can have some sort of control over nature. In the end we know this control is just a farce. In Katchadourian's case, the rub-on letters wash away, the rat goes back to being a rat, and the spiders discard the string from their webs. So with her new project, Katchadourian's slapstick continues, but this time it is not about animals but about trees, or more so about how humans revere trees. *Fall's Colors* (2008) is exactly as it sounds: it is a fabricated tree branch that exists only in brilliant permanent fall colors. Aesthetically we are trained to "oooh" and "aaaah" over beautiful fall leaves. It is not clear why we cannot marvel over green, but are

conditioned to respond to red, it is like a living Hallmark card, a mediated and therefore culturally constructed beauty. Katchadourian's tree exists outside the grounds of the museum therefore it is up to viewers to pay attention to the landscape around them to find this anomaly. Of course in the Fall, the branch will be completely camouflaged, whereas for the rest of the year it will stick out like a sore thumb. *Fall's Colors* points out our own system of aesthetics and appreciation by wrapping it up in one neat little fake tree branch, much as early landscape painters composed the landscape to present the most ideal, if not most accurate, views.

Mary Temple's trees are almost as hidden as Katchadourian's, but not quite. They are the first things you see when you enter the museum but are so easily mistaken for shadows that you might not see them initially. Like all the artists in *Badlands*, Temple asks her viewers to take their time, to stop for a moment and really look at the world around them. With this kind of close attention, the world can only reward you, and when you leave the museum all the trees and their shadows will seem brand new. Temple's work began with the problem of how to represent light as it intersects with interior space, rather than a negotiation of the landscape. Temple then added landscape imagery to delineate the indoor from the outdoor, and immediately her work became about a ghostly representation of nature as its shadows filter into interior space. When experiencing Temple's work there is a very subtle trick of the eye that takes place, a trompe l'oeil representation of shadows upon the walls and floors

of the gallery space, it is so true to life that you expect the shadows to dance across the wall as they would in reality. However, once you focus your eyes onto the shadows and realize they are painted images, you also notice that they exist with the absence of windows; these are therefore memories of shadows, or the materialization of shadows, in the object of painting. Temple's work becomes a trace (or memory) of light, a construction of natural phenomena. This dichotomy of artifice and actuality imbue Temple's work with a ghostly aura of the beauty of nature that is even more poignant given our current state of ecological crisis, leading one to wonder if one day all that will remain of trees are their shadows.

66 **W**ilderness hides its unnatural- ness behind a mask that is all the more beguiling because it seems so natural. As we gaze into the mirror it holds up for us, we too easily imagine that what we behold is nature when in fact we see the reflection of our own unexamined longings and desires."[10] In *Badlands* the unnaturalness of the landscape, as well as civilization's longing to be part of it, are made apparent as a new chapter in landscape art takes hold, bringing with it the baggage of history along with the devastation of the planet. Where does this art leave us, and what will the mirror we hold up to it reveal? Is disaster imminent? Maybe, but I like to think that these artists offer a flicker of hope, that both their tradition and the landscape can endure. Perhaps the best way to sum up what these artists are doing is to quote Molly from Werner Herzog's 1982 film *Fitzcarraldo* who stated that: "It is only the dreamers that move mountains." These artists are the dreamers, they dream of a landscape that will survive, that will endure with all its beauty and complexity. May we all become dreamers, for unlike the devastating passages that opened this essay, our world has not reached the Apocalypse. There is still hope left and with this glimmer, only together can we not only move, but also save the mountains.

—————

Endnotes

1
Don DeLillo, *The Names*
(New York: Vintage, 1982), page 303.

2
Cormac McCarthy, *The Road*
(New York: Vintage, 2007), page 8.

3
Simon Schama, *Landscape and Memory*
(New York: Alfred A Knopf, 1995), page 61.

4
Brian Wallis, *Survey* in *Land and Environmental Art*
(London: Phaidon Press Limited, 1999), page 26.

5
Rachel Carson, one of the early pioneers credited with
starting the environmental movement dedicated her 1962 book
Silent Spring to Schweitzer with this quote.
Rachel Carson, *Silent Spring*, (NY: Houghton Mifflin, CO., 2002).

6
Deborah Bright, "The Machine in the Garden Revisited" *Art Journal*
(Summer 1992 Vol. 51 No. 2 Art and Ecology).

7
Rebecca Solnit, *Wanderlust: A History of Walking*
(New York: Penguin Putnam, Inc., 2000), page 5.

8
These words come from the
Corpus Hermeticum of Hermes Trismegistus.

9
www.clui.org

10
William Cronon, *The Trouble with Wilderness: or,
Getting Back to the Wrong Nature* in *Uncommon Ground*,
(New York: W.W. Norton and Company, 1996),
pages 69–70.

THE HISTORIANS

One could say that the pictorial tradition of the American landscape began in earnest in the mid-nineteenth century with the Hudson River School artists (i.e. Thomas Cole, Frederic Edwin Church), who sought to depict the natural world in a time of discovery, exploration, and settlement. These artists often chose unspoiled views of a seemingly "untouched" landscape pushing aside images of early industrial progress and colonization. This landscape history continued with the photographers of the 1930s (i.e. Ansel Adams and Paul Strand) who often depicted the unspoiled American West in sweeping, carefully constructed in black and white. Though many other landscape traditions would be born after the 1930s, a shift would ultimately take place in the 1960s, with the start of the Earth Art movement. Here, artists like Robert Smithson, Michael Heizer and Walter DeMaria (to name a few) pushed aside pristine tourist America in favor of decay and entropy, creating works both of and in the environment, with the full knowledge that in the end the Earth will always have the last word.

So it is with this trajectory that The Historians come to be in *Badlands*. These six artists are deeply aware of the lineage of the art historic landscape and use the past to both develop and reinterpret these traditional genres of landscape depiction, emerging with a new take on an enduring tradition.

Art Center College Library
1700 Lida St.
Pasadena, CA 91103

In a time when beauty is almost a dirty word, you embrace it. But you don't present a typical beauty, rather, it is one of looking deeply and finding the wonderful or sad in something like a tree trunk or insect riddled leaf. Can you tell me about how you come to find the beauty you capture in your work?

The honest answer is luck. Every project started with a gift, a picture I didn't plan or earn, one that suggested a new way. Photography is a wonderful medium for allowing that to happen. By its nature it tends to let life flood in, rushing past all your preconceptions. William Stafford's line as a photographer's motto: "Smart is okay, but lucky is better."

There is something primary about your photographs, the sun flares, unorthodox composition, and gray skies. These are elements traditionally thought of as "wrong" within the genre of landscape photography, yet they are more true to how we actually view the landscape. What made you decide to focus on this seemingly anti-heroic landscape rather than the sublime vista?

If there ever were places like those Albert Bierstadt painted, they're gone now. But even if those places were real and I lived in the nineteenth century I think I'd still probably want to picture somewhat less grand locations—flatter ones, and tending to the shapeless. Exploring that kind of geography is what most needs doing.

For *Badlands* I choose to exhibit multi-paneled works from *Listening to the River* and *Notes for Friends*. These pictures seem to tell a poetic story about how we relate to the landscape. Does this pictorial language stem from your early work with the written word? Also, how do you negotiate the way that your photographs are seen in exhibitions as opposed to in book form?

I sometimes work with a line or two of poetry in my head, but the origin of the sequences was primarily in the force of memory as it had accumulated through a lifetime, and in the pleasure of walking again in those places. On some days I couldn't stop shooting and—it seemed—I couldn't make a mistake. I know it doesn't always show, but the experience of making the pictures was among the most joyful in my life.

Books and exhibitions on the same subject are related but never synonymous. Kerstin, my wife and collaborator, and I start editing both books and exhibitions by laying out all the pictures so we can arrive at a rough overall sequence. Eventually, however, the book has to be edited by considering only

what is visible on two pages at a time; whereas an exhibit must eventually be edited with a lot of pictures visible at once. Peripheral vision is a part of the experience. The issue with both the book and the exhibit, of course, is to determine how pictures modify each other.

I recently saw you interviewed on the PBS series *Art 21* and you mentioned that you feel bad for anyone who has never felt connected to a tree. This intimacy with the landscape is so apparent in your work; it is almost like you are visiting and conversing with old friends. In our current ecological times, many people are losing their connection to the trees. What advice would you have for this situation?

The problem is one we all share: how, in this over populated world, to get out of each other's way enough to converse with non-human life? If overpopulation is discussed at all it is almost always in terms of economics and physical survival, but the problem is every bit as much of spiritual survival.

On a personal level, Kerstin and I attempt to keep in contact with trees—and the rest of the landscape and seascape, all of which is alive—by trying to be attentive to what is close to home, by getting out of the car as often as possible, by trying to escape human noise... Fortunately, even one small

© Robert Adams, courtesy Fraenkel Gallery, San Francisco and Matthew Marks Gallery, New York

tree, like the plum in the front yard, is sometimes enough. As Edward O. Wilson observed, "It is possible to spend a lifetime in a Magellanic voyage around the trunk of a single tree."

There is help for all of us in the guidance offered by those who preceded us, and in the inspiration provided by our betters who are here with us now—by poets like Emily Dickinson and W.S. Merwin and Wendell Berry, and by essayists like Thoreau and John Hay and Edward Abbey.

We can also improve our friendliness with trees by attending to the work of visual artists. Atget and Cezanne are supreme examples. I've been helped too by the Barbizon painters, especially Theodore Rousseau. Even artists who might not seem to be exactly tree people can bring things into focus: Matisse observed with passion, for example, that "in a car, one shouldn't go faster than five kilometers an hour. Otherwise you no longer have a sense of the trees."

Finally, beyond each of our individual efforts not to lose contact with the blessings of the natural world, there is, of course, the obligatory political struggle. We have to work with all our might to try to convert our neighbors away from seeing things in exclusively mercantile terms. There are some signs of progress here. We mustn't give up.

Robert Adams *Longmont, Colorado* from *Notes for Friends* 1987

Robert Adams *Along I-25, Weld County, Colorado* from *Notes for Friends* 1987

Robert Adams *Longmont, Colorado* from *Listening to the River* 1987

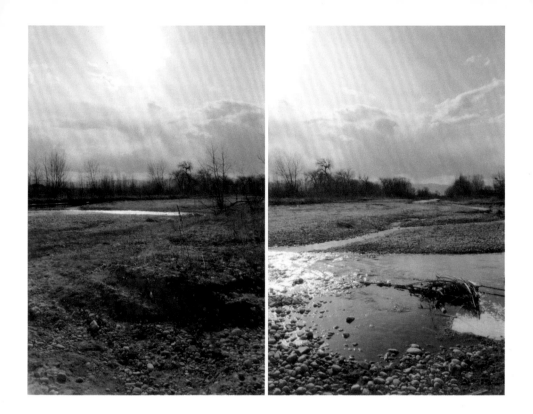

Let's start with the land adoptions performances. All too often we take our land for granted, but this project seems to encourage people to assume ownership. How does the adoption process work and how rigorously do you screen people to make sure they will take care of their piece of land?

The land adoptions have taken place in a lot of different contexts: in galleries, at events, and in public spaces. When they happen in a context where people have heard about it, or are expecting a performance, they slip very easily into the conversation. Sometimes people come up to me having heard about the adoptions and make their case as to why they are a good adoptive parent. When I do these in public spaces, where I talk to random passersby, the conversation gets even more interesting. It's delightful when someone encounters the work out of the blue and immediately gets into the spirit of it.

I start by inviting people to adopt some land. They usually think it is for sale, so I emphasize that it is a free gift—but only to a good home. If they think they want to adopt, then the "screening" process begins. We talk about what is living in the land, what kind of home and care it needs. Sometimes at this point they realize that they cannot adopt—they may not have a good home for the land, or they may not be up for the job. I always have to tell people that I am not able to check up on them. I can't send a social worker around to see how they are treating their land, and I can't conduct a background check on them, so we have to develop some trust before the adoption can take place. At the same time, I have to have faith in the participants, that they will take their commitment seriously. This is where the adoption form comes in. The pseudo-legality of the form emphasizes that it is a binding contract. The form is a reminder of their pledge, and also their title and deed to the land.

So, yes, the project encourages people to "take ownership" of something they may not have felt was theirs. I like to think about the ways in which ownership entails responsibility and care. On the bigger scale of how we treat the land, some people believe that ownership means the right to destroy, but in this work the adoption ceremony makes clear that ownership is a relationship of care, and possibly a burden of responsibility.

When viewing your *Personal Biospheres*, with people sticking their heads into these suspended domes, my first inclination is to laugh. At the same time, the domes become like science fiction, where access to the landscape is controlled, which makes the work alarming. What was your impulse for creating these isolating chambers?

This work began as a sort of dystopic take on urban life. I made one initially that was called the *PPB (Portable Personal Biosphere)*, which was sized to be worn over the head when walking around the city and it had a device built into it so it worked like a helmet. It created an artificial horizon of green right in front of your nose, and it allowed you to smell the forest instead of the diesel fumes, and it muffled the noise of the city. I thought the image was funny, but also really sad; not only was it about estrangement from the living world, but it was also about isolation from other people. Then I made some larger-scale *Personal Biospheres* and called them *Home Biospheres*. When you got home from work, you could take off the *PPB* and spend some time in your *Personal Home Biosphere*. You could sit inside while watching TV, relaxing, whatever... effectively creating an alternate environment for yourself.

The original impulse behind the biospheres was ironic, but at the same time the actual experience of being in them appeals to me in a very different way. When you are inside, the smell is really strong and you notice how sterile the surrounding gallery is by contrast. Also, when you stand inside, the moss, plants and other

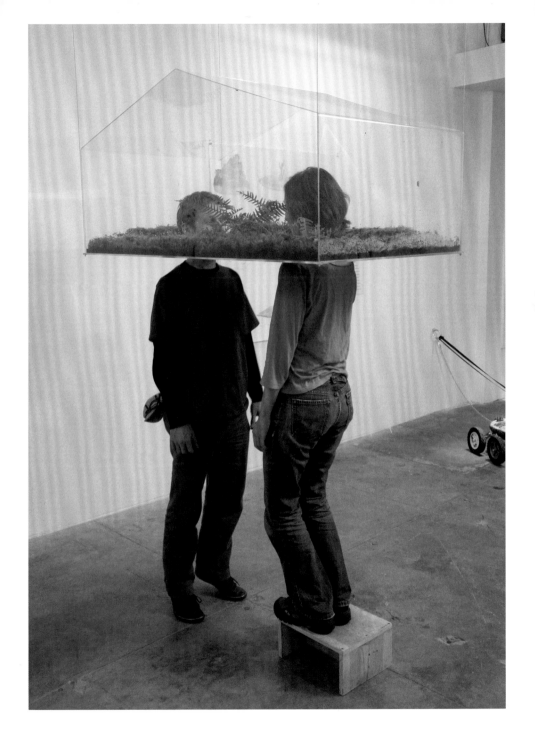

Vaughn Bell *Biosphere Built for Two* 2006 Photo: Richard Nicol

living things are right at eye level, which is a way we rarely experience the landscape. So, the visceral experience of the work, while on the one hand is isolating, on the other hand it's a whole different connection.

Can you talk about how you made the works in *Badlands* specific to the Berkshire landscape?

Some of the first *Personal Biospheres* were made to represent a lot of different environments. The wearers could decide whether they wanted to live in a forest, jungle, herb garden, etc. All of these environments contrasted with the locales of the installations: that is, in cities dominated by human infrastructure and not a lot of green.

In the Berkshires, there is not that same sense of the desperate need for green things that exists in the midst of a big city. I referenced the idea of the village green—a piece of open land owned in common by the people in the town. It recalls a sort of idyllic past from rural New England, which is enclosed in plastic inside the gallery. Instead of a contrast to the surrounding environment, the biospheres are a microcosm of the Berkshire setting. In a way the installation turns the site inside-out.

Right now I'm interested in what expanding the scale of the biospheres does. When you put two people together in the space, there is an intimacy, which can be uncomfortable. Suddenly, instead of sharing a small space with a bunch of moss, there is another person in there too, which might be more like what it is like to live in a small village. Do we feel this environment as comfortably intimate, a peaceful, shared space, or is it confining and discomforting?

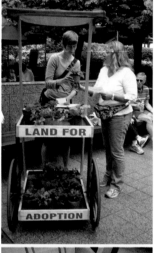

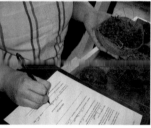

Vaughn Bell Land Adoptions with the CUV (Cultivation Utility Vehicle) 2006–ongoing
The CUV travels to various urban locations offering "land for adoption."
Participants sign an adoption form affirming their responsibility for their new land.

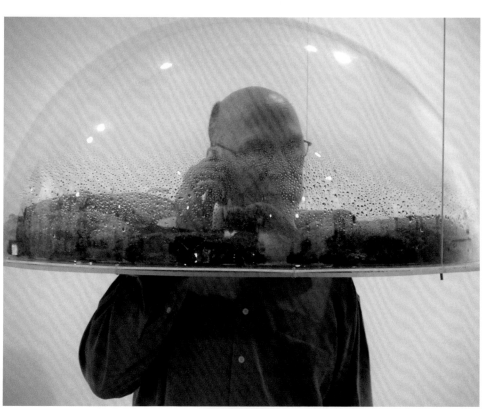

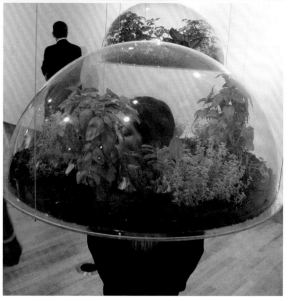

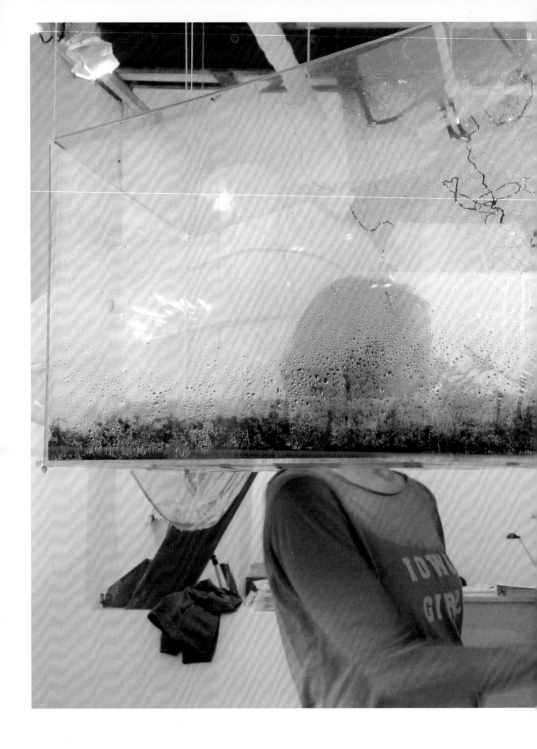

Vaughn Bell *Biosphere Built for Two* 2006 Photo: Richard Nicol

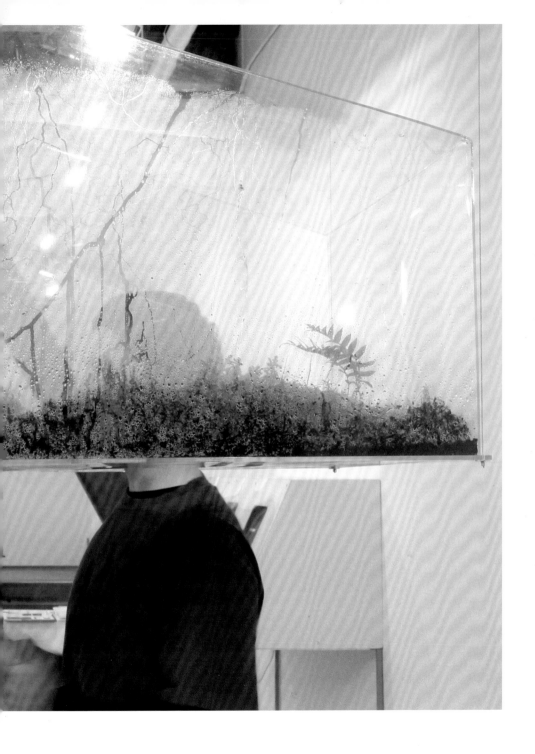

Interview with Sebastian Boyle

Boyle Family is not your traditional art venture: it started with your parents, Mark Boyle and Joan Hills, and then came to encompass you and your sister Georgia. How did the whole family become involved in the creation of the work and how does your mission continue since Mark passed away in 2005?

The main reason we ended up working together was because Mark and Joan worked at home. Mark and Joan met in 1957. He was a 23 year old poet stuck in the army, whilst she was a 26 year old painter and single mother, running a small business. They started living together and were increasingly working together by the time Georgia and I were born in London in the early 1960s. Whichever flat we were living in was our studio. Assemblages and the first earth studies would be worked on in the back room, whilst experiments for events and projections would develop in the kitchen. As we got older, we got more involved, from doing site work and resin mixes to painting and discussing ideas for works and shows. Mark and Joan were very open about the work. It was an exciting period, all sorts of people would drop by, ideas would be chucked around, and we were encouraged to be part of the debates. However, the art world found it hard to accept us as a collaborative team. Galleries wanted to stick

to Mark Boyle as a single artist. We tried to get around this by inventing umbrella organizations like the Institute of Contemporary Archaeology or the Sensual Laboratory, which could incorporate more people, including us. During the 1970s our cover organizations fell away and Joan's first son, Cameron became less involved, so it gradually came down to the four of us as the core. We finally adopted the collective title of Boyle Family in 1985. We don't think we are that unique. There have been many families and relatives making art together going back to the Renaissance, maybe hidden from view, but working together nevertheless. If it hasn't already been written, there is a fascinating history waiting to be told.

I cannot say how much Mark's death changed things but it was a huge blow to all of us, individually and collectively. He was a very creative and original artist: serious, passionate, generous and hilarious. Sure we would all argue, but you don't work together for nearly forty years without having a great deal of humour in the studio. I am convinced he and Joan will be recognized as giants of post-war British art, partly because they were big enough to share the credit with Georgia and me. We haven't tried to change or continue as if nothing has happened and whilst we rarely discuss what Mark would have liked,

I am sure that he would have been knocked out by some of our recent pieces like the eight-hour time lapse film we shot over eight months for our *Seeds for a Random Garden* project or the new pieces from the Barcelona site in the *World Series*.

Journey to the Surface of the Earth started out as a Fluxus-like game of chance, where darts were thrown at a map to determine where the earth paintings would be made. How much has chance continued to play a role in your activities? Also, how many works are planned and how many have been made?

Our use of random selection techniques to choose our sites isn't really a game of chance, but a way for us to minimize our role. We would like to take ourselves out of the equation. We are trying to present reality as it is, not as we would like it to be, so we don't go around selecting something because we think it is beautiful or ugly or because it will make a good piece or a comment on contemporary society or art theory. We want to see things for themselves free from all those associations. Having said that, we freely admit that our random selection techniques are pretty rudimentary; for example, people being blindfolded and sticking a pin in a map or throwing a carpenter's right angle into the

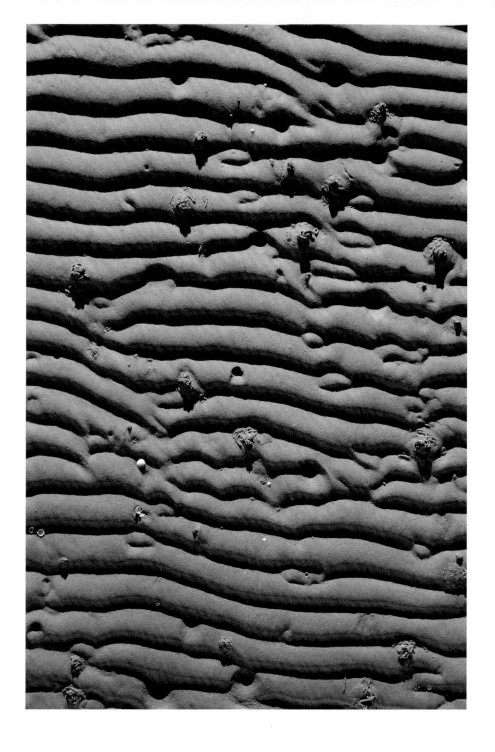

air to select the first corner. We also admit that we allow practicality to have a role. We see it as another variable. For example, somewhere might be too dangerous or too sensitive to work in, like a war zone. We accept that some sites might never be accessible; we note them and move on to the next project. That might undermine our objectivity, in that some sites get delayed for practical reasons, but it is the attempt that is important.

The main series in the *Journey...* is the *World Series*, for which 1,000 sites were selected by blindfolded friends and gallery goers in London between 1968 and '69. We have managed to do about forty of those sites, mostly in Europe but also in Japan, Israel, Australia, and New Zealand. There are related Earth pieces such as the *Sand, Wind and Tide*; *Chalk Cliff*; and *Japan* series, where we go and work in a particular area or country. There are also projects that look at other aspects of reality, for example the *Skin Series*, *Body Work* and *Multi-Human Being*, which look at mankind and society again using random selection. Many of our projects, even ones from the 1960s are still considered works in progress.

The *Journey...* series functions in a zone between painting and sculpture. They are sculptural in their inclusion of relief elements, yet they hang on the wall like traditional paintings. What kind of transformation takes place when the horizontal surface is made vertical and the earth is placed in the gallery?

The *Journey...* project involves us going to the random sites and trying to record and fix the surface of the Earth using a combination of real material from the site with paints and resins. We like the way they can move between painting and sculpture, although we don't really see them as either, but as their own thing. We call them pictures, pieces, works, or presentations. Some people might see them more as paintings, others as sculptures, but we are relaxed about both. The move from horizontal to vertical is not really a great issue for us. It has always been a more practical issue of space. Rooms and studios tend to have more wall space than floor space. We like to think that the move from the floor to the wall presents them more clearly as evidence, so that we or the viewer can be more like a microscope, zooming in and out. But at the same time, being on the wall they invite the comparison with paintings, which we have to accept. We see the work somewhere between art and science and so it seems right that the pieces should also be somewhere between painting and sculpture.

In 1966 Mark stated: "The most complete change an individual can effect in his environment, short of destroying it, is to change his attitude to it." This sentiment is so pertinent today, given the critical state of the environment. How much does the project of replicating the land have to do with preservation?

I think this is mainly a call for less certainty, a call for people to be open to other ideas and possibilities. Mark was interested in how to have new perspectives, how to be less sure that you are right. He started another statement with the words: "In a condition of adamant doubt." So whilst the timing and title of *Journey to the Surface of the Earth* could be seen as questioning space exploration when we possibly know relatively little about our own planet, Mark and Joan were not setting out to highlight environmental issues. We don't replicate the land in order to raise awareness of the need to preserve the world. Funnily enough we don't even see them as replicas. We see them as an attempt to present facts, not to promote an agenda, no matter how worthwhile. We are concerned with the question of whether it is possible to give an account of even a small section of reality and say in any meaningful way that it is accurate.

Boyle Family **Study of** *Brown Mudtracks with Tyre Tracks and Coal Dust, Portishead* 2006

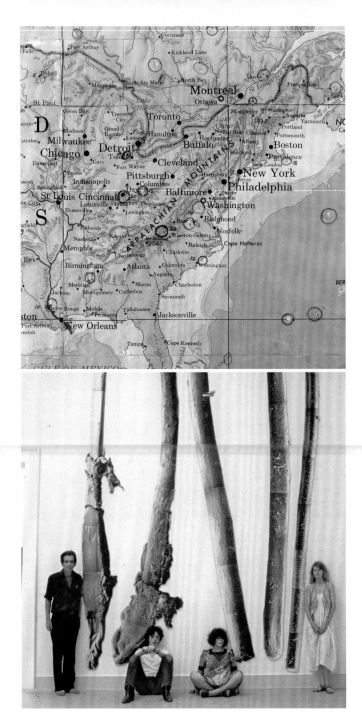

TOP Detail of the *World Series* map showing random selections, 1968/69

BOTTOM Boyle Family with mosaic of electron microscope photographs of hairs, Venice Biennale, 1978
Left to right: Mark Boyle, Sebastian Boyle, Georgia Boyle and Joan Hills

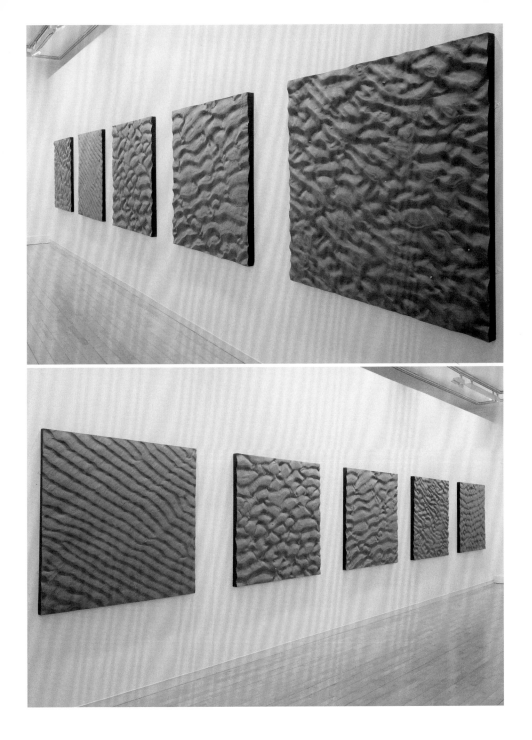

Installation shots of the *Sand, Wind and Tide Series* in Boyle Family exhibition
at the Scottish National Gallery of Modern Art, Edinburgh, 2003

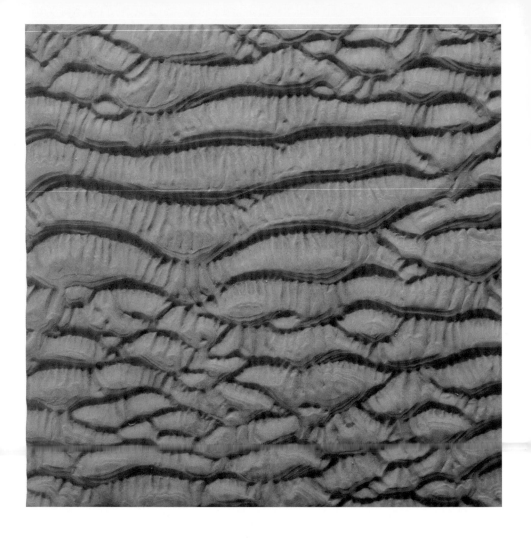

Boyle Family *pm 4/11/1969* from *Sand, Wind and Tide Series* 1969

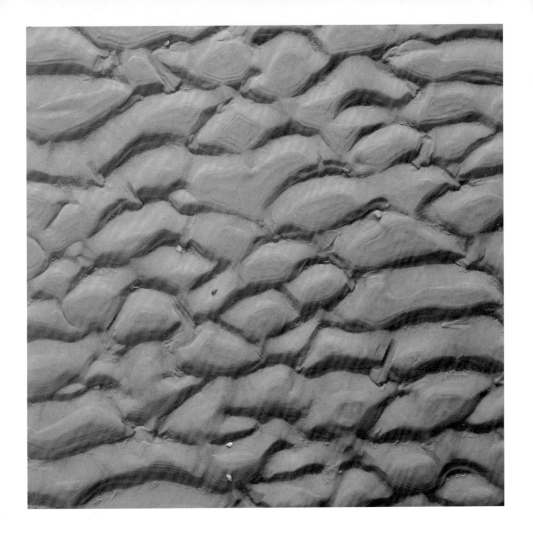

Boyle Family *pm 2/11/1969* from *Sand, Wind and Tide Series* 1969

**Your work clearly refer-
ences the nineteenth-century
Hudson River School painters.
Those artists were enamored
with the spiritual sublime;
but people like Thomas Cole
also looked at the darker
trappings of civilization. Your
work pushes these errors of
humanity even further by
presenting us with a sort of
post-apocalyptic Hudson
River School. How do you use
and then subvert these influ-
ences for the present?**

I hope that painters like
Thomas Cole and Albert
Bierstadt would be quite
horrified to wake up in today's
world. But from what I have
seen and read they were real
cheerleaders for the genocidal
march of Western Civilization
through the "New World." I am
intrigued how often art is used
to serve the dominant culture.
It is almost unbelievable, but
Bierstadt is quoted as saying
in reference to his painting
*The Rocky Mountains, Lander's
Peak*: "Upon that very plain
where now an Indian village
stands, a city, populated by our
descendantsm may rise, and
in its art galleries, this picture
may find a resting place." That
painting is so beautiful and
its reality so gruesome. I see
their work as having implicit
connections to the subject of
my critique, civilization.

I based the scale of my
two paintings on this and

other Beirstadt works, and I
composed my landscapes from
photographs I have taken of
the American Rockies. As far
as a post-apocalyptic Hudson
River School, I like it, but am
trying to coin my own word,
misapocalyptic, to imply a ne-
gation of apocalypse through a
controlled collapse. In contrast
to Cole, I don't present ruins of
an isolated civilization's failed
attempts. I am presenting the
image of a collective refusal
to continue our quasi self-
imposed domestication.

**Even though you are present-
ing a dark vision of the future,
you are careful to do so with
an eye towards retaining
beauty and the sublime. This
is a major conceptual compo-
nent to *Badlands* as well. How
do you balance beauty in the
face of a potentially horrible
future, and how do you infuse
your work with a sense of
renewal?**

I try to use imagery that I think
will speak to a wide range of
the population in the same
way an advertiser would. I
try to make the message as
easy to swallow as possible.
I like to think of my work as
anti-civilization billboards,
the prettier the better. In
2007 there was a show at the
Guggenheim Museum *Arcadia
and Anarchy* focusing on the
Italian Neo-Impressionism that
really clarified something. The

work seemed to begin with a
lot of social pieces about the
workers and resistance but
then changed to paintings of
idyllic landscapes. It clarified
for me that the painter who
hopes to change things might
as well retreat to the woods
and paint mystical scenes of
naked women.

**History, both in art and
culture, is a big part of your
work. You seem to look back
at history and the mistakes
we continually make as a
way to understand just why
civilization seems hell-bent
on destroying the planet. How
do history and the repeated
collapse of civilization factor
into your work?**

Presently my interest in history
is how it avoids critiquing its
progenitor civilization. This
has brought me to look at how
the civilized reacted to the
non-civilized only a handful
of generations ago here in
America—they killed them. The
Hudson River School artists
played their role in history
by making the record. They
showed the superiority of the
system by performing the sys-
tem's highest achievement: art.
I think it's important to look at
the spell of history that we are
living under. The spell that says
we have found the best way to
live and that we must continue
no matter how much land
and resources we need and

Paul Jacobsen *Sky Phenomenon* 2005

how many traditional ways of life must be minimized out of existence. I am pointing to the fact that if we do not stop civilization's quickening progress through the world, we will lose the heritage of the human race and will totally replace it with a techno-corporate hegemony. We are experiencing a system of control that begins with control of the food base by the dividing and selling of the land and ends with the implanted RFID chip.

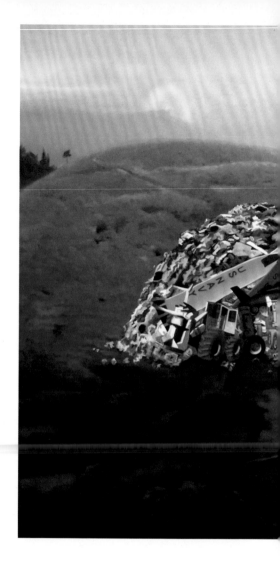

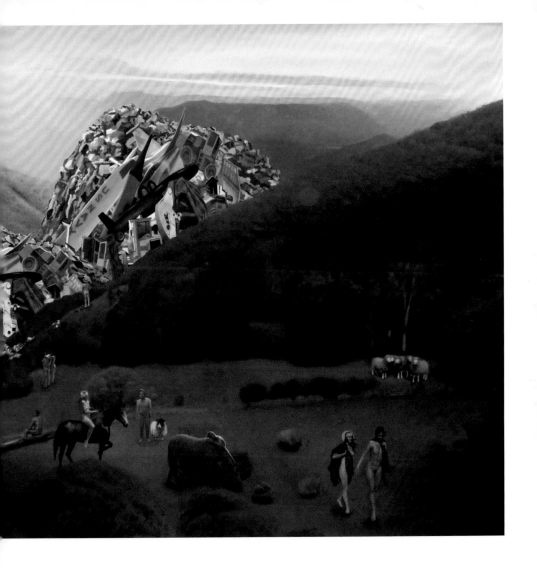

Paul Jacobsen *Post Industrial Collapse* 2005

Paul Jacobsen *Metaphorical Investigation of Metaphysical Reunion* 2008

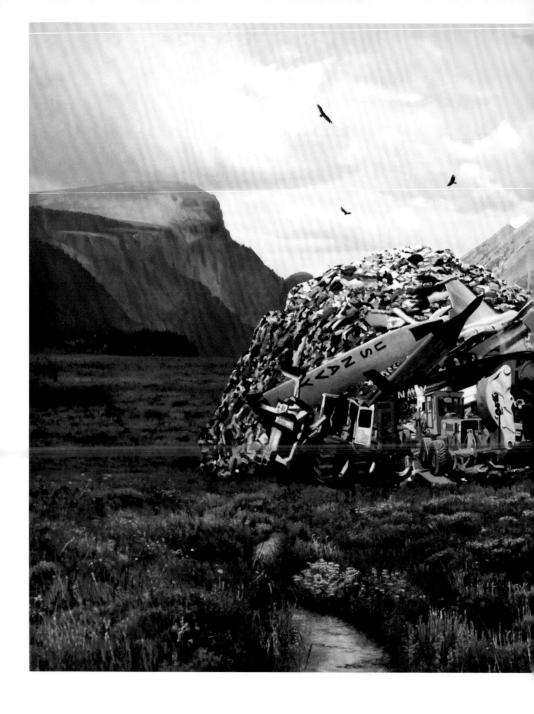

Paul Jacobsen *The Final Record of the Last Moment of History* 2008

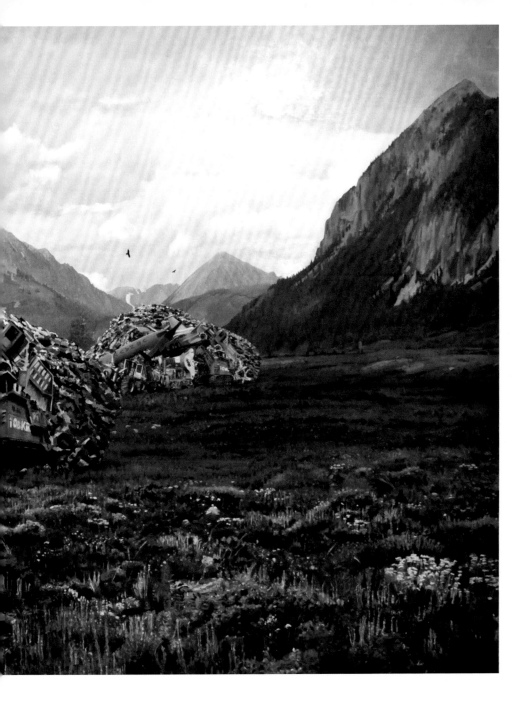

In the past, you have approached your work from a more scientific or natural history angle. This new work focuses on a landscape, besieged by the elements (weather, global warming, etc.), which in many ways makes it more real, and therefore more frightening. What made you decide to shift to this subject?

In my previous work I was interested in the history of scientific pictorialism, like natural illustration and photography. Those forms of representation are really about the description of specific information within a scientific gaze. This also allows for the representation of the impossible, for example, simultaneous views of above and below the water or showing microscopic life. With this new body of work I moved away from that. What I thought would be interesting for me to do in terms of the way I was painting was to think about landscape almost as an alchemic event, to try and set myself up with opportunities so that the material could have a chemical reaction that would mimic or resemble the way weather or the landscape interacts.

The materials and techniques I use are both traditional—like oil paints, varnishes, wax, and paintbrushes—as well as eccentric—like toothbrushes or turkey basters. These materials are used to achieve certain types of puddling and other effects in painting. The works are done on heavily gessoed paper, because

the paper almost feels like human skin, like a more organic surface. Also, I needed something rigid, since the paper is stretched over Masonite and flexible, so I could puddle the materials and allow them to have a mind of their own. And paper is literally from the landscape.

Your work in _Badlands_ reflects a recent trip to Antarctica. Can you tell me what it was like to take in that kind of environment and what events occurred on your journey?

My partner Dorothy Spears and I were invited by Sven Lindblad, who owns Lindblad Expeditions, and is a partner with _National Geographic_. I was excited since going to Antarctica might be the closest thing there is to leaving the planet. Humans have never been able to live there: the winters are just too brutal. We sailed aboard The Endeavor, which makes five or six trips a season, during what is their summer. I had not realized that there is a tradition of ecotourism that goes back into the 1960s, which Sven's father Lars Lindblad pioneered.

We were on the boat for twelve days, including the two days it takes each way to get across the Drake Passage, from Ushuaia, Argentina to the Antarctic Peninsula. There were about eight naturalists on board specializing in geology, ornithology, etc., who led day trips via Zodiac onto the peninsula, where we saw penguins, leopard seals, sheathbills, and other players

in the ecosystem. There were lectures and film programs; it was very educational. I went there thinking I might do a lot of watercolors in the field or on the boat and ended up doing none, instead I just took a ton of photographs. I wanted to have an open mind. The tradition of the Antarctic is very rich, but it is also very recent. I just tried to educate myself about it as a place and an ecosystem.

Just after we crossed the Drake Passage we were woken at 4:15 a.m. Tim Soper, the expedition leader, explained to us that another passenger ship in the vicinity, The Explorer, may have collided with an iceberg near the South Shetland and was sinking, and we were heading to its rescue. It is ironic that The Explorer was in fact the first ecotourist boat that had been built by Lars Lindblad, but subsequently sold in 1982. In the late 1960s Sven Lindblad and many of the crew of The Endeavor had spent the early part of their careers on The Explorer and it was very emotional for them to see it sinking before their eyes. Sure enough, when we went out on deck, there it was listing at thirty degrees. There was a helicopter from the Chilean navy flying above it and about five lifeboats full of passengers who had been at sea for over four hours. Luckily there was a larger boat right behind us that took on the passengers. Dorothy ended up being _The New York Times_ correspondent for the story sending firsthand information back to the United

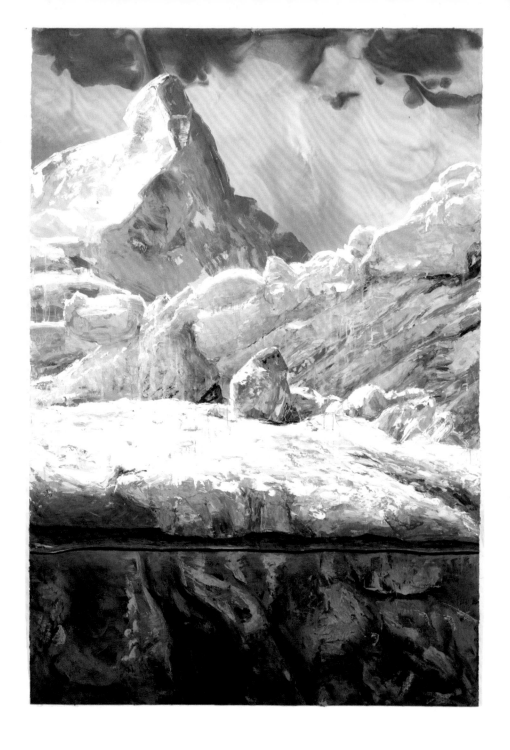

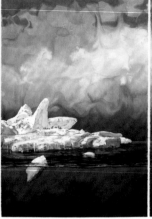

States. It was an exciting and interesting experience, but also a little unnerving.

The imagery for your work comes from outside sources: internet searches, books, magazines, but also firsthand exploration. Antarctica must have been a very different kind of landscape than anything you had experienced. How did that factor into your new work? How much did you consider the nineteenth-century artists who worked in Antarctica?

In the early 1990s I based my work almost entirely on received images, mostly in the form of nature photography and natural history illustration and diorama display. At that time artist Mark Dion suggested that we go on a trip to Guyana in South America and I thought it was a wonderful opportunity to immerse myself in a tradition of being the field naturalist, drawing specimens, taking notes, etc. The trip started a cycle of work that I still do, which involves going to a place and making work from the experience and materials on site. I began by making very detailed pencil drawings of insects collected on site. When my pencil became unusable, I started to experiment with other materials, like mud from the river, which opened up the possibility of using all sorts of new materials. In my work since then, I have used everything from my own blood to wombat scat. I have since used this approach in Tasmania, South Africa, and various other places. For me, using materials found on site is a way of being diaristic and intimate: like a combination of an artist like Richard Long and a field naturalist.

When I decided to go to Antarctica I first thought I might make drawings out of water, but soon lost interest. The idea seemed to be more of an intellectual conceit. Instead, I had a digital camera and computer and I took dozens of photographs a day. From this investigation, I realized that what I actually wanted to do was make a big *work* of what the ice itself looks like. This is a substance that has never really been photographed in a way that I think is convincing. The fascinating thing about the glaciers, which are hundreds of thousands of years old, is that they are described as geology even though they are frozen water. Curiously enough, Antarctica is a desert in terms of precipitation: it is covered with five kilometers of ice, which only accumulates at a rate of about one inch per year. It is like imagining the whole of the Rocky Mountains enrobed in ice with just the tops sticking out.

The final project for *Badlands* ends up being a group portrait of icebergs. The difficult part came in trying to describe a phenomenological experience. Ice conducts light, it gathers it, and projects it to you. That is something that cannot really be photographed. So the finished painting becomes a construction of photographs, notes, and memory.

As much as I love painters like Church and Friedrich, their work is very different from what I was actually looking at. I had never seen anything like it before and though I respect those artists and

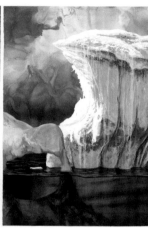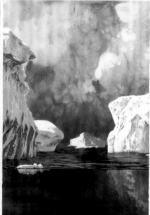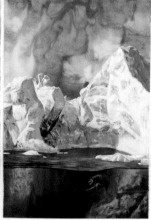

what they did, I felt that I was in a landscape that has never really been painted. In experiencing this landscape firsthand I could see how these early artists' paintings were more like snow and rocky geology, with Church's small studies of icebergs as the exception. I think you really have to suspend disbelief and treat the glaciers as geological structures that project light, and that is very hard to do, it is much stranger. Photography is a helpful note-taking tool, and obviously these early paintings predate photography.

These drawings truly do evoke *Badlands*; they are filled with a vast beauty as well as an underlying threat. How do you work with both of these factors in mind?

It was a sparkling sunny day with temperatures in the low forties as our ship returned to Ushuaia, rounding Cape Horn, and our Captain explained that we were going over a graveyard of thousands of ships that had been destroyed by the treacherous currents. It is a very confusing place; there is a huge history of loss and beauty there because the weather can turn so quickly. The passengers of The Explorer that were in their lifeboats could have easily not made it if the weather had been bad, and in fact, it would have been a very different experience for them had it been six hours later, since there was a storm right behind us.

If I had not gone to Antarctica firsthand I would never have made this work. The whole trip still seems very strange. The essence of this work lies in the infinite variety and spectacular impossibility of that landscape, how alien it is to the human eye.

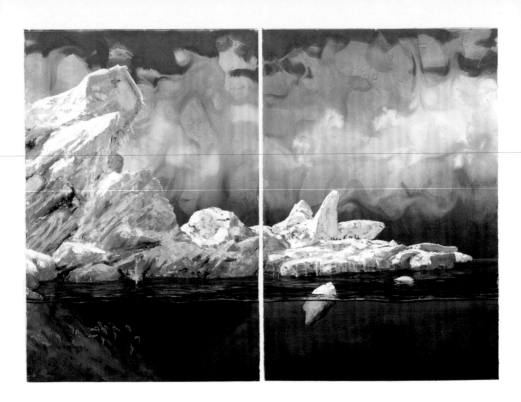

Alexis Rockman *South* (panels 2 & 3) 2008 Photo: Thomas Müller

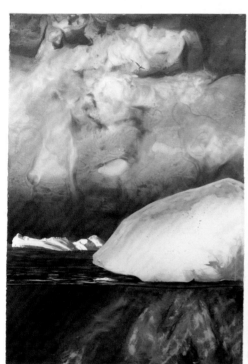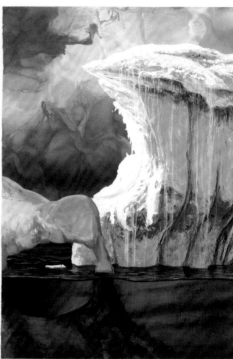

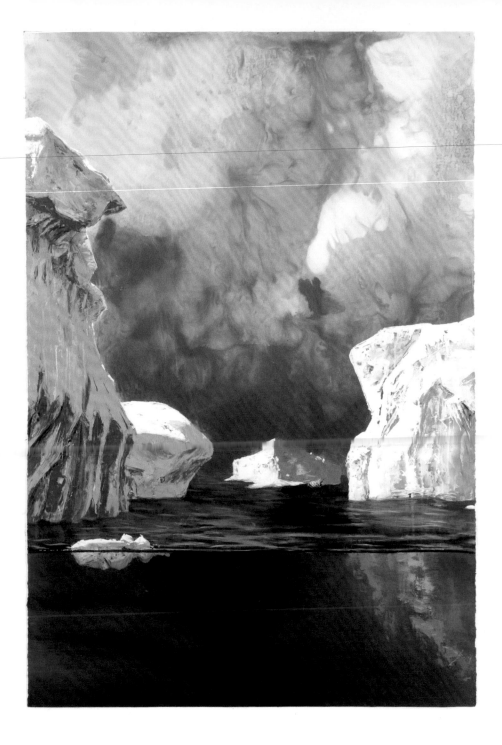

Alexis Rockman *South* (panel 6) 2008 Photo: Thomas Müller

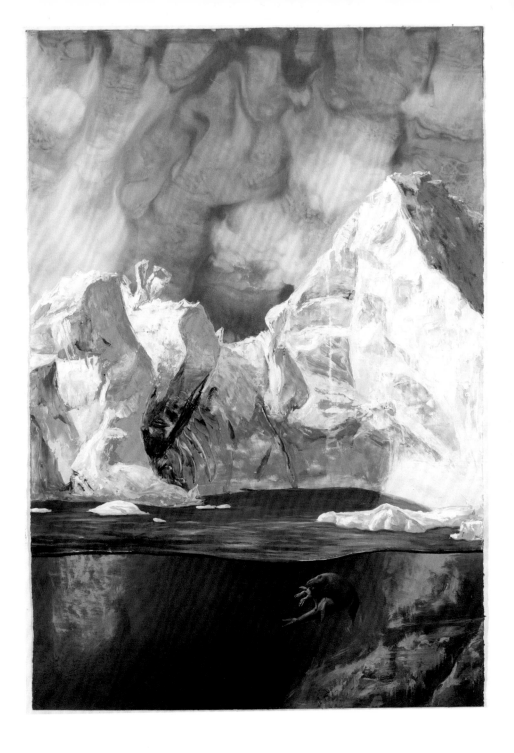

The landscape is a central theme in your work from *26 Gas Stations* (1963) to *Course of Empire* (2006). In many of these series the landscape is that of the built environment, however, in *Country Cityscapes* (2001), you focus on a more rural setting. Can you talk about the different ways in which you depict the landscape, and the meanings these diverse settings hold for you?

I attempted to find fluffy, ideal American landscapes to counter the harshness of the message. The images, or backgrounds, had to be pre-established ideals of the sweetness of scenery.

In 2005, you took on your own history in the *Course of Empire*, where you revisited Images from past work, while at the same time referencing Hudson River School painter Thomas Cole's series *The Course of Empire*. How does Cole's notion of progress factor into your view of the contemporary landscape? Also, what is your relationship to the landscape genres of the past, including the Hudson River School?

I have no affinity with the Hudson River School except as historical perspective. Thomas Cole himself, however, had a powerful message to deliver

and did so. In some way, I feel I am carrying on certain parts of this message.

Just as the landscape is recurring in your work, so is the use of text. In *Country Cityscapes* the text is printed so that it is barely visible, yet it contains such alarming phrases as "You will eat hot lead" and "It's payback time." One would think that to have these abrasive statements softly exist alongside seemingly idealistic landscapes would diminish their impact, but in fact, the opposite is true. How did this series come about to include this play between text and image?

I get reminded of that old saying, "Shut Yo' Mouth" where a hand gets slapped across a mouth, a blunt form of censorship. A static, abrupt strip of white becomes a stand-in for a word. It became another way of laying out a verbal thought.

DO AS
TOLD
OR SUFFER

U.S.F. Proof ½

Ed Ruscha 2001

BE CAREFUL ELSE WE

BE BANGIN ON YOU

YOU HEAR ME?

U.S.F Proof ½ Ed Ruscha 2001

IT'S
PAYBACK
TIME

V.S.F. Proof 1/2 Ed Ruscha 2001

Ed Ruscha *It's Payback Time* from *Country Cityscapes* 2001

NOOSE

NECK AROUND

YOUR

H.C.E. Proof ½ Ed Ruscha 2001

Ed Ruscha *Noose Around Your Neck* from *Country Cityscapes* 2001

H.S.E. Proof ½ Ed Ruscha 2001

Ed Ruscha *You Will Eat Hot Lead* from *Country Cityscapes* 2001 **79**

YOUR
A
DEAD
MAN

V.S.F. Proof ½ Ed Ruscha 2001

Ed Ruscha *Your a Dead Man* from *Country Cityscapes* 2001

At the Limits: *Landschaft,* Landscape and the Land

Ginger Strand

No one believes in landscape anymore. As a self-contained genre, pretty vistas and sublime scenes feel compromised. There's a shadow moving across those sylvan fields, the shadow of ideology. Sneaking into the Western tradition via religious iconography, landscape masqueraded for several centuries as objective, a window onto the natural world. That's all over now. Today, like so much else, landscape has been unmasked. Its aesthetic is culturally constructed, its origins philosophically tainted, and its politics downright dodgy. Take English rustic painting, which came into ascendance just as Parliament hastened the carving up of the former commons, consolidating the countryside in the hands of 400 families. Poor John Clare went mad just looking at it. Enrolled in the service of empire, the image is no longer innocent. John Constable is no mere chronicler of cows; Thomas Gainsborough no dauber

of greenery. Scenic beauty was invented, and like all acquired tastes, it answers to the needs of its inventors.

This is not just a question of art. The land itself is in question. Power and politics trail in landscape's wake, because land itself is never un-ideological—at least not once humans begin to take its measure. Before long, it is not even natural. Cicero called it "second nature," nature transformed by the human hand. In our age, second nature is all there is; "first nature" has gone AWOL. Niagara Falls is turned up and down on a diplomacy-determined tourist schedule; the great Columbia River is caught and released at the behest of the Army Corps of Engineers; mountaintops are removed, forests turned to monocultural croplands, and aquifers emptied with little more effort than a beaver takes building his dam. The closer we look at the land, the more it appears to be a human sandbox, cluttered with our construction toys and sculpted by our ongoing efforts. Nor is this new, though its scale has increased exponentially in recent years. Humans have been firing woodlands, redirecting watercourses, and draining swamps since the dawn of tools. We didn't just invent the ideal of beauty; much of what we consider beautiful we shaped ourselves.

We are, of course, ambivalent about this, because the human hand has wielded a bludgeon as often as a paintbrush. Melting polar ice caps, deforested hills, vaporized South Sea Islands, desertified coasts: these manufactured landscapes induce in us a feeling of guilt at once so profound and so removed from individual action it can only be described as sin. What have we done to the world? What have we done to ourselves? At the edge of this howl in the wilderness, is it possible landscape might return, unrepentant in its ideological raiment, to help us find our way back to the land?

The land. Land art, landscape art, landscape, land: the terms mark out distinctions, fence off their little terrains, but those who speak them keep leaping the fence, breaking into each others' pastures and wreaking havoc with the hay. The very origin of the name is problematic. Landschaft. Europeans of the Middle Ages used the word to refer to a particular kind of place: the village, the commons, the wells and plowed fields—the neat topography of a human-shaped world on which day-to-day life relied, bounded by the untamed wilderness beyond. The Dutch said landskip to English sailors who took the word home with canvases showing villages nestled in rolling hills and fields dusted with painterly light. Ever

since, landscape has bounced back and forth between referencing a real place and a representation of it. We use the word today to define a genre. But we also use it while zooming down the freeway—*Just look at that landscape!*—to mean a piece of the world out there. We use it while trolling the daily news—*The landscape of politics has changed*—to mean a cordoned-off conceptual space. What connects all the usages is limitation. The landscape never sprawls infinitely, the way the world does. It always comes to an end.

In fact, the frame's the thing. Move your camera viewfinder across the scenery, trying to find the best view. The elements compose themselves— sometimes beautifully, sometimes not—into landscapes each time the square box halts. But what of the moment when it's traveling? And what if you take it away? Is what's outside the viewfinder incipient landscape, waiting to be revealed by art, like Michelangelo's figures lying dormant in their marble blocks? Ansel Adams would speak of a picture "waiting" for him to arrive and take it: the land is always ready for its close-up. Looking at the represented landscape, we want to believe the land is there, beyond the frame, contiguous with the rectangle carved out of it. We can't jump into it through the picture—though

that Mary Poppins-ish fantasy always tugs at our hearts—but we can get absorbed in it via thought. The imagination makes that leap. The representation offers itself up as a hiking trail for the mind. And so—again—the landscape genre is really about us.

But not all of us. Huddled in cottages, laboriously eking a hardscrabble existence from dirt and water and seed, the inhabitants of those original landschafts had little interest in admiring the beauty of nature. Admiration was reserved for the sharpness of a scythe, the water-resistance of a well-made roof. Whatever was not useful, as Puritan preacher Cotton Mather famously said, was vicious. Beauty was the domain of the Church: the cathedral spire pointing to heaven, the altarpiece yawning forth hell, the stained glass saint suggesting that beauty, too, was an intercessor, something you passed through to get to the next world. On Earth, that was its only use.

What happened to put pretty into the picture? To admire the land requires at least momentary respite from working it. Leisure leads to the landscape as surely as it does to the mall. The pleasing prospects of the landscape genre are the view from a Roman villa, an English manor, or a country house. There's a sort of hand-rubbing anticipatory eagerness

inherent in how landscape frames the land: the composition preliminary to the conquest, the paintbrush prequel to the plow. Here is land that could be made to yield. Perhaps the most important thing about the word landscape is that it designates something we consume. Even outside of art, to look at the landscape—rather than the land—is to order it, if only by eye, into something that meets our needs. Hills there, trees there, and beyond, a small, curving road for the mind's eye to wander down. Just as the phrase "standing reserve" transforms a forest ecosystem into something measured in board-feet rather than biotic riches, so the framing tropes of landscape turn the land into exploitable resource. More than that, they al-

chemize it into that ultimate abstraction, capital. How many times have you heard someone, on achieving a stupendous vista, make the joke "All this is mine?" The landscape is always seen through the eyes of the ruling class.

Which is not to say it hasn't also proved remarkably populist. Early tourists visiting natural wonders clamored to take home "views," and middle-class living rooms have often been graced with a landscape, real or reproduction. Yet our suspicions of the genre remain. We suspect that populism might be a sort of aspirational acquisitiveness: we too can own the land. We suspect that the very genre drags domination through the door of beauty, that it transforms biosphere into real estate. And we're beginning to understand the significance of how this positions us vis-à-vis nature.

Today we don't talk about scenery or landscapes as much as we talk about the environment—or, if we're being trendy, "place." The new terms signal a change in our understanding of how we fit into the world. When nature is landscape, we look at it. When nature is the environment, we live in it. We are in it and of it, and our relationship to it is one of mutual dependence and responsibility. Can there be a landscape genre to express this new relation? The question is vital. If not, landscape is damned to being merely the zoo of nature, the natural world taken captive and made subservient to what we know about it—landscape becomes, as art historian Christopher Wood has said, "a symptom of modern loss." We don't have a real connection to nature anymore, so we look at landscape pictures instead.

Here we might invoke Thoreau: I believe in the forest, and in the meadow, and in the night in which the corn grows. But setting aside our graven images and setting forth to be in the

world won't solve our problem. Because even in looking, we are influenced by our cultural expectations of beauty. The eye is no innocent either. In fact, one school of thinking about landscape has reduced it to the most primal manifestation of self-interest. Taking a page from the book of evolutionary biology, some art historians today propose that the landscape genre appeals to pleasure centers deep in our brain, hearkening back to an evolutionary past when humans lived on the savannah. We love small group-

ings of trees because we can hide behind them to hunt; we love high prospects because they make us safer from predators. Open grassland is kinder to human feet and flesh than prickly woods or treacherous marsh; rolling hills are easier to climb than craggy rock face.

This evolutionary explanation may help explain the vogue for a very particular kind of landscape, the kind that flourished not just in European rustic paintings, but found physical expression in the gentle slopes and graceful brooks of the classic English landscape designs of Humphrey Repton and Capability Brown. This aesthetic, the picturesque, valued land that looked like landscape art—carefully balanced, organized according to strict conventions, and welcoming to the human visitor.

The picturesque made its way to America via Frederick Law Olmsted, who helped redesign unloved corners of American cities—Boston, Buffalo, New York—in this mode. And it's a mode that functions. But it does not define all landscape, and it does not show us how landscape might lead us beyond its limits, helping to create a better world. For that we have the sublime.

Writer Curtis White recently proposed a revival of the sublime as the only hope for art in a co-opted world. This makes intuitive sense. The sublime forgoes mastery in favor of mystery. More a disposition than an aesthetic, the sublime is at heart a willingness to be awed, to pay tribute with awe to the incomprehensible and the indescribable, even as we aim to comprehend and describe. What could be more salutary than some measure of humility towards the human project that is so lacking in almost every endeavor today? We don't have to measure, map and master everything, from the edges of the universe to the intimate workings of the atom. There might even be value in not always grasping—in, as Shakespeare said (and the Beatles), letting it be.

This is the bright sun on landscape's new horizon. To take up the sublime once more

takes us beyond the limits of genre and into the realm of real imagination. Take, for instance, the urban landscape. Landscape has traditionally meant "country," whereas views of predominantly human settings have been called something else: cityscape or skyline or veduta. The country and city are traditional opposites: the rural landscape is spacious, flowing, totalizing, and spiritually uplifting; the cityscape is crowded, sharp-edged, fragmented, and morally corrupting. That tradition is being challenged. The city, more and more, is understood as an ecosystem, and the country is allowed corruptions and constructions of its own. Neither could exist without the other, and understanding their deep connectedness makes it harder to uphold the polarity. This is more than just rewriting old canons of scenic beauty: it is to say that sublime mystery adheres not simply to natural wonders, but our own potentials too.

This move breaks with old aesthetic boundaries, but it is a return to aesthetic purpose. Even early landscapes, in their supporting role as mere settings, had a crucial part to play. Spiritual crisis, human error, religious conversion, ethical orientation: all could be registered in trees and rocks and hills. The Romantic theory of the sublime took this one step further:

the land itself had a moral message to convey. Merely gazing at sublime sights put viewers in a morally righteous frame of mind, conveying creation's grandeur, demonstrating the consolations of spirit, and adding just the right touch of terror to remind them of God's potential wrath. Whenever landscapes—real or represented—have been popular, they have been said to have spiritual or moral meaning.

Today, with the environment imperiled, moral meaning has come back to the foreground. We see it in the anxiety that sometimes attends artists who turn the landscape genre's gaze onto damaged nature. If such landscapes evoke horror, they're branded manipulative. If they evoke beauty, they're feared to be aestheticizing and ideologically suspect. There are boundaries here worth crossing, a discomfort that may have real value. What's at stake is not simply beauty, or its moral meaning, but our very way of moving forward in a flawed world.

When we invoke the sublime, we find another way of looking at looking: the landscape genre can be seen as a kind of performance, an interaction between land and viewer that is rehearsed endlessly in the presence of the viewer. It may even draw the viewer in. This gives it a spiritual substance. It is an

exchange—though not a monetary one—between human and natural. It may even be a kind of giving voice. Thomas Cole once said, "the waterfall is the voice of the landscape." Then he went on to paint it. Can we attune our ears to this new vision? To give voice to nature in our era is not just an aesthetic act: it's political and activist. The best new work today is pushing beyond the limits, engaging in a dialogue with both landscape and the land. It commits an imaginative act that both makes and is made by the world out there, as well as the I in here.

Let's hope it's in time.

Bibliography

Malcolm Andrews. *Landscape and Western Art*,
(Oxford: Oxford University Press, 1999).

John Berger. *About Looking*,
(New York: Random House, 1980).

Ann Bermingham, *Landscape and Ideology:
The English Rustic Tradition, 1740–1860*,
(Berkeley: University of California Press, 1986).

Simon Schama, *Landscape and Memory*
(New York: Alfred A Knopf, 1995).

Anne Whiston Spurn, *The Language of Landscape*,
(New Haven: Yale University Press, 1998).

John Stilgoe, "Landschaft and Linearity: Two Archetypes
of Landscape" from *Out of the Woods: Essays in
Environmental History*, Ed. Char Miller and Hal Rothman,
(Pittsburgh: University of Pittsburgh Press, 1997).

Henry David Thoreau, *Walking 1862*
(New York: Cosimo, 2006).

Curtis White, *The Middle Mind:
Why Americans Don't Think for Themselves*,
(New York: Harper Collins, 2003).

Raymond Williams, *The Country and the City*,
(Oxford: Oxford University Press, 1973).

Christopher Wood, *Albrecht Altdorfer and the Origins of
Landscape*, (London: Reaktion Books, 1993).

THE EXPLORERS

One of humankind's eternal quests is to know the unknowable; in other words... to explore. It is impossible to date this desire back to any one point, for we are all explorers in our own way, whether it is braving new terrain or just discovering a different corner of our own backyards. The explorers' stories become our stories; we imagine what Ernest Shackleton experienced on his 1914 Imperial Trans-Antarctic Exploration, we empathize with the plight of Edmund Hillary and Tenzig Norgay as they completed their grueling quest to ascend Mount Everest in 1953 and we are filled with exhilaration at the sight of Neil Armstrong's first steps on the moon, in 1969. Exploration is a huge part of knowing the world around us, and a way of negotiating the landscape.

The Explorers of *Badlands* similarly look at and physically examine the landscape from both macro- and microscopic viewpoints. These artists start with the latitude of their own backyards and move onto more vast terrain, finally ending up at the North Pole, all the while, they seek to illuminate, through exploration, our relationship with these varying landscapes.

You talk about how early childhood investigations in the landscape informed your work. That makes a lot of sense, since that is how most of us first experience the outdoors. What kind of landscape did you grow up with, and how do you transform and deconstruct that memory in your work?

When I paint a landscape, I am not painting a specific place; rather, I am constructing a type of composite image of landscapes I have encountered, either through mediated image or firsthand experience. I believe the process through which I depict these vignettes or landscapes mimics the process of experience and of memory. I paint them, wash them away, allow the paint to collect in pools of watery pigment that settle in the valleys of the paper, and repaint the image after it has melted away. For me, this process, or performance, is an important part of the way that my images are constructed. Like both memory and experience my paintings are a building up of images, a melting of one moment into the next.

By incorporating sculpted paper, my works attempt to mirror our experience within the land. We see the land from a distance, we move into it and then become part of it. The bent paper substrates offer peaks and valleys with opportunities to observe details and absorb panoramas.

Your work plays with the natural and the depicted landscape, combining drawings and found items from the outdoors with elements like lead. Can you talk about the materials you use in your work and how they play off the delicately drawn imagery?

I am interested in the traditional idea of the picture plane being viewed as a window on to the world. By sculpting paper, adding artifacts from the land, and working with the fluid potential of my materials, I rethink the frame and remake it into a new space. It is no longer just a representation or illusion of space. It not only challenges representational conventions of landscape painting, but it also creates space phenomenologically instead of simply representing the spatial illusion.

Although my landscapes display a dynamic Baroque sensibility, the paper is often torn and appears to be in decay. The tension between the carefully rendered vignettes and the crumpled topography highlights the struggle that exists between order and chaos, growth and decay, even nature itself and the conventions imposed on it by man.

Time is an important element for you; these works exist as a building up of many moments conflated into one form. Another element at play here is a sense of the throw away, in the crumpled look of the work. What is the relationship you see between time and the discard?

A traditional view of time is linear, with a past, present, and future. I believe the past, present, and future all exist simultaneously. All three inform and influence experiences of the present. I imagine each plane within the wrinkled masses of my works as tied to an experience that is continually shifting and morphing, with material being added and lost from moment to moment. The space and its pictorial treatment is an expression of fluid time.

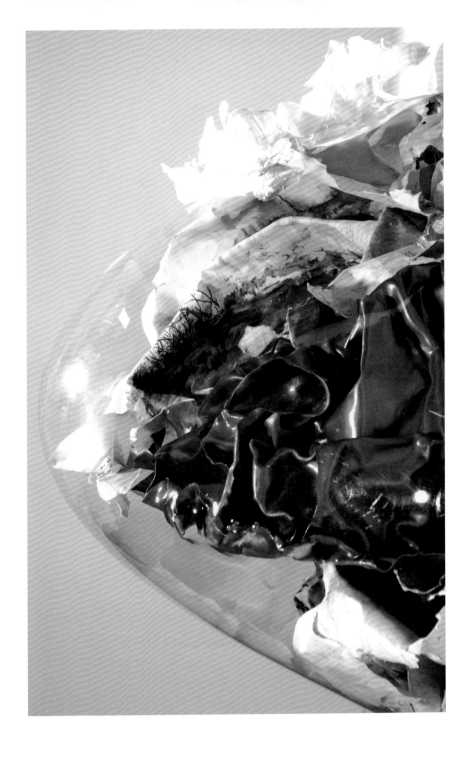

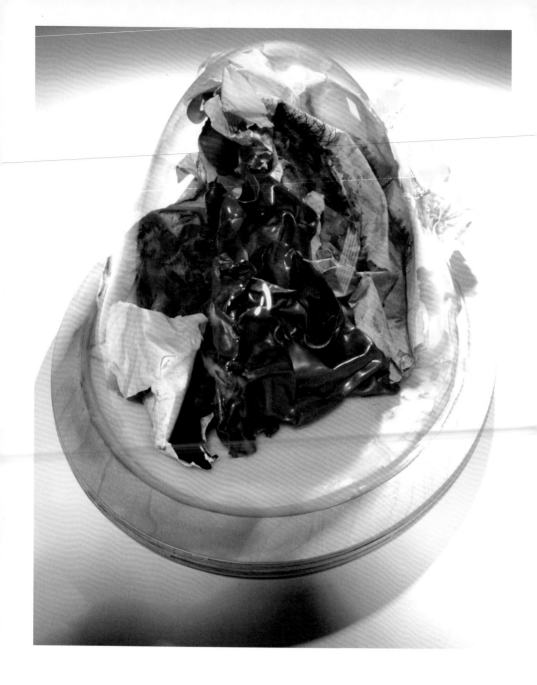

Gregory Euclide *A White Plane of Light Pushing Forward Again* 2008

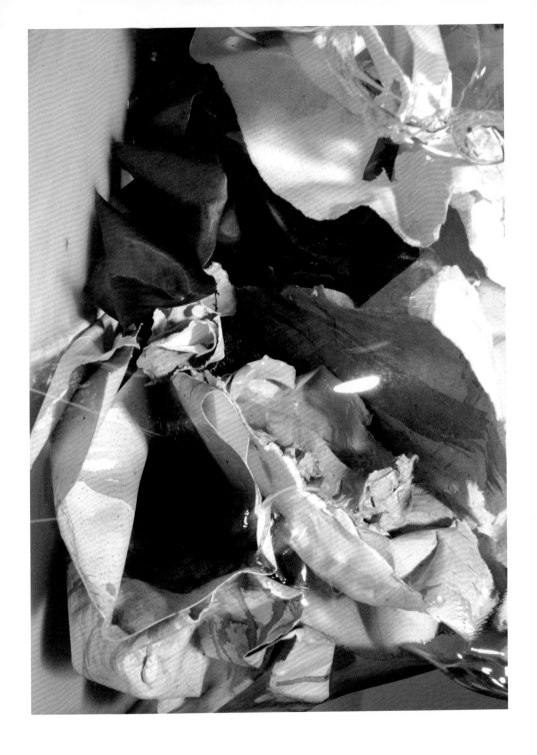

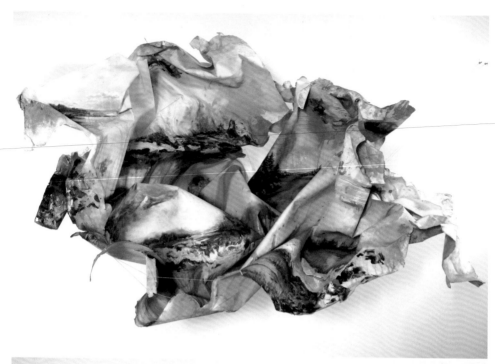

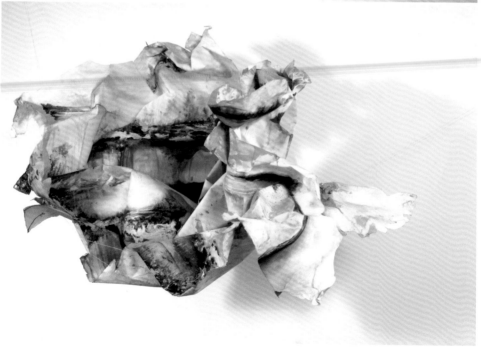

Gregory Euclide *I Was Only The Land Because I Liked Predictable Stillness* 2008

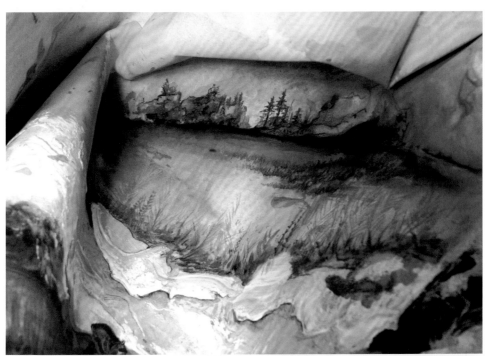

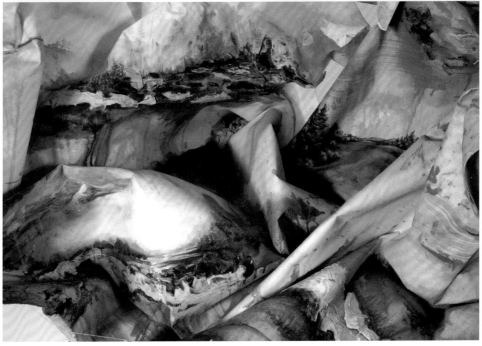

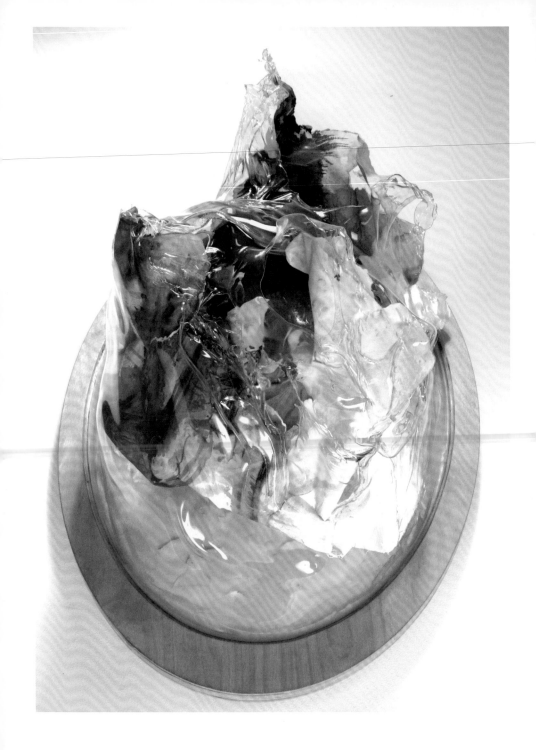

Gregory Euclide *Something More Than My Ribcage Because Several Treelines Are There* 2008

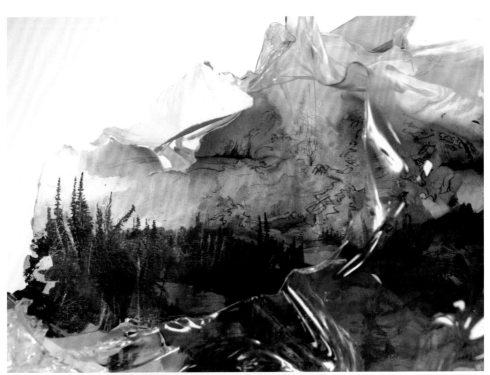

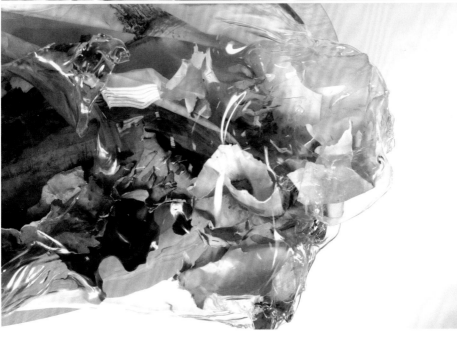

Your series of works on view in *Badlands* are part of a larger project. Can you talk about your recent travels and how this work fits into the project as a whole?

Standing among leaves and birds and dirt and sky and painting the mix is a happy thing. Although "happy" might not express the sensation as well as "rapturous," but that word is cluttered by religion. "Inspiring" is too pious, and "stimulating" is too geriatric, so "happy" will do. But this is not to say that the landscape is a happy place. Have you ever been struck by the weirdness of trees that compete for light? It's a report of their daily striving set into a shape!

Landscape is a vital thing, and human survival within its mass is always in question, but more so because of accelerating environmental changes. Compelled by the pleasure and politics of working within this urgent scene, I've started a *plein air* painting project that has three parts. The first part, *Latitude*, which is included in the *Badlands* exhibition, is an account of the changes of light, color and motif in one place as the Earth tilts on its axis over the course of a year. The second part, *Longitude*, is a record of traveling along an arc that extends from the Arctic Circle to the equator to study the changes in a given region. The third section, *Antipodes*, is a comparison of

locations on opposite points of the globe. Together, the three projects visualize the Earth as a shared space, sectioned by scientific measure rather than political boundaries. I hope the project creates more compassion for the living world and that this sensitivity translates into improved environmental policy. But the product of *plein air* painting is by nature modest and, therefore, absurdly mismatched to the task of consciousness-raising in a digitized, global environment. I have tried to compensate for the limitations on distribution that painting has (by posting weekly accounts of the adventure on a blog called Along a Long Line (alongalongline. blogspot.com). I have doubts about the effectiveness of any of this, but the combination of hope and futility in the project is at least a realistic position from which to act.

How different was it for you to get in touch with your own backyard as opposed to traveling across the globe? What were the surprises that emerged from both journeys, and how has your relationship with the landscape changed as a result?

It has been much easier to paint with spontaneity and confidence in my own backyard than it has been to paint in unfamiliar locations. At home the look of the land is already a part of me, so I can

access it through memory as well as observation. In both the Arctic Circle and the rainforest, I spent a good deal of time observing and recording the look of things before I understood it well enough to animate it with feeling. As for surprises, there is little middle scale in the Arctic. Other than the occasional boulder, one sees either the vast rolling space or the tiny plants and lichens that make up the tundra underfoot. As a result, the landscape feels lonely. Only the Inuksuit, stone cairns erected by the Inuit, provide comforting human scale. The rainforest, however, is all foreground. The density of living matter is astonishing. Life grows on life in parasitic and cooperative relationships. It's almost impossible to see uniqueness of form and color in the tangle. If the visual density is not challenging enough, the heat, humidity, microbes, thorns, and probing insects constantly open and test the body for weakness so that it can be recycled into the biomass. As a result, the landscape feels alive and competitive and it is a stimulus for self-consciousness. Funny, but this project has altered my awareness of language more than it has my sense of the landscape. For example, words set things in time. Once something is described, it becomes a part of the past. Landscape, however, is always in the present and it's an interesting challenge to visually represent

Mike Glier *September 27, 2006, 56°, N42° 52.551, W73° 20.792
(The Creek in the Hedgerow)* from the *Latitudes* series 2006

this "constant present." Also, language tends to divide experience into distinct bits. For example, we have "landscape," "cityscape," and "seascape," but there is not a word that describes these three things as one entity. Similarly, the words "culture" and "nature" set up a duality that may be false. I'd like to see these two words combined into one noun that describes a common process that is based in evolution.

This work is part of a tradition of landscape depiction; specifically *plein air* painting. The act of painting outdoors requires the ability to deal with a variety of unknowns. There is immediacy to this type of work, a sense of first impression. How much of that first impression remains in the final image, or do you go back and work things out after that first take?

Like many artists before me (Jackson Pollock comes to mind most quickly), I'm trying to use the process of painting to describe the diversity of life and the complexity of our perception of it through analogy rather than description. For example, I brush, splash, glaze, knife, scrape, and feather the surface of pictures in an attempt to represent the diverse physical textures, and the oscillating psychological textures that ignite perception. Since the concepts of diversity and complexity are at the core

of this project, I standardize a few of the variables, like size and materials, and try to be very free with others, like brushstroke, color, scale, and time. If a *plein air* painting can be completed in several hours in the field, great. If it needs to come into the studio to find completion, that's fine too. I'm not trying to heighten "authenticity" through the *plein air* process, nor am I trying to "brand" a style of representation. Instead, I'm trying to create a heterogeneous group of objects that flaunt their uniqueness, while maintaining just enough similarities to cooperate as a whole.

Mike Glier *August 30, 2006, 64°F, N42° 52.638, W73° 20.654*
(Front Pond) from the *Latitudes* series 2006

Mike Glier *December 1, 2006, 53°F, N42° 52.649, W73° 20.742*
(The Studio Yard) from the *Latitudes* series 2006

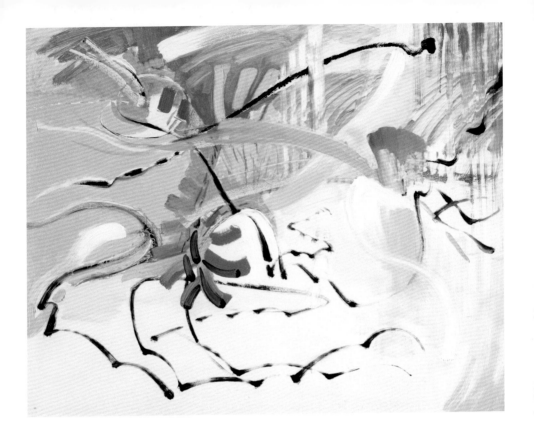

Mike Glier *February 25, 2006, 24.5ºF, N42º 52.649, W73º 20.742*
(The Studio Yard) from the *Latitudes* series 2006

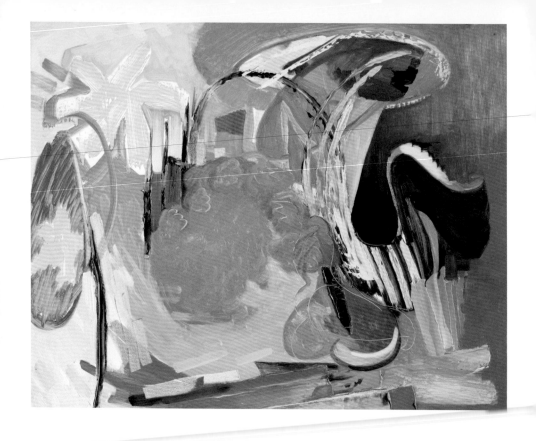

Mike Glier *July 31, 2006, 74.5°F, N42° 52.631, W73° 20.689*
(Under the locust) from the *Latitudes* series 2006

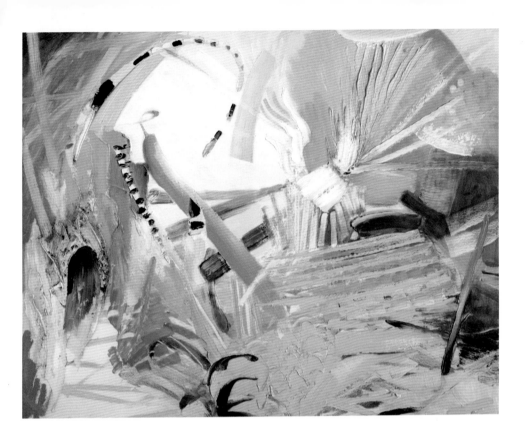

Ariana is part of a trilogy of films that you created, all of which in some way or another speak specifically about the politics of tourism. Could you talk about how the series evolved and how each part fits into the whole?

My three films—*Ariana* (2003), *The Last Tour* (2004), and *Travelling Amazonia* (2006)—form a trilogy shot in Afghanistan, the Swiss Alps and Brazil, respectively. I shot the first film, *Ariana*, in 2002 and very soon realized it needed a second part. I wanted the second film to be less discursive so in 2004 I made *The Last Tour*. While I was making it, I realized three points of view make for a better conversation. In 2005 I started gathering ideas for *Travelling Amazonia* and the trilogy was retrospectively completed in 2006. It was not planned as a trilogy from the beginning.

In Ariana the journey ends up being an impotent one, where you set out to capture a panorama but are stopped by Afghani officials. This, in a way, becomes a metaphor for the cinematic panorama itself, which for the most part is a fictional construct. In tourism, however, the panorama becomes like the Holy Grail. How do these two ideas of mass entertainment (cinema and tourism) factor into your failed attempt?

Because the access to the main vantage point of the Pandjsher Valley was denied to us by the local authorities, our trip was aborted. From that point we had to think why it had been so important to us to see that panorama and what it actually meant to our Western culture. Very soon the idea came to mind that a panorama was not only a vantage point in military terms but a camera movement and a pre-cinematic form of mass entertainment. It transpired to be very interesting to address these issues in the context of Afghanistan.

The Panoramas in nineteenth-century Europe were foremost a project to unify the population around the imperialist project and it was interesting to think of cinema as a way to prolong that propaganda. *Ariana* is an essay about space and scale and mostly this is what cinema is: a way to appreciate distances.

The frames of black that punctuate the film, where the panorama was to be viewed, also become stand-ins for the political issues surrounding Afghanistan; representing the ideologies of a landscape gone wrong. How do you view and represent the politicized landscape, not just in Ariana, but in the series as a whole?

I am not quite sure that the "ideologies of the landscape had gone wrong." *Ariana* is

about the military gaze, *The Last Tour*, the tourist gaze, while *Travelling Amazonia* is about what had inspired the gaze in the first place. They raise questions about the process of viewing. I see landscape as a form of cultural mediation, a social construction that informs the conventions of its representation. The trilogy questions these conventions, ideologies, and the tools that have helped to establish them.

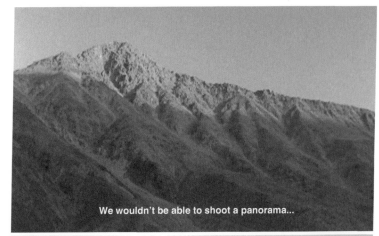

We wouldn't be able to shoot a panorama...

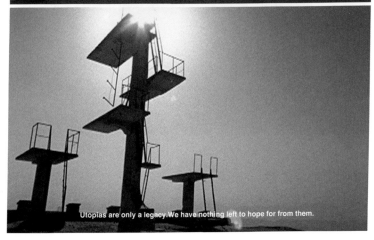

Utopias are only a legacy.We have nothing left to hope for from them.

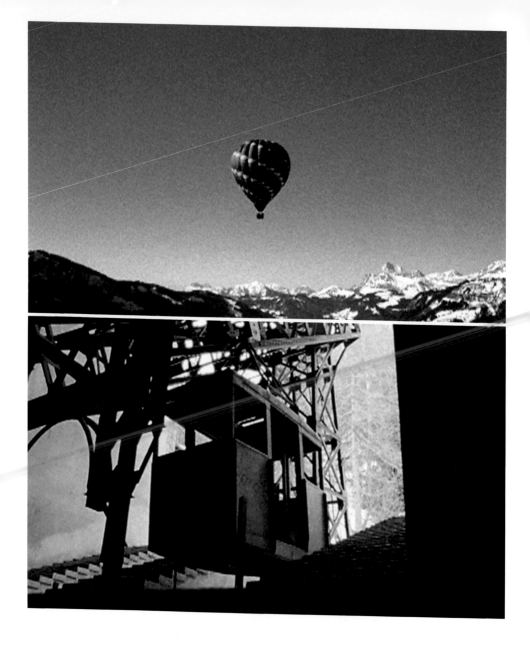

Marine Hugonnier *The Last Tour* 2004

You proudly pretend to be the last where you were once led to believe you were the first.

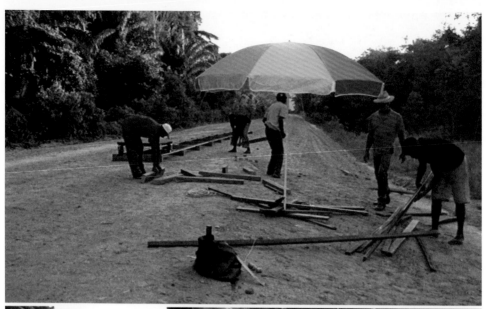

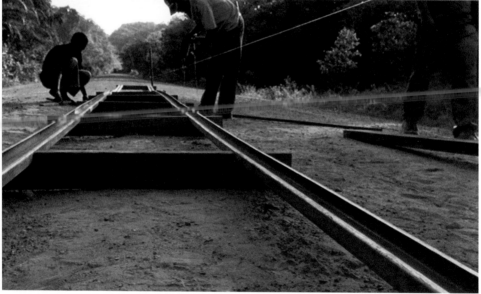

Marine Hugonnier *Travelling Amazonia* 2004

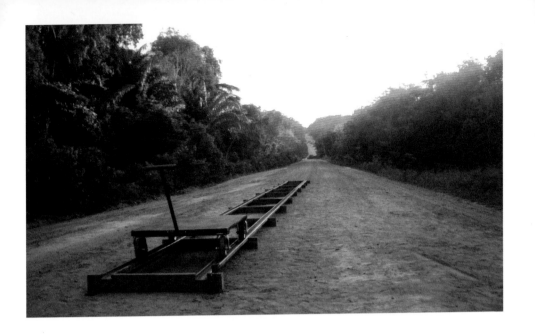

JANE D. MARSCHING AND TERREFORM

Some of your past work dealt with systems of information, the paranormal, and phenomenology. This new work presents a shift, but in other ways it is deeply connected. What first drew your interest to the future of the North Pole?

In 2003 I was investigating the prevalence of webcam technology in our lives. I was searching for cameras that were related to the paranormal, as part of a series of works about the phenomenon of Pareidolia (a condition where people see, with blind certainty, representation in unstructured data). I ran across the National Oceanic Atmospheric Administration's North Pole webcam, which observes meteorological equipment. The camera never sees anyone and nothing ever happens, except for the changing light, temperature, snow cover, etc. It struck me that the North Pole is perhaps the place on our Earth where there is the least amount of visual information, and yet our stories about it are rife with the paranormal: Santa Claus, Yeti, Frankenstein's Walton, etc. I made a time lapse film of one season of images from this webcam, with sound by Victor McSurely drawn from Internet archives of Arctic sounds from throughout the Arctic environment.

All my work is heavily based on research, so I launched into a year of exploration into the cultural representations of the farthest point north as part of the web project, *Deepnorth: A Virtual Expedition to the North Pole*. My exploration was not a harsh trial of physical endurance as in ages past, but instead a trip on my laptop through the Internet. Through research I learned about the richness and diversity of the Arctic, and began to see that it is a terrain that is changing quite rapidly in our imagination.

Arctic Listening Post is a large project of which only a portion is on view in Badlands. Can you describe the other phases of the project, both past and future?

The first phase, completed in the winter of 2007, included the works described above as well as *Arctic Then*, a series of large-scale digital prints in which digital elevation models of the Arctic Circle terrains were obtained from scientists, such as glaciologist Matthew Nolan of the University of Alaska Fairbanks, and were translated in a 3-D rendering program into virtual landscapes. Each glacier is the focus of research for glaciologists around the world who seek to understand the accelerating response of Arctic glaciers to climate change. The images remind us of the usual magnificent images of glaciers we see in calendars and postcards, as well as historical traditions of landscape painting including Caspar David Friedrich and others. Rather than drawing on the sublime, the moods of these landscapes are more uncertain and brooding. Into these landscapes, I digitally insert narrative tableaux of vaudevillian performers engaging in feats of wonder, which is based upon the habit of nineteenth-century Western explorers to bring all the comforts of culture with them, including libraries, sets of silver, and costumes with which to create spectacles upon the ice during the long dark winters. The *Arctic Then* images reenact this need for fantasy in the face of overwhelming destruction, suggesting how we might face our future in the impending climate crisis.

The most recent phase of this project, *Future North*, imagines a built environment at the North Pole in one hundred years, a period of time well beyond climate forecasting. While we can talk with some confidence about temperature and climate models for forty to fifty years from now, it is almost impossible to speak of climates in one hundred years. So any image of the far north in a century can only be based on current fears and imaginings about our future based on our current world and history. *Future North* imagines the future of climate change, sustainability, technology, communication, social mores, and environmental concerns. Will the North Pole

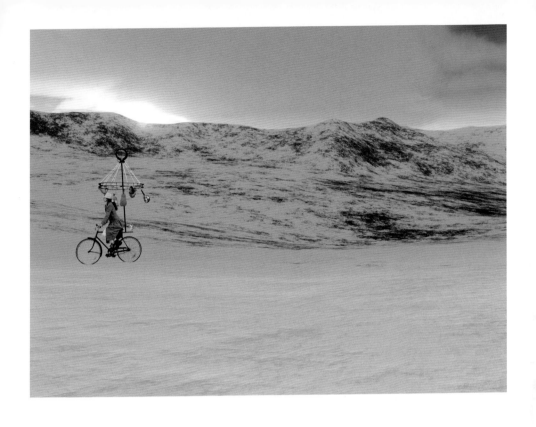

Jane D. Marsching *Arctic Then: Deb questing, McCall Glacier, Alaska*
(DEM 1956; Glaciologist: Matthew Nolan) 2006

be an open ocean all year? Will people live there (or anywhere) year round? How would the built environment reflect a technological relationship to the natural world? In conversations with Arctic climatologist Mark Serreze from CIRES/ NSIDC (Cooperative Institute for Research in Environmental Sciences/National Snow and Ice Data Center), I have been formulating a picture of the climate at the North Pole in one hundred years based on data from many climate models. Working with architect Mitchell Joachim of Terreform, we are creating an Ecotarium, a mobile floating observatory at the North Pole for the study, sharing, and archiving of the many lost and changing planetary ecosystems.

Much of the impetus for embarking on this project came from my video *Rising North*, a color field visualization of the change in temperature at the North Pole over the next one hundred years (an increase of ten degrees in winter, five degrees in summer). Out of a background of static rises the voice of an opera singer improvisationally singing the headlines from a Google News search for "North Pole" on March 21, 2007. The impossibility of rendering any

future accurately, while our culture obsessively imagines dire futures, fascinates me.

For this project you collaborated with experts from diverse fields. What does multi-disciplinary thinking do for you as an artist, and how do you take in all the information and distill it into a cohesive series?

As I was first working on the project, I began to contact scientists to bring their knowledge and experience into dialog with my own. I am very interested in what is implied by Pierre Huyghe's term "an aesthetics of alliances," which suggests a number of efforts, productions, and dialogues working alongside each other, intersecting or simply informing each other. This way of framing my practice opens up the potential of the work to become part of the communities and ideas with which it is allied. One example of the way this works was *Climate Commons: A Networked Conversation about Climate Change, Sustainability, and the Arctic*, created with Matthew Shanley. This project brought people together who were working on sustainability, climate change, and/or the Arctic in

a wide range of disciplines: a glaciologist, an architect, a blogger who was an expert on sustainability, a journalist, an Episcopalian priest, and others. Readers could join our ongoing conversation, and over time, the different practices on a central topic, created a more layered community, based not on place or discipline but on a shared thirst for knowledge and dialogue.

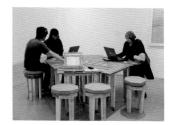

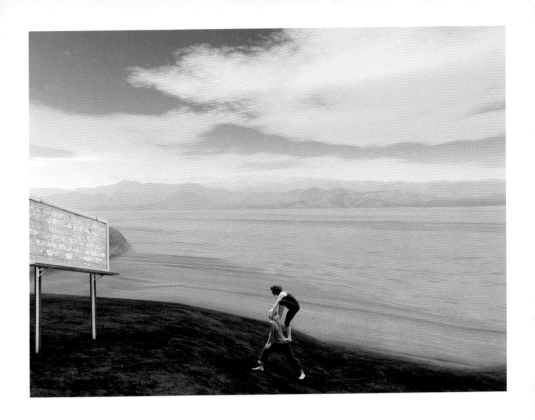

Jane D. Marsching *Arctic Then: Bonnie and Tim, Colulmbia Glacier* 2006

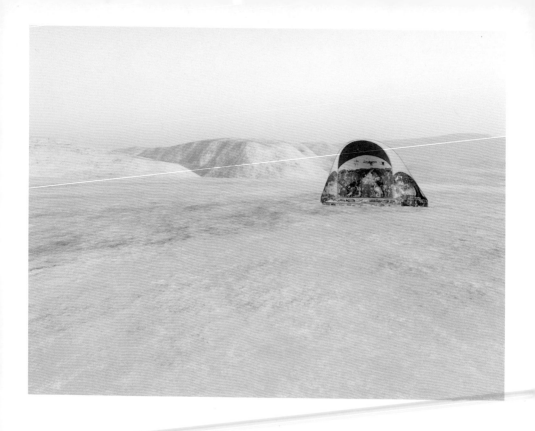

Jane D. Marsching *Arctic Then: Martini Hatchshell, Devon Ice Cap, Canada* 2006

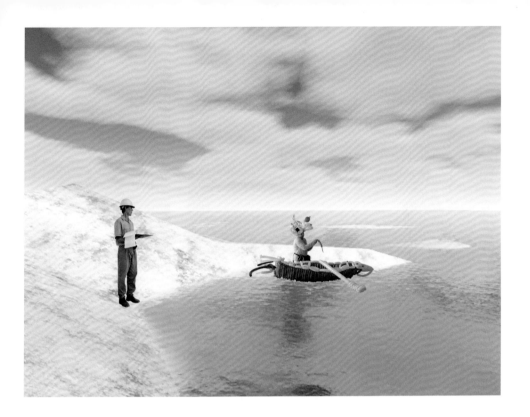

Jane D. Marsching *Arctic Then: Mike supervising Naomi building a umiak,*
Austfonna Glacier, Svalbard, Norway 2006

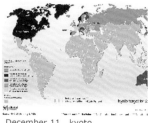
December 11 kyoto

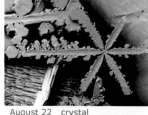
August 22 crystal

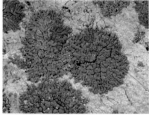
September 11 tundra

November 14 Chaplin

November 22 proven

January 5 travel

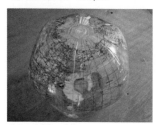
August 25 globe

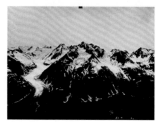
July 27 glacier

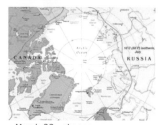
March 22 shapes

People and the Planet

Tensie Whelan

B adlands: New Horizons in Landscape unleashes the creative vision of a group of artists who give us a new perspective on our world—one colored by the enormity of the pain we are inflicting on the landscape. By looking with a clear eye at the destructive beauty of the massive terraforming that has been a side effect of our headlong plunge towards every greater consumption, a number of these artists provide us a with a vision of a future that we want to avoid at all costs.

There are 6.5 billion of us on the planet. By 2020, we are likely to be 7.7 billion strong. More than 1.1 billion people live in the world's biodiversity hotspots. Population pressures, unsustainable practices, and consumption have led to severe pressures on our world. Much of the planet's land base is degraded by various forms of land use: overgrazing has degraded 680 million hectares worldwide, deforestation (580 million hectares), agricultural mismanagement (550 million hectares),

fuel wood consumption (137 million hectares), and industry and urbanization (19.5 million hectares). Approximately 50% of our planet's land mass is occupied by forestry, agriculture, and livestock.

If everyone in the world consumed at the same rate as an American, we would need three planets. And most people around the world aspire to reach the American model.

According to the Millennium Ecosystem Assessment by the United Nations, these patterns of land use and consumption are destroying the ecosystem services on which our health and that of the planet are based. Ecosystem services include soil formation, water, protection against floods and extreme weather, food production, biodiversity, and so on.

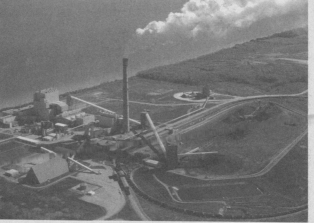

The Forests

Over the last four centuries, half of the world's forests have been cleared. In the 1990s alone, the planet lost 94 million hectares of forest worldwide—2.4% of the total. This reflects a deforestation rate of 14.6 million hectares a year offset by 5.2 million hectares a year reforested. Almost 70% of the deforestation

was due to agricultural conversion, predominantly under permanent, rather than shifting, systems.

Forest ecosystems are the most critical ecosystem for humans. More than 20% of annual carbon emissions come from deforestation. Forests provide watershed protection, flooding and storm protection, habitat for biodiversity, and livelihoods for billions.

At the end of the twenty-first century, 25% of the world's approximately 4,630 mammal species and 11% of the 9,675 bird species were at significant risk of extinction. Habitat loss and degradation are the most pervasive threats to species, affecting 89% of all threatened birds, 83% of threatened mammals, and 91% of threatened plants.

Nearly 90% of the world's forests lay outside governmental protected areas. Current projections are that if only the current protected areas remain as habitat, between 30–50% of the remaining species will be lost.

Agriculture

As population has grown, nearly half of temperate broadleaf and mixed forests and tropical and subtropical dry and monsoon

broadleaf forests have been converted to crops and pastures. More than a quarter of tropical and subtropical conifer forests and mangroves are occupied by agriculture. Since 1972, more than 500,000 km² of the Amazon rainforest (13% of the region) have been converted to crops and pastures. In total, agricultural conversion to croplands and pastures has affected some 8 billion acres, or 26%, of the Earth's land area. This trend shows no sign of slowing, in fact, the world's demand for food is likely to grow 50–60% by 2030.

Small-scale agriculture employs, at minimum, one billion people worldwide. These farmers live in Latin America and the Caribbean, Southeast Asia, and Africa, and produce commodity crops such as coffee, cacao, sugar, fruit, and vegetables. Coffee and cacao occupy 27 and 20 million acres of land, respectively, and many of these farms overlap with the world's most species-rich areas.

The linkages between failing farms, rural poverty and biodiversity loss—always apparent to field biologists and rural development specialists—are increasingly well-documented and understood. Most rural inhabitants in developing countries are farmers. Agriculture—the human activity that affects the largest proportion of the Earth's surface and is the single biggest user of freshwater worldwide—is the principal agent of ecosystem destruction and species extinction. Global freshwater use exceeds long-term accessible supplies by 5% to possibly 25%. Additionally, 15% to 35% of irrigation withdrawals exceed supply rates and are therefore unsustainable.

The rush to biofuel crops such as corn, palm oil, and sugarcane threatens to exacerbate pressure on agriculture to use unsustainable farming techniques and convert more forestland to crop and grazing land. There is a serious threat that without verifiable standards and sustainable practices, biofuels will be a large net loss for the environment and for livelihoods.

Global application of chemical fertilizers has increased from 14 million tons in 1959 to 137 million tons in 1998. Global pesticide use results in 3.5–5 million acute poisonings a year.

A new study by scientists at the University of California concludes that agriculture will have an impact on the global environment "at least as great as global warming."

Fisheries

The last fifty years has seen an unprecedented geographic expansion and increase in fishing intensity by industrial fleets from the core areas in the North Atlantic and North Pacific, to areas that were unexploited or underexploited in the 1950s. As a result, 25% of commercially exploited marine fish stocks are over harvested. Peak catch took place in the North Atlantic before the 1970s, and as exploitation patterns shifted towards more underexploited areas Eastern Pacific and Central Atlantic reached the peak during the 1980s. The pattern further extended into South and Western Pacific in the 1990s.

Climate Change

Climate change presents serious risks to humans and to all biological life, and is the most pressing environmental challenge of the twenty-first century. Rapid changes to the climate will occur unless international action is taken to reduce greenhouse gas and

ozone emissions. Key climate change related factors are: the rise of temperature, changes in precipitation patterns, the rise of sea levels, increased incidence of extreme weather events, and the increase of greenhouse gases in the atmosphere, of which carbon dioxide is the most prominent.

To prevent rises in global warming above 2°C, we will need to cap emissions at approximately 80% above pre-industrial concentrations and approximately 40% above 2005 levels. According to the Intergovernmental Panel on Climate Change, stabilization of carbon emissions is recommended at 450 parts per million as a target and is expected to cost 0.1% GDP globally each year until 2050.

The last 100 years' cumulative emissions serve as a meaningful indicator of relative contributions of different countries and regions. Developed countries, home to 20% of the world's people, are responsible for about 63% of net carbon emissions from fossil fuel burning and land use changes since 1900. North America and Europe contributed 25% and 21% respectively, and the 140 or so developing countries contributed a combined 37%.

Deforestation accounts for up to 20% of global greenhouse gas emissions, contributing more to climate change than transportation and second only to fossil fuels. For many developing countries, greenhouse gas emissions from land use change (deforestation) and agriculture (tillage/methane from livestock) account for 50–70% of greenhouse gas emissions. When emissions from these sectors are considered, developing countries such as Indonesia and Brazil rank as those with the most potential to mitigate greenhouse gas emissions. Tropical forests are one of the world's most productive long-term carbon sinks—stopping deforestation is thus an urgent priority.

The "biofuels gold rush" threatens many ecosystems, but especially forests. Dominant biofuel feedstocks—soybeans, oil palm, and sugarcane—are displacing forests, and wood itself can be a biofuel. Deforestation and loss of critical habitat, wildlife, and other forest ecosystem services are already well-documented negative impacts on cultivation and expansion of these crops. In twenty years, according to the Food and Agriculture Organization of the United Nations, we will need 50% more food

J. Henry Fair *Magnum Mine* *Kayford, WV* 2005

Earth movers queue to remove overburden from blasting Kayford Mountain, WV. Mining operations work around the clock at amazing speed; this lonely stand of trees disappeared in barely a day. The small bulldozer on the upper level pushes loose material down to the loader, which scoops it up into the next earth mover in line which will dump it into a nearby "valley fill," burying the stream there.

production to feed the world. Competition by the energy sector for food crops compounds this challenge as does the pressure to convert remaining forest area.

Vision for a Sustainable Future

To achieve a sustainable future moving forward, we must completely transform the current destructive system into one that protects the planet and provides sustainable livelihoods for its people—one that values sustainable production, sourcing, consumption, and equitable trade. In fact, we need a revolution in design—a revolution in engineering, architecture, manufacturing, farming, financial markets, education, and, in fact, in every field of human endeavor. We need the revolution to happen at all levels—in the professional schools, in the field, in the boardrooms, in the supermarkets, and in our homes.

We know what the key elements of that redesign would require:

• Clean air and water for all
• Healthy biodiversity and habitat/ecosystems
• The reduction of waste and toxicity
• The reduction and mitigation of global warming
• Dignified and safe living and working conditions for all people
• Adequate food, housing, education, and health care for workers and their families
• Equal opportunity for all

In the past we have not had to design production, manufacturing, and consumption to take these issues into account. But there is no reason why human ingenuity can not,

if properly directed and motivated, radically transform the current wisdom and design for a finite world.

Imagine if:

• Sustainable sourcing, supply chain management, and public accountability were standard practice
• Products carried prices that reflect their real environmental, economic, and social value
• Sustainable producers and small and community-based businesses had equitable market access
• People demanded and had access to high quality, sustainable and healthy products/choices
• The financial/insurance sectors supported sustainable operations and penalized unsustainable ones
• Governments supported sustainability through procurement, incentives, and regulations

Change is already upon us. Even before the current focus on climate change, forward-thinking business leaders, governments, and civil society leaders have been forging new ways ahead. The U.S. Green Building Congress has created a standard for green building construction that is rapidly becoming a must-have for new construction and increasingly applied to retrofits as well. Chemical companies are experimenting with far less toxic alternatives—Clorox just released a line of "green" cleaning products. General Electric, which spent the last few decades fighting responsibility for cleaning the toxic mess they made of the Hudson River, paid their bills and launched the Eco-Imagination program. Financial institutions, which five

years ago, denied any responsibility for what nefarious deeds their clients were up to have created and begun to implement the Equator Principles, which provide environmental and social guidelines for large investments. The European Union has been issuing increasingly stringent rules around waste, energy use, and labor. Even China, which has been developing at an astounding rate with little interest in environmental impacts, is beginning to recognize the need to change its ways.

There are examples of positive change in every corner of the world and at every level of society. Unfortunately, the media prefers to cover the negative stories and the controversies, so the average citizen believes there is little progress and feels overwhelmed and discouraged, and ignores his/her responsibility and his/her role in change. Nevertheless, where government, the private sector and civil society lead—as they are beginning to do—the average citizen will follow.

Positive Solutions

The Rainforest Alliance (www.rainforest-alliance.org) pioneered a market-based approach to changing unsustainable practices some twenty years ago, and is a world leader in independent, third-party certification of agricultural, forestry, and most recently tourism operations worldwide, aimed at conserving biodiversity and preserving and improving the billions of livelihoods derived from natural resources.

We are beginning to reach the tipping point. We have now certified 100 million acres of forests as sustainable and work with nearly 2,000 companies including IKEA, The Home Depot, Gibson Guitar, Xerox, Scholastic, and others. We have certified 15% of the world's bananas, working with Chiquita, Dole, and others; 3% of the world's coffee working with Kraft, Caribou, and others; and in the next eight years will certify 14% of the world's tea through a partnership with Lipton.

Working with producers of all sizes, from farms and forests owned by small co-ops and First Nations to Fortune 500 companies, we have been able to use the very size and environmental and social footprint of various commodities markets to retool them for positive environmental and social impacts, by adopting best practices and verifiable, independent standards for habitat preservation, integrated pest management, sustainable forestry, worker safety, health care, community reinvestment, etc.

Rainforest Alliance Certified coffee, bananas, and cocoa sales are over $1 billion annually. Rainforest Alliance Certified FSC (Forest Stewardship Council) wood, paper, and wood products sales are over $2 billion annually. FSC products are a $5 billion global market—all rapidly growing.

The largest industry in the world is not energy or defense but travel and tourism, somewhere around a $5.5 trillion sector, generating one in twelve jobs worldwide and a major source of foreign exchange for a majority of the world's nations. If it were a country it would be the second largest economy in the world after the U.S. It has great potential to help capitalize an economy retooled for sustainability, with economic development based on sustainable tourism practices that have an incentive to keep forests and other high-values intact as destinations, rather than

cannibalizing them for short-term agricul-
tural production or resource extraction. The
Rainforest Alliance is working with the travel
industry, the United Nations and others to
train hoteliers in sustainable practices and
help travelers find sustainable alternatives.

Visualizing a Design Transformation

The redesign of our world will need art-
ists to provide imagination, creativity and
emotional connections—both to the mess we
have created and to the possibilities we can
create together. *Badlands: New Horizons in
Landscape* gives us the perspective we need to
change. We have no excuses left. The prob-
lems are known. The solutions are known. We
now need the will.

J. Henry Fair *Vehicle tracks in fallow field* *Baton Rouge, LA* 2007

THE ACTIVISTS & THE PRAGMATISTS



132 **MELISSA BROWN**

140 **CENTER FOR LAND USE INTERPRETATION**

148 **LEILA DAW**

154 **J. HENRY FAIR**

162 **JOSEPH SMOLINSKI**

170 **YUTAKA SONE**

Problems and solutions are the big conundrum of our current environmental debates. Scientists report that our planet is in decline, the ice caps are melting at an alarming rate, honeybees are disappearing, and over the past 50 years some 30 million gallons of oil have continued to seep into New York's Newtown Creek, making it larger than Alaska's 1989 Exxon Valdez disaster, yet still, for the most part, publicly unrecognized. So what do we do? Do we hold a "Live Earth" concert, do we "go green" and install solar panels on our roofs, do we sign petitions to our government... the list could go on and on. The solution: we become aware, we become activists and pragmatists, trying to suss out the problems and work towards viable answers. The planet is not indestructible and it is our responsibility.

The Activists depict both natural and man-made environmental disasters, while The Pragmatists deal with sustainability, politics of land use, and alternative sources of energy. However, these two groups are inextricably linked; they look at the problems and offer an insight into possible solutions. Adopting both serious and ironic approaches, these artists ultimately take on the responsibility we have to the landscape while at the same time using art to open peoples' eyes to change.

MELISSA BROWN

Your landscapes contain a sense of fantasy, but still remain rooted in reality. *New Valdez*, for instance, takes a disastrous moment and infuses it with surreal beauty. It is a twisted juxtaposition, but not an ecologically unnatural one, since many toxic sites eventually flourish. Can you talk about that dichotomy between beauty and the horrific that exists in your work?

In the last ten years I have watched a lot of disaster movies. After seeing the movie trailer for *Starship Troopers* in July 1997, I was hooked. Computer special effects have done a lot for the apocalypse industry and nothing seems to be more charming than watching familiar American landmarks get blown to bits. The combination of reality and fantasy is what makes watching disaster movies nerve-wracking, awesome, satisfying, and inspiring all at once. The representation of destruction is inevitably beautiful. Human nature makes you want to look at what you don't really want to happen. It is a fantasy that is worth paying $12 for. However, according to cinematic reality, standing back to enjoy the apocalyptic fireworks is a surefire way to be vaporized. Movie characters are never given the privilege of soaking up the dark beauty of their neighborhood crumbling at the hands of alien electromagnetic lightning and live to

recount the elaborate details of what it looked like. Inevitably, only movie characters that can resist the temptation to stand there and watch are those who also get to survive. What a pity! Here you are, a cardboard cut-out character, with the opportunity to witness an event that will shape the future of mankind and you don't even get the chance to pull out the digital camera, let alone a sketch pad, to capture a landscape with splintering trees, exploding gas stations, and psychedelic light patterns?

However, illustrating destruction is just not enough. Movies already do a pretty good job, so what is left for painting? How can a static image offer anything more than DreamWorks? Here's where the fantasy elements apply. In any real disaster there is a lot more going on than what is immediately visible. Not only would the landscape scene be baroque chaos and visually overwhelming, but there would be a hefty dose of crushing psychological and spiritual side effects as well. Unless you are actually experiencing an apocalypse, you can't really understand the mind melt that would occur. The only things left then are your personal apocalyptic fantasies, which can indulge all of the uncanny, spooky, color saturation, and holographic pattern making all rolled up with news stories that are tragic and dismal.

Landscape fantasy allows you to visually appreciate the beauty and be glad that it is not a part of your immediate reality, yet.

What are some of your influences? I see links to Japanese art in the stylization of the landscape, but there is also a cartoon-like sense of fantasy as well.

Hokusai's woodcuts of Mt. Fuji were one of my first significant influences. I love that his pictures are centered on a single mountain but also depict the occupations and culture surrounding it. It is a landscape informed by culture. The title, *36 Views of Mt. Fuji*, is deceptive. In the *Views*, culture and Mt. Fuji are given equal representation. This is a great metaphor for how visual influences really work. If you are really committed to a creative project, and by committed I mean walking around all day trying to figure out what a picture should look like, you know that almost any cultural fragment can suddenly become an influence. There is an ocean of visual influence between idea and installation. So, here is a short list of some of my favorite informants: foreign and outdated currency, scratch-off lottery tickets, vintage vacation postcards, slightly outdated computer graphics, stenciled detailing on cars and fingernails, assembly line

paintings (the kind that you can buy on the boardwalk), Hieronymus Bosch, Northern Renaissance painting (I like the scenes in the background more than the religious narratives that are front and center), Shaker drawings, Warhol's Do-It-Yourself pictures, mistake and poor quality commercial printing, magic eye books, and, of course, my genius artist friends.

In works like *New Valdez* or *Forest Fire*, the decline of the environment is apparent, but in other works like *Pollination Station* or *Niagara at Dawn* the danger is not as obvious, yet still lurks. What is it about the landscape that is so ripe for this type of tension?

The moment before the moment before the moment before the moment. I like to imagine what a landscape looked like two minutes, or an hour or a week before a catastrophic event. Is a future state of decline somehow visible in the present? Tourists travel to visit locations where historical events or natural disasters have taken place. You go there and revel in the idea that something drastic had happened right where you stand. If you had arrived ten years or a hundred years earlier, you may have gotten coated in Exxon oil or captured at the Alamo. The scene may now be pastoral, complete with a gift shop and mementos but

at some point in the past, a now historical destination was once the site of devastation and upheaval. Landscapes are time capsules in this way. There is a yellow flowering shrub that grows in the volcanic dust around Mt. Etna. Experts can determine exactly how long ago the devastation took place, based on the bloom. Nature has built-in methods of reveal-ing the past. There is even more tension in the time before a catastrophe. Animals and a few very sensitive humans can pick up on it. Most animals flee to a higher ground before a tsunami hits. Looking out at a landscape can make one eerily aware of a place in history; you can all at once enjoy the peacefulness and thrill at hav-ing just missed an apocalypse or an ice age by plus or minus a million years.

Art Center College of Design
Library
1700 Lida Street
Pasadena, Calif. 91103

TOP: Melissa Brown *Niagara at Dawn* 2005 Photo: Bill Orcutt
BOTTOM: Melissa Brown *Pollination Station* 2003 Photo: Bill Orcutt

Melissa Brown *New Valdez* 2007 Photo: Bill Orcutt

Melissa Brown *Forest Fire* 2004 Photo: Bill Orcutt

CENTER FOR LAND USE INTERPRETATION

Interview with Matthew Coolidge, Director

The Center for Land Use Interpretation (CLUI) is a non-profit organization. Can you start by giving our readers a bit of back story on how CLUI got started and how it has come to exist as a sort of love child between art and science?

I suppose the Center was born when it became an official institution in 1994, with the filing of our Articles of Incorporation and tax-exemption papers with the IRS. The actual moment of conception for the Center—to continue your "love child" metaphor—is forgotten, or indistinct. The gestation period though lasted years, and involved a number of people, places, and events. For my part, it was things like a good old liberal arts cornucopia in college, studying geomorphology, environmental science, art history, vernacular architecture, and film, without really knowing why, but generally learning all the ways the world was going to end really soon, and, like a lot of people, being confused, unprepared, and maybe even a little disappointed, when it didn't. One hot summer, while not working as a production assistant on a continuously postponed Todd Haynes movie, I spent a lot of time in the New York Public Library, following threads and making files. I later headed westward to see if all the things I had been discovering for myself in the library were really there or not. I ended up

having a near miss with art school, and spending a lot of time in the alleged wasteland-scape of southern Nevada, where epiphanies come easy. From this, and other things, the Center emerged.

CLUI makes it clear that they are not an activist organization, rather, it functions not unlike a museum: gathering, archiving, and presenting information. How does it negotiate the terrain between staying seemingly neutral while at the same time provoking people to seriously consider the ways in which we use the land? Does your work ever fall under criticism from people who don't understand your "hands off" approach?

The Center is fixated on the ground, which by itself means nothing, and is neutral. You might say we fertilize it with interpretive manure, growing, and eventually extracting meaning in the form of interpretations, which we convey to the public, who then make up their own minds about what it means, if anything. Just like they say everything is political, everything is also subjective, of course. But there are degrees on the scale, the spectrum ranging from "not much" to "very." Even more than that, there are many different versions of these scales, depending on the idiosyncrasies and distortions in the lens of the beholder. So we work within

this miasmic gray area, where conflicting and even contradictory things can exist at once, overlapping, in a space where paradox is a continuous predicament, and is recognized as another form of truth. Whether we negotiate this terrain successfully or not is up to you. I don't know, for sure.

CLUI has various outposts across the country, but for *Badlands* you chose to focus on the East Coast, a look into our own backyard. What did you learn about Massachusetts through this project?

Our work is about America, and more accurately the USA. Who are we? How does our landscape, built and altered by our society, harbor meaning about us, collectively, and even individually? We collect information and imagery on places of every conceivable type all over the country. We then draw from this collection of places and representations of places to make exhibits, tours, and other public programs. We can make thematic programs, looking at one sort of phenomenon as it occurs in different or similar forms across the land, or we can do regional projects, where we take a defined area, and see what is there, creating a characterization of that region, and making inferences about how that region relates to, and within, the larger context of the country. This exhibit is regional, about the state of

140

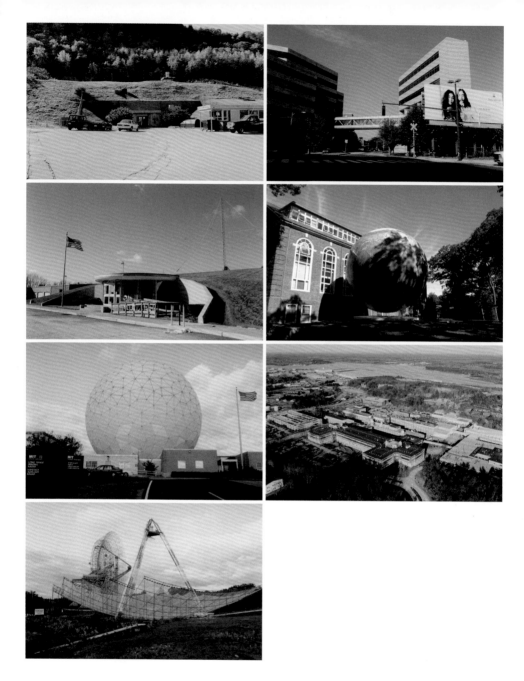

CLOCKWISE FROM TOP LEFT
Archival images from *Massachusetts Monuments: Images of Points of Interest in the Bay State
from the Center for Land Use Interpretation*: Amherst Bunker, Draper Lab, Babson College Globe,
Lincoln Laboratory, Millstone Hill Antennas, Haystack Observatory, FEMA New England

141

Massachusetts. We went to our database and photo archive and extracted sites that fell within the state's boundaries. We also did some additional documentation, research, and writing. The result is what you see here.

What has been the most surprising instance of land use that you have come across in your research, both in Massachusetts and further afield?

While it is impossible to say which is the *most* surprising thing, in this state or elsewhere, I was surprised to notice how this state has been such an electromagnetic proving ground. Though well known in a general way, it is still surprising to see how the

Route 128 high tech corridor, with its anchors of Lincoln Lab, Hanscom Air Force Base, and Raytheon, is one of the most progenerative places on the planet for technologies that define our lives today. Elsewhere, and on a smaller, though no less significant scale, I was also struck by the evocative, articulate beauty of the forest dioramas at the Fisher Museum in Petersham, which depict the landscape history of central New England, shrunken into miniature archetypes that enable a larger view. It is my hope that we, at the very least, have conveyed the majesty of the Commonwealth, from the micro to the macro.

View of the CLUI program *Margins in our Midst* 2003 Photo: Steve Rowell

Archival image from *Massachusetts Monuments: Images of Points of Interest in the Bay State from the Center for Land Use Interpretation* Hoosac Tunnel Portal

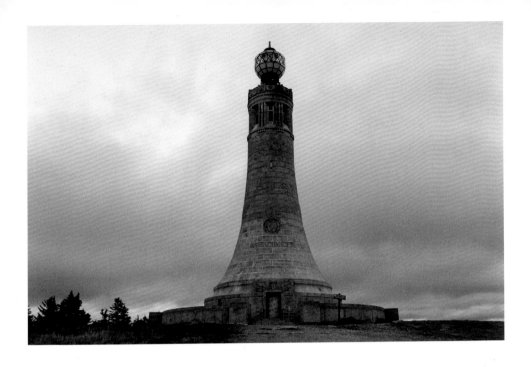

Archival image from *Massachusetts Monuments: Images of Points of Interest in the Bay State from the Center for Land Use Interpretation* Mount Greylock Tower

145

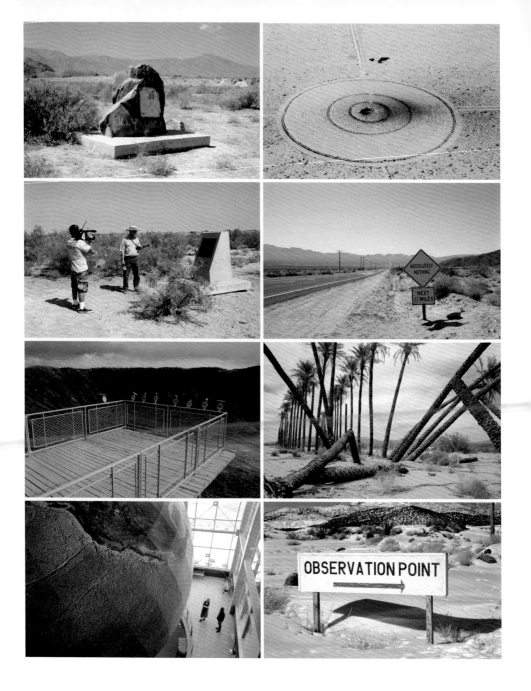

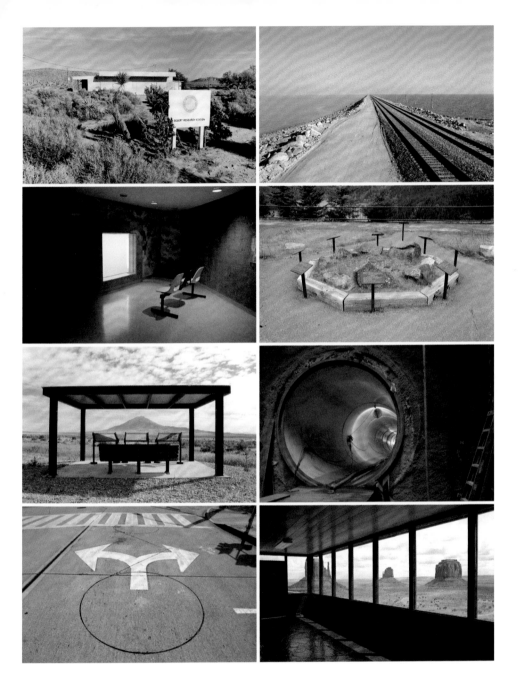

Can you start by telling me about your interest in natural disasters?

Natural disasters are the ultimate expression of *power*—tremendous, total, inexorable, unpredictable forces making themselves known on an enormous scale. There's always the *potential* of this power, all around us, but until there's a disaster, you don't really see it, and maybe don't believe it exists. I'm fascinated by natural power, whether it is the power to sail a boat, or to engulf our homes in lava. Disasters make this invisible power visible.

All this natural power is very dangerous—it can and certainly will destroy us, which is part of the appeal and fascination for me. In my disaster work, I, and you as the viewer, are located right in the path of destruction; we've been swept out into the sea boiling with molten lava, or, we've been tumbled into a netherworld and ground to sludge by an epic flood. You're watching all this happen, so somehow you've miraculously survived. I feel like it's my job to witness and exhibit the powers of nature, and in doing so make others witness it too. Also, it makes me feel kind of immortal, working on these disasters from multiple points of perspective at the same time, being not only able to watch, but to create what's happening.

Once there is a disaster, things can never be the same, human life may or may not continue, but if it does, it will forever be changed. Disasters are a huge turning point. But what fascinates me most about disasters is that, if we can move outside of ourselves, all that power is really *beautiful*—worthy of respect, appreciation, maybe even worship.

This work seems like a good way to exorcize some demons, in particular, the jab towards the trappings of suburbia evident in the flood.

It's more than personal, it's about Earth exorcising Her demons—and that would be us. It's probably about time for Mother Earth to wipe humans off her face. We tend to forget that Earth won't end if we're not here; She'll probably do just fine. But I do wonder if any other species will witness—and fear—and celebrate—Her power as we do. As for exorcising personal demons, well, because of my obsessive way of working, I tend to work on things a long time, and as I work, details start to develop meaning in addition to their original context. It was very satisfying making lava flows and creating a city for the volcano to destroy, because I was angry with a particular city at the time. I knew I wanted to have an ordinary suburb being

inundated by the flood, so inundated that it sinks below the surface of the known world, on its way to utter oblivion; as I worked, it became a specific neighborhood. As the creator of these little worlds, I control the powers of nature for my own ends.

Aside from floods and volcanoes, another interest of yours is maps. Maps are a way of negotiating place, but they are also beautiful documents of the mapmaker's vision. Depicting the landscape is similarly subjective. How do you manipulate the dichotomy between the subjective and the given?

Mapping is one of the ways we try to control our environment, a tool we use to try to harness or avoid its power. We draw diagrams, loosely overlaid on an idea of land forms, based on what's important to us. Any map tells you more about what the mapmaker (or the mapmaker's patron) was thinking than it tells you about the terrain. All maps are either subjective, or so selective that the "given" is kind of not there. The exact same goes for landscape art.

Mapping and landscape painting are also about attempting to understand the environment, about how to make things visible that you know, or believe, are there. For example, if I'm making a cliff, the particular cliff I start with

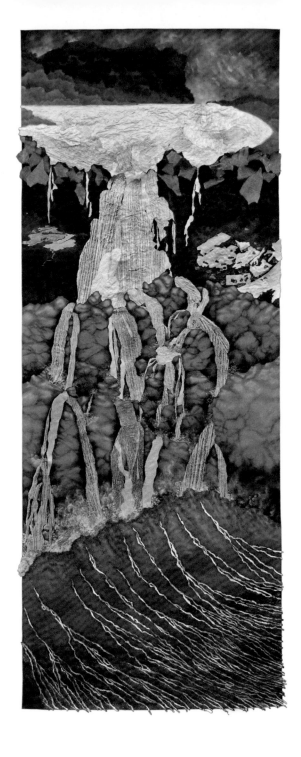

might not exude the necessary essence of *cliffness*, so I'll have to change it, to make it closer to the archetype of cliff, to be unmistakable. Also, I use whatever vantage point is most important to show a particular section of a geographic or atmospheric or demographic feature—there isn't one single horizon line or vanishing point, or even a consistent aerial view, throughout an image. Similarly, if I'm mapping something, what aspect I'm mapping might change from one area to another. I tell myself a lot of stories while I'm working, because all my map-land images are stories, histories. It's all about *meaning*.

Like maps, your work is also imbued with a sense of history, but also fear of history repeating itself; how many floods or volcanoes do we have to endure before we understand and respect the Earth. Is this why you often look towards spiritual totems?

Yes, absolutely! I used to think I could change people's attitudes and interactions with the world by showing its powers, interrelationships, dangers, and unexpected beauty. I'm still trying, but am more cynical.

I will go on pilgrimages—I do use that word—to see stone circles, and there is no denying their spiritual presence, especially when they're not overrun by other tourists. Like maps, the stone circles were imposed on the Earth's surface partly to understand the structure of the universe: the orientation of the sun, passing of seasons, and location in the ceremonial space of life. They are always in sites perfect for viewing the surroundings, so you can understand where you are. Stone circles grew out of the same impulse as mapping. It is all kind of, I hate to use the overworked word, but, spiritual.

Stone circles—and other archaeological ruins—are also visible marks of earlier disasters. A great civilization built the monolithic stone circles, with a wide network of trails connecting the sites. Where are these civilizations now? One theory I've heard is that they created a kind of environmental disaster, by overpopulating the land so it could no longer support their particular way of use.

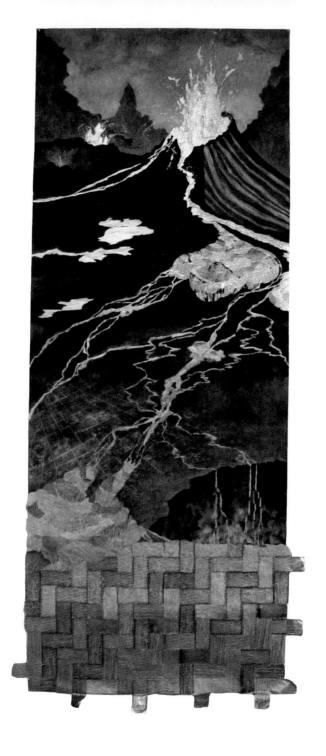

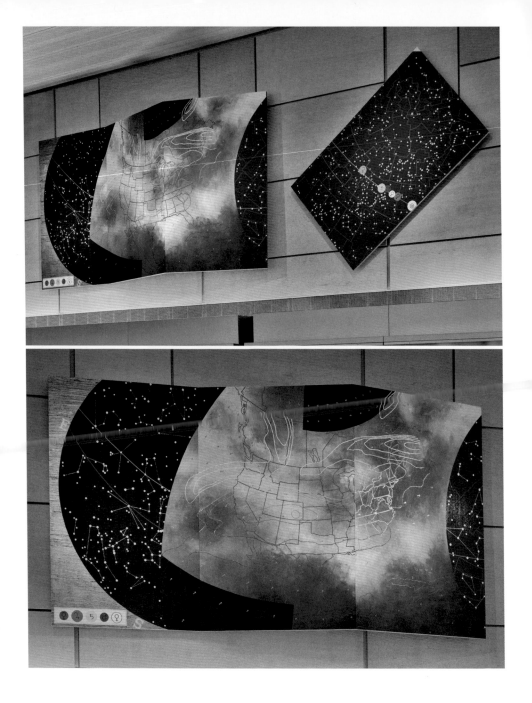

Leila Daw *Weather Starscape* (detail of Planetary Conditions) 2004 Photos: Robert Benson

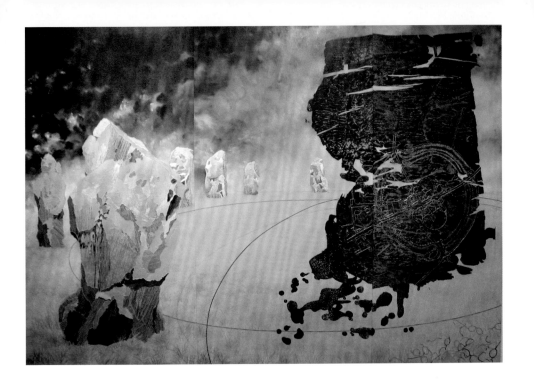

At first glance your work is about a kind of abstract beauty, one that has a painterly quality. However, upon closer inspection, there is something deeply disturbing in the fact that these gorgeous images come from the vastly polluted Earth. How important is it for you that the seduction of beauty is followed by repulsion?

We always want simple answers and emotions. The truth is, no human emotions are simple. In this modern world the media overwhelms us with imagery, especially relating to topics that are *au courant*; for example, we are constantly bombarded with environmental images, however mundane. If images aren't beautiful, people won't look at them. This project is all about inspiring people to stop and consider the consequences of their actions and purchases. My goal is to hypnotize the audience with these beautiful abstract images; then the viewer reads the caption and realizes that what she is looking at is actually the detritus from the facial tissue bought at the local grocery store. To produce this tissue, an old growth forest will be cut down and millions of gallons of toxic effluent will be dumped into a river. Hopefully, this information will cause the viewer to buy a tissue brand made from recycled newspaper, or, better yet, use a handkerchief. An image like

Cover-Up is intended to make us realize that by burning coal to produce electricity we are supporting the total devastation of an old growth forest, burying streams and watercourses, and devastating the region's wildlife. All of this is in addition to the global warming and acid rain, not to mention the emphysema and asthma caused by the pollution of coal combustion. We are all complicit, and we all have the power to solve the problem. Turn off the lights. Turn off the air conditioner. Our grandchildren's future depends on it. By making smart decisions and small lifestyle changes, we can solve these problems.

How do you go about tracking down, and more importantly finding information about, the sites that you photograph? There must be a good deal of sneaking around involved.

Many times I've been chased away from industrial sites, threatened with arrest, and questioned by the various authorities. Sometimes I begin by seeing something that catches my eye, other times I start with an interest in a particular industry and its impact. The process begins with a lot of research: the nature of the industry, environmental impact of its practices, different companies, and their locations. Then I start asking questions of people that have insight, whether they are environmentalists, people

working in that industry, or people living or working in the surrounding area of the industrial site. Lastly, I approach the sites from every angle; I drive around them, fly over them, and sometimes I get in a boat and float around.

What kind of call to action do you hope to encourage in people who see your photographs? In other words, what do you expect your viewers to take home with them—a greater understanding of the environment, a compulsion to act, or just an appreciation of the landscape?

I want people to look at my photographs and realize that we are all part of the problem and can so easily be part of the solution. The project is about exposing the consequences that our consumer economy has on the Earth that supports us, and that will hopefully support future generations. Many people with knowledge of the environment and understanding of the problems sink into despair, but I take a different view. The answers are there, and really not as complicated as they are often presented. If you buy one brand of toilet paper, old growth forest is cut down, but if you buy a different brand a forest is saved and so much waste is removed from the waste stream. My hope is that people walk away from my pieces and go home and turn off the lights and walk to the

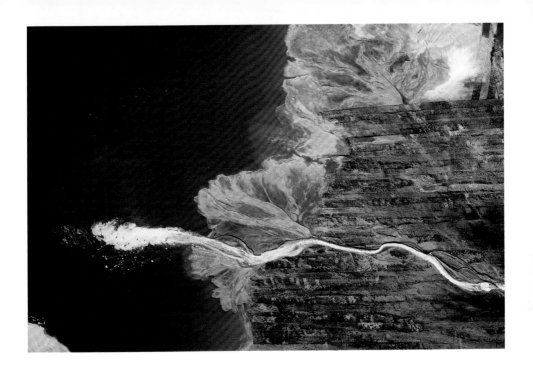

grocery store instead of drive. It's better for them and better for the planet.

Where do activism and art intersect for you? How do you balance the two while keeping a diverse audience interested in your work?

I'm not sure they can be separated for me. Every project I do for myself is about a message. I think art has to have substance, or its pabulum. With any edgy art, the audience must be sophisticated in their comprehension of it, and predisposed to looking at something new, or they will not be able to see it.

J. Henry Fair *Expectoration Bauxite waste from aluminum processing Darrow, LA* 2005
Producing aluminum metal involves refining bauxite (the ore) using caustic chemicals to produce
alumina and the electrolytic reduction of alumina to produce aluminum. This depicts the disposal of
the byproducts, in which the solids (mostly impurities in the bauxite) are separated from the liquids.

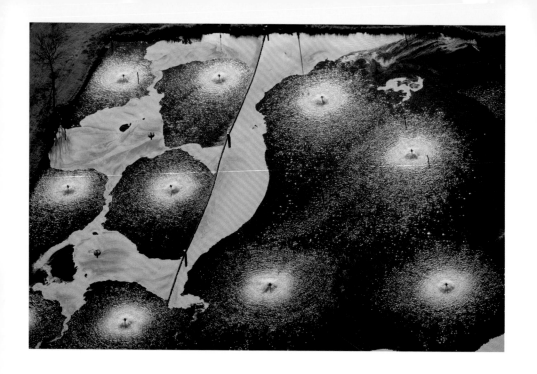

J. Henry Fair *Dividing Line Aeration tanks at sugar mill Gramercy, LA* 2005
Many industries use aeration tanks to process waste for several different purposes:
• It speeds evaporation of the chemicals into the air, and thus reduces the volume of material that must be disposed.
• Prevents growth of certain foreign bodies.
• Keeps solids suspended.
• Can aid in breakdown of compounds.

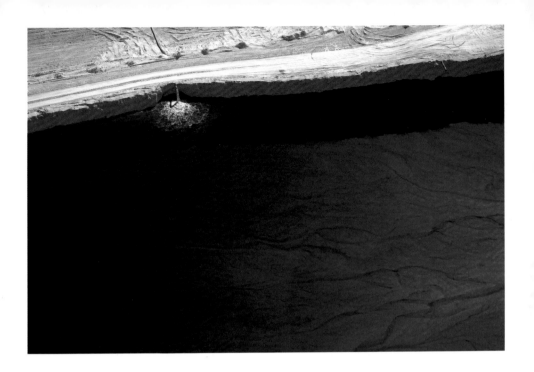

J. Henry Fair *Outlet Phospho-Gypsum Fertilizer Waste Geismar, LA* 2005
Effluents from fertilizer production are pumped into this "gyp stack." The solid gypsum is
scooped out by excavators before it hardens and spread on the "impoundment" to build it up
and allow for higher capacity. This solution is gypsum, sulphuric acid and an assortment of heavy
metals, including Uranium and Radium. When the price of Uranium is high enough, this facility
can produce large quantities for sale to the nuclear industry. Small radioactive particles
(radionuclides) from the impoundments can become airborne as wind-blown dust that people
and animals can breathe, and they can settle out onto ponds and agricultural areas. Many of these
impoundments are not lined, allowing the toxic slurry to mix with groundwater, and heavy rainfall
will cause it to overflow and mix with surface water.

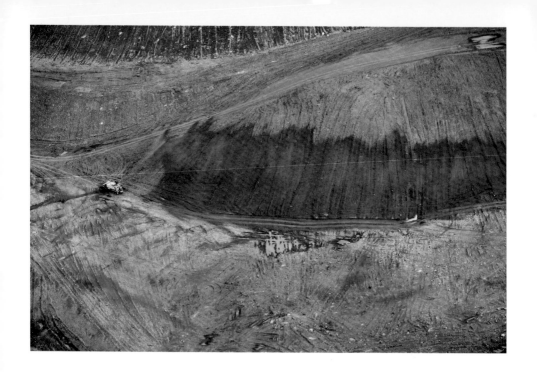

J. Henry Fair *Cover-Up Hydroseeding after Mountaintop Removal around Kayford Mountain, WV* 2005
The forested mountains, valleys and streams that once stood here are now buried beneath the
overburden from mountaintop removal coal mining. It is leveled and then sprayed with a mixture
of grass seed and fertilizer. This satisfies the EPA regulations on mitigation.

J. Henry Fair *Pilings* *Wharf pilings, sulfur and water at abandoned facility* *Port Sulfur, LA* 2005
The Grand Ecaille sulphur mine site was known as "the mine that couldn't be built" because it
was covered by 150 feet of quicksand and marsh and inhabitated by vast hordes of mosquitos.
Humans persevered and extracted the suphur over 40 years. These pilings are the remains of
a wharf built as a transit point between the mine and a 10-mile canal carved through the marsh to
the Mississippi River. Freeport Sulphur Co.

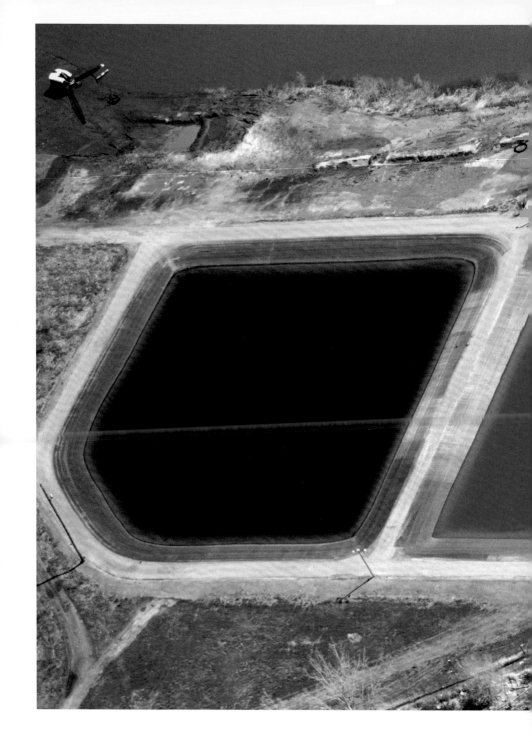

J. Henry Fair *Paintbox Coal Fired Power Plant Niagara Falls, NY* 2002
Both the combustion ash and the smokestack residue from coal burning power plants are
extremely toxic. Coal plants are the major source of radiation released into the environment, as
well as concentrated levels of arsenic, cadmium, chromium, lead, selenium, sulfates, boron,
and other contaminants.

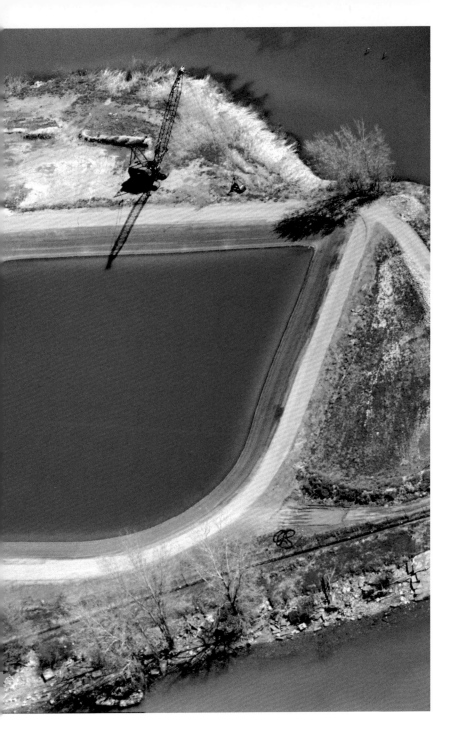

JOSEPH SMOLINSKI

In some of your past works you created installations that depended on ideas of satellites or parasites; a host with other elements working off of it. Trees naturally evoke these relationships as well. But your trees are not usual. Can you start by talking about how you came to the image of the Frankentree?

I was driving to New York from Connecticut when I saw this giant fake tree on the grounds of a rest stop. When I got closer and realized it was a cell phone transmission tower, I was blown away. It was the icon I had been looking for and I instantly imagined these fake trees taking over the landscape like that of a parasite. It was also a sudden realization of the impending biotech hybrid future, and the Frankentree seemed to me as the poster child for that, looming over the landscape.

Once you landed on this cell phone tree phenomenon, what made you decide to twist the initial concept and create something useful out of this artifice?

I started by working on a series of cell tower tree drawings and then I realized that the tree is a really powerful symbol that relates to culture, religion, politics, and the environment. I started to think about what else the tree could become. Then I read an article in *The*

New York Times about wind power and its opponents who felt these efficient sources of electricity disrupted the landscape. These were the same groups that had their cell phone towers disguised as trees so I figured that the best solution was to use the aesthetics of the Frankentree for a wind turbine. I had also been trying to work the tree into my digital animations and when I finally made one spin, a light bulb suddenly turned on. I think the light bulb was powered by that spinning tree.

There have been debates over wind turbines being an eyesore in the landscape. Do you think people would embrace the turbine more if it resembled nature, and if they did, what would happen if these were to proliferate the same way in which cell tower trees have?

The Midwestern highways, on which I've spent a lot of time, are littered with towering monuments of Paul Bunyan, giant fish and blocks of cheese, and military weapons. The town I grew up in has an enormous concrete snowman as its icon. These roadside curiosities, whatever their form, attract people from all over the country. I see the tree turbine in the same vein, and if they do populate, I have a series of drawings ready for their demise.

This project is as much about artifice as it is about providing sustainable energy solutions. How important is it for you that this piece functions and generates energy as opposed to just being an ironic take on the human desire to manage the landscape?

I did an installation once with 500 pounds of potatoes that were converted into batteries. They were covered with electrodes and wires to power tiny red flashing LED lights. Aesthetically it was a beautiful mix of nature and technology, but what really made the piece was the fact that it did produce useable power. To me the *Tree Turbine* piece is an extension of the potato battery work. It has to function to be worthwhile. I'm not planning to reinvent the wheel. Current wind turbines work very well, but when this tree spins and generates whatever electricity it can, it will hopefully pose new questions about our relationship to the landscape.

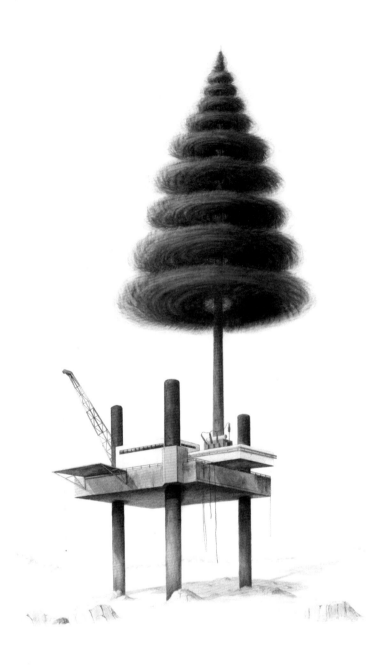

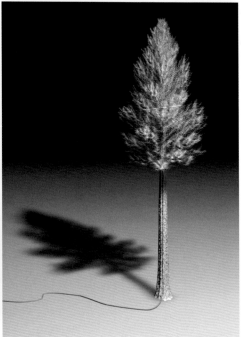

Joseph Smolinski *Tree Turbine* MASS MoCA site mock-ups 2007

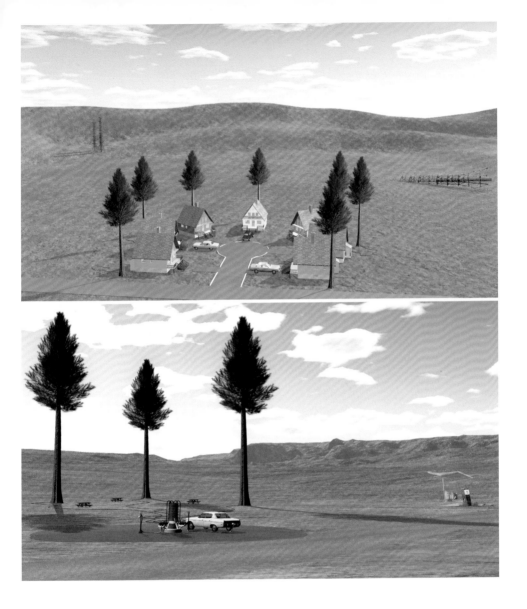

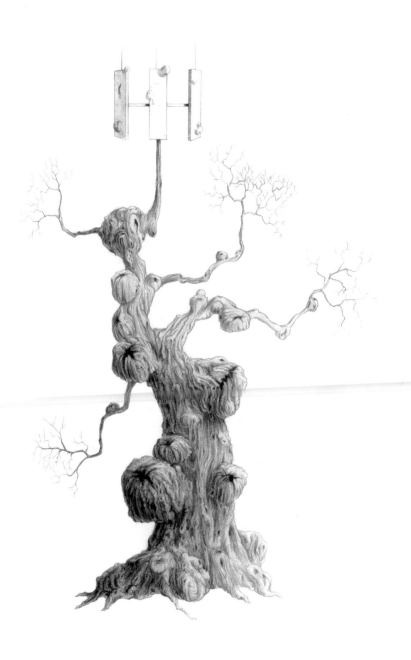

Joseph Smolinski *Virus* 2008

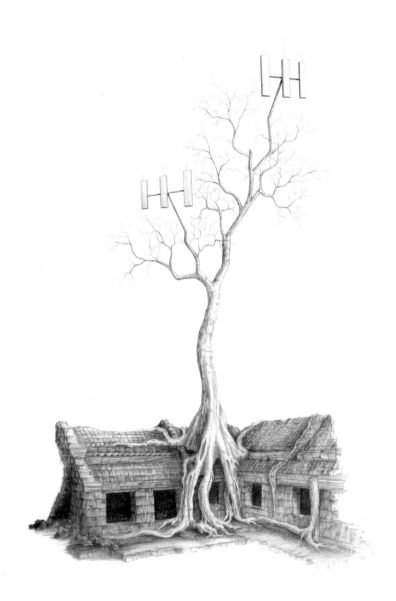

Joseph Smolinski *Temple* 2007

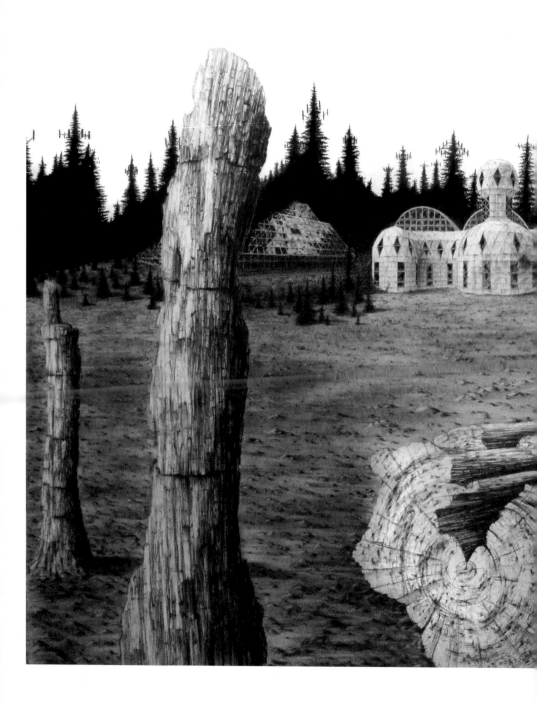

Joseph Smolinski *Biosphere* 2007

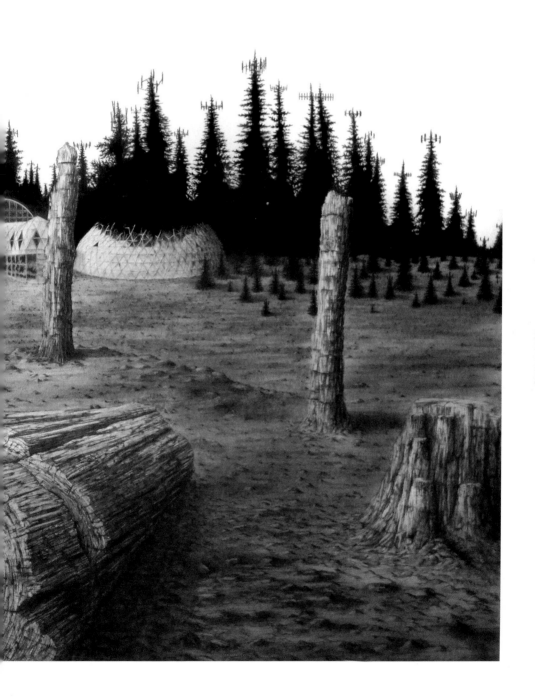

YUTAKA SONE

In your work there is an ongoing relationship with nature, whether it is one of leisure in your paintings of ski slopes and lifts, or one of the connection between the natural and built world, such as the work on view here in *Badlands*. How did you become interested in the landscape and how do you see your work fitting into such a traditional genre?

Landscape is definitely a traditional genre. When artists captured the landscape in their works, they put a frame on it or cut it out from the unlimited actual 3-D landscape, and infused it with a certain point of view. That means that depicting landscape in art has mostly been through painting, or other 2-D works.

If an artist wishes to make a landscape sculpture, that would be a very contradictory way of working because the landscape in front of me is an unlimited 3-D space but a sculpture is a limited 3-D space. Sculpture also has a unique point of view. My work begins with the challenge of transferring the unlimited landscape into a limited sculptural space. I think I'm working on a traditional subject but in an untraditional way.

The installation for *Badlands* is an experiential work, it requires viewers to suspend their disbelief and walk through a museum space filled with plants and to feel the dirt under their feet and smell the greenery in the air. How do you think viewers are transformed because of this shift away from a traditional art experience?

In this installation, I intend *not* to show the whole image to the audience at one time. Walking through paths in a museum, viewers would get to know what is there one by one. I hope there is "the encounter" with something unknown to them. Since this installation is a portrait of the city of Los Angeles, I would like to make the viewers actually cross and meet at junctions along paths in the museum; just the same way as the city functions.

The *Highway Junctions* that sit amidst the plants represent the densely packed cityscape of Los Angeles. These delicate marble carvings are dwarfed by the plants around them, a reverse sprawl, where nature takes over. Can you talk about the relationship between the man-made metropolis and the fragility of nature?

The *Highway Junction* sculptures follow the same direction as my first marble sculpture, *Hong Kong Island*. In front of a hallucinatory nightscape in *Hong Kong Island*, I chose fragile marble for its material. When adding more, I needed to install a lot of plants around the *Junction* sculptures because vegetation in LA is quite a unique mosaic of multicultural plants from tropical palm trees to Italian coniferous trees, and some are even artificial. I could find no order within nature in Los Angeles. To me, the man-made metropolis and fragile nature reverse their position in the installation, and lead to the feeling of a site of ruin.

Yutaka Sone *Highway Junction 110-10* 2002

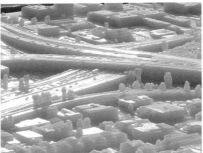

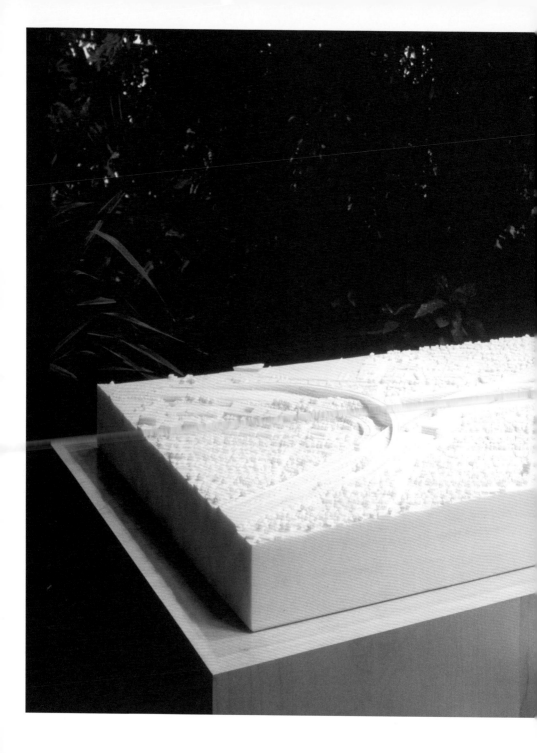

Yutaka Sone *Highway Junction 405-10* 2003

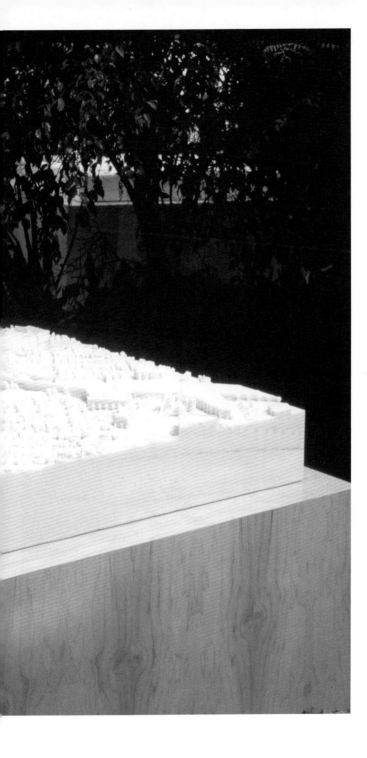

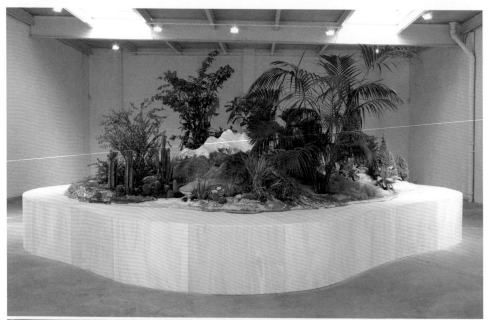

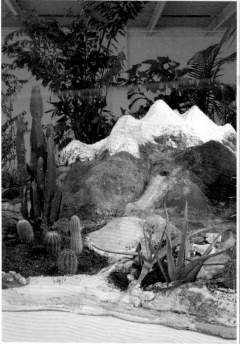
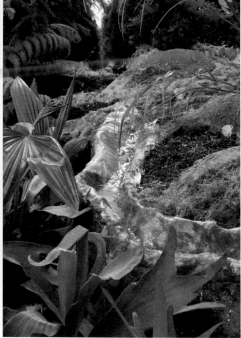

Transparent Eyeball: Toward a Contemporary Sublime

Gregory Volk

Quite some time ago, I was reading Barbara Novak's excellent book on nineteenth-century American painting, appropriately titled *American Painting of the Nineteenth Century*. I recall being enthralled and inspired by her chapters on American Luminist painters, such as Fitz Henry Lane and Martin Johnson Heade, whose shimmering landscapes and seascapes involve exacting depictions of the physical world but also seem reverential, ethereal, and imbued with pure spirit. Both of those painters deemphasized brushwork and paint in favor of presenting the image in as clear and luminous a manner as possible; their paintings seem incredibly smooth, even glassy, while refulgent light suggests both literal and spiritual illumination. Both artists' paintings, for instance, of commonplace Massachusetts sites like a Gloucester beach (Lane) or the Newbury Marshes in Newburyport (Heade), also suggest enraptured psychological states: meditative

quiescence; a radical, almost egoless, merging of self with world; a humility that shades into reverie and bliss.

Novak identifies Ralph Waldo Emerson as a major impetus for Luminist painting: the Transcendentalist poet/philosopher who counseled immersive and ecstatic encounters with nature, understood to be suffused with divinity and eternal spiritual truths, which could animate poetry and art. Although Emerson was a convincing theorist of such ecstasies, he rarely attempted to describe what they actually felt like. There is, however, a famous passage in his essay *Nature* that comes close. The passage begins, "Crossing a bare common, in snow puddles, at twilight, under a clouded sky, without having in my thoughts any occurrence of special good fortune, I have enjoyed a perfect exhilaration. I am glad to the brink of fear" Emerson then goes on to memorably declare, "I become a transparent eyeball; I am nothing; I see all; the currents of the Universal Being circulate through me; I am part and parcel of God." Becoming a "transparent eyeball" is exactly what the Luminists were after, and it's why their paintings don't so much seem to be of a place, but rather formed from a complex dialogue and exchange with that place. The landscape with all its immanent power enters the artist's consciousness, while his consciousness almost vaporously infuses the landscape, and the painting is the result.

Emerson, and Transcendentalism, represented an extraordinarily fresh synthesis of American religiosity, attitudes toward nature and place, and art; this was the period when utopian religious energies underpinning

the culture since Puritan times began to be channeled into a uniquely American art. As Emerson, who was an ordained Unitarian minister, moved from organized religion to literature and art for his spiritual inquiries, he made enormous claims for both, seeing them as inseparable from questions of individual character, psychological growth, revelation, and redemption. In his essay *The Poet*, which is the first great radical statement of art-making in this country, he championed not formalism but "the instant dependence of form upon soul," artistic forms that would elastically take the shape of the artist's own psyche and that would respond to a still young country in flux; thus encouraging risk-taking artists in his own day, but also anticipating all sorts of innovators who would come much later.

For all his focus on exaltation and catharsis, Emerson was hardly some wild enthusiast prone to emotional excess. On the contrary, he had a remarkable ability to treat sophisticated ideas sensually and poetically; rigorously conceived ideas about nature, for instance, led to experiences in and with nature that could be expansive, liberating, and mind-bending. Moreover, an art based on those ideas and experiences could be the same. Emerson's fundamental approach was at once questing and cerebral, simultaneously visionary and empirical. "We want the Exact and the Vast; we want our Dreams, and our Mathematics," he wrote in his journal, and this is something one finds in a broad range of American art. Think of the exhaustive and detailed information about shipping, whaling, and whales presented

TOP Fitz Henry Lane *Brace's Rock, Eastern Point, Gloucester* c. 1864 Photo: Lyle Peterzell

BOTTOM Martin Johnson Heade *Sunlight and Shadows: The Newbury Marshes* 1871–5

by Herman Melville in the great doomed quest of Moby Dick; the young Vito Acconci counting, calibrating, timing, and measuring as he went about his eccentric actions on the streets of New York; or Sol LeWitt's sculptures and wall drawings with their use of mathematical progression and seriality pushed to the extreme. "Conceptual artists are mystics rather than rationalists," LeWitt wrote in *Sentences on Conceptual Art*, sounding frankly Emersonian, "They leap to conclusions that logic cannot reach."

Emerson immediately affected other writers, notably Henry David Thoreau (author of *Walden*) and Walt Whitman, who once declared, "I was simmering, simmering, simmering; Emerson brought me to a boil." His influence also quickly extended to visual artists, including the Luminists, as I mentioned, and the Hudson River School painters. Long after Transcendentalism's brief heyday in the 1830s to 1850s ended, quite a number of subsequent writers and artists have revealed pronounced affinities with Emerson, including poets Wallace Stevens and John Ashbery, and the novelist Paul Auster, as well as visual artists such as Edward Hopper (who read Emerson assiduously), Barnett Newman, Mark Rothko, and Agnes Martin, among many others.

It may be the case (and this is something I first began to seriously wonder about while reading Barbara Novak) that some of the ideas and the demands made on art by Emerson remain pertinent now, in however an altered manner, and they keep appearing in art that might otherwise seem very diverse, whether because the artists in question have read Emerson, or because core level Emersonian

concerns are close to the bone in this country, part of the artistic vernacular when it comes to an especially questing kind of art. Of course, not only art has changed considerably since Emerson's day; nature has changed as well. It has long since been populated, cultivated, marketed, mediated, and simulated, and now it is also marked by crisis, with the advent of global warming. At issue here is not just Emerson and his legacy, but how or even whether sublimities are possible in these fractious, information-saturated, and, it appears, increasingly dangerous times.

If there are Emersonian implications for current and recent visual art, an obvious question is what that art might actually look like? One answer is that it might not (although it certainly could) look like landscape paintings, videos, or photographs. It might look, for instance, like a spiral shape made of salt-encrusted boulders and crusty earthen mounds jutting into the Great Salt Lake in a part of Utah so remote, weird, and science fictive that it seems not of this country, and maybe not of this world. Conflating the microscopic and the macrocosmic, Robert Smithson's great earthwork *Spiral Jetty* (1970) suggests spiraling galaxies and the intricate spiral structures of salt crystals; wonders in the heavens millions of light years distant; and the wonders right in front of you, which you'd hardly notice at first glance. Speaking of Emerson's "transparent eyeball," *Spiral Jetty* has this in droves, which I only understood when I visited the site, spending a whole day at the work from one morning until the next. Nothing I had read or seen in photographs and films prepared me for the experience. For one thing, the work does not

Robert Smithson *Spiral Jetty* April 1970 Photo: Gianfranco Gorgoni
© Estate of Robert Smithson/Licensed by VAGA, New York, NY Image courtesy James Cohan Gallery, New York

seem very monumental, as it often does in photographs. Instead, it seems rather modest, even humble: not an earthwork imposed on the landscape but rather one which merges and blends with the landscape. It also repeatedly changes over the course of a day, from bedazzling white in pinkish red water to a somber grayish black in blue water. Even though it is largely made of stones, it seems hyper-alert to everything in its vicinity: to the vicissitudes of changing light, passing clouds, the great horizontal expanse of the lake, and really to a vast scale of time, including cycles of creation and destruction. The work also has a tremendous impact on one's humanity. You feel contemplative and concentrated but also remarkably open and invigorated.

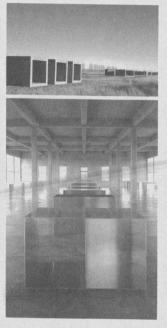

Smithson is an especially interesting figure when it comes to the enduring impact of Transcendentalism, because on one level he was much more of an anti-Transcendentalist than anything else. He was skeptical of spirituality in art and frankly dismissive of any claims that there is something "good," "pure," and morally uplifting about nature; in fact, he was far more interested in geology, entropy, pulverization, and granulated eons than in exploring how natural beauty might act as a redemptive force. But that's when things get much more complex. Smithson of course, was an important figure in land art, and it's worth recalling that when a whole group of artists left the gallery to accomplish earthworks outdoors, they were, in effect, updating

a centrally Emersonian call to venture outside in the largest sense: to shed psychological and cultural restrictions, and seek an original engagement with nature. "In the wilderness," Emerson wrote in *Nature*, "I find something more dear and connate than in streets or villages." The way that Smithson's works involve and embrace natural forces intersects with Transcendentalism's desire to cross the borders, whether psychological or cultural, separating oneself from the world. Referring to his various "non-site" pieces, in which he would go to a specific site outdoors, experience it, analyze it, pay close attention to its geologic make-up, collect some of its materials, and then use these to recreate it as an abstract system in the gallery, Smithson had this to say in an interview: "There's a central focus point which is the non-site; the site is the unfocused fringe where your mind loses its boundaries and a sense of the oceanic pervades... The interesting thing about the site is that, unlike the non-site, it throws you out to the fringes." Being thrown out to the fringes, pursuing discoveries at the malleable borderlines where hierarchies and categories falter, and doing so with an interest in the "oceanic"—this is prime Emersonian territory. As a trailblazing artist, an impassioned and idiosyncratic essayist, and as a charismatic agitator for freedom and renewal, Smithson—in his own very different era, and with his own very different concerns— was probably closer to what Emerson was up to than any other artist in his generation.

TOP Donald Judd *100 untitled works in mill aluminum* (detail) 1982–6 Photo: Florian Holzherr

BOTTOM Donald Judd *15 untitled works in concrete* (detail) 1980–4 Photo: Florian Holzherr

Minimalism, of course, is commonly understood as an anti-spiritual, non-emotive reaction to the excesses of Abstract Expressionism. But you can also see Emersonian implications right from the beginning in Minimalism, and especially in the work of Donald Judd. Judd's use of industrial materials like anodized aluminum, stainless steel, brass, plywood, and Plexiglas, which had previously not been used much in sculpture, fits with Emerson's democratizing and freedom-seeking drive to seek out beauty and possibilities in unexpected places, revelations that are embedded in the mundane and seemingly ignoble. Judd's focus on artworks that are not composed of parts but that exist on their own as total entities also echoes the Transcendentalist drive toward unity and wholeness. Furthermore, in describing his ideal poet, Emerson wrote in *The Poet*, "He is a beholder of ideas and an utterer of the necessary and causal." This, too, seems awfully close to Judd, as a rigorous sculptor dealing in complex ideas and a dauntingly opinionated writer.

It's one thing to see Judd's work in a gallery, but quite another to see it in situ, for instance at his own highly utopian venture, the Chinati Foundation, in Marfa, Texas, where he transformed large sections of a remote West Texas town into a permanent home for contemporary art, and not only his own, but the works of many others as well. Outside, there is a line of large scale, white geometric sculptures that seem supremely alert to the landscape, to the sky and horizon, and to the spectacular quality of light in that region (*15 untitled works in concrete*, 1980–4). Inside a converted window-filled artillery shed, rows of Judd's spare aluminum cubes are downright dazzling in the natural light (*100 untitled works in mill aluminum*, 1982–6). Daylight floods the hall, interacting with the works; there is flowing exchange between inside and outside, between these hard silvery works and the vast West Texas landscape and sky, stretching in all directions. Much more than housing a compelling installation of sculptures, this is a place where one wants to be, comprehensively and patiently, absorbing its mix of logic and luminous magic.

With both Smithson and Judd in mind, consider Teresita Fernández's sculptures, which have everything to do with fabricated nature. *Fire* (2005) is a cylindrical structure with a circular steel base and top, with hundreds of taut, upright silk threads strung between them. Reddish orange flame-like forms, tinged with yellow, made solely by the colors of the silk yarn, ascend and interplay with areas of translucent white. The surface, made of fabric, suggests a screen upon which videos or films are projected, and there is something filmic (a recurrent motif in Fernández's work) about how this "fire" operates: it resembles a video projection and you almost expect it to start flickering and dancing. However, because this work is mostly made of silk threads it also seems vaporous and ethereal, and because it is semi-transparent you look at it, at its whole volume as well as at its elaborate surface activity, but also through, into, and beyond it. Rigid borders and barriers break down and Fernández's fire seems exquisitely permeable, implicated in mysteries and immensities.

Something similar happens with Roxy Paine's ongoing series of large denuded trees made of welded stainless steel. Paine recently exhibited three gleaming trees and a sizable metal boulder in New York City's Madison Square Park. These ersatz trees and rock are outrageous artifices, focusing attention on the many ways that our world, including nature, is manipulated and simulated. They are also visually stunning, even breathtakingly so, and they inspire wonderment, amazement, and acute psychological openness. For Emerson, the heart of the matter was an ecstatic and spiritually charged immersion in nature, and an art based on that immersion: a fluid, border-defying exchange between self and world. Paine, with his sculpted trees, courts such a similar immersion, yet now no longer with a "pure" nature but instead with a hybrid nature, a socially molded nature, a nature infiltrated and infected by technology, consumerism, industry, and entertainment.

Or consider Fred Tomaselli's extremely unorthodox paintings which set a standard for what painting can accomplish in an ultra-mediated age when there is so much slippage, notably between nature and its myriad cultural representations. In Tomaselli's works, painted forms, both abstract and representational, combine with various objects, such as pills, hemp leaves, ephedra stems, insects, tiny photocopies of songbirds and human body parts, pieces of maps, and cutouts from outerwear catalogues. Because everything is sealed behind layers of highly polished resin, you look at Tomaselli's paintings but also through and into

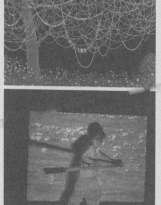

them, which is an updated take on the very old idea of paintings as a window into cosmic reality, and which also connects with the smooth surfaces and seeming transparence of Luminist works. Tomaselli's paintings typically emphasize their extreme artifice, while they pull in multiple references, including theme park attractions, surfboard designs, glossy magazine advertisements, and record album covers, to mention just a few. In the midst of their blatant artifice, however, these paintings are often based on visceral and profound encounters with nature, and they suggest that artworks can also offer ecstatic encounters, that they can yield, quite literally, mind-altering experiences. *Hang Over* (2005), in which a tree sporting strands of flowers, hands, birds and pills stands on a flower-filled meadow, is one of Tomaselli's paradisial garden or nature scenes, with folk art suggestions that also seems like an ecstatic vision, or perhaps a hallucination.

The pioneering video and performance artist Joan Jonas is increasingly (although belatedly) being understood as one of the most innovative and meaningful artists of a spectacular generation who emerged in the late 1960s and early 1970s. Jonas' combination of video, live and recorded activity, fragmented narratives, mediated bodies and selves, and eclectic cultural references, has resulted in a strikingly idiosyncratic body of work that has also proved enormously influential for many subsequent artists. Seldom discussed, however, is how so many of Jonas' works involve thoughtful, meditative, occasionally sublime, and consciousness-altering excursions into

TOP Fred Tomaselli *Hang Over* 2005 © Fred Tomaselli

BOTTOM Joan Jonas *Volcano Saga* (performance view from The Performing Garage, New York, 1987) 1985–9
Photo: Gabor Szitanyi © Joan Jonas

nature. Beginning in the late 1960s, Jonas staged seminal performances at Jones Beach on Long Island or next to the ocean in Nova Scotia. Consider, for instance, Jonas' 2003 video *Waltz*. A small group of friends go down to a Nova Scotia beach and out into the woods, dress up in odd costumes, arrange and rearrange several objects, and make an improvised performance that's at once whimsical and haunting. Throughout there is a cyclical exchange between human actions and natural environs: the spirit of the woods, sky, and ocean, so to speak, flows into and affects the work, even to the point of evincing, as Emerson wrote in *Nature*, "an occult relation between man and the vegetable." *Volcano Saga* (1985–9), based on excerpts from the thirteenth-century Icelandic Laxdaela Saga, features two actors who perform a fraught, erotically-charged encounter between Gudrun, a legendary heroine, and her cousin Gest. This encounter occurs against a backdrop of video images and photographs of contemporary Iceland, including lava floes, craggy mountains, jagged lava fields, turf houses, and steaming waters. Present and remote past, ancient journeys in Iceland, and Jonas's own journey to the country all intertwine, while the remarkable Icelandic landscape functions as a powerful zone of transformation where the known abuts the unknown, and where rational thought merges with magical poetics.

"The sky is the daily bread of the eyes," Emerson wrote in his journal, in one of his

spectacular conflations of the Bible and the Earth, and that's the kind of sentiment that proved most fruitful for the Luminists, who lavished attention on the vast, ever-changing, reverie-inducing sky, because it was a permeable membrane between the earthly and the divine, and also because it allowed them to acutely concentrate on light. A contemporary sublime work might not depict such a sky overtly, but instead through a conflation of sculpture and language. Roni Horn's *Limit of the Twilight* (1996) is a solid aluminum parallelogram set on the floor. Plastic lettering in Horn's signature wraparound style presents the message "49 Miles" on one side, and again on the opposite side, but reversed, as if in a mirror. This cryptic signpost refers to the distance one would have to travel straight up to rise above the twilight altogether, where one would reach a presumably majestic overview. This, incidentally, is just one of numerous works that suggest profound connections between Horn and Emerson (and his milieu). Horn's many elemental photographs of the surface of water also evoke hidden depths, both in the water and ourselves, and suggest complexities: water as a gentle and supple substance that can wear away rock and shape continents, as a changeable thing that can easily move from placidity to awesome power.

A contemporary sublime work might be a highly artificial sculptural rendition of the sky, for instance, a particular summer sky in Massachusetts. Spencer Finch's marvelous

Sunlight in an Empty Room (Passing Cloud for Emily Dickinson, Amherst, MA, August 28, 2004) (2004), exhibited in his recent exhibition at MASS MoCA, uses a wall-mounted bank of precisely calibrated fluorescent tubes as a stand-in for blazing sunlight, which illuminates a suspended "cloud" made of blue, gray, and violet filters. Finch went to great lengths to engineer and replicate the exact light he experienced on a single day in Amherst, yet his elemental work effectively conjures the kind of borderless visual and mental transport that one sometimes experiences outdoors, when you are alone with the sun, clouds, and sky.

A contemporary sublime work might also be the sky altogether. In James Turrell's room installation *Meeting* (1986), at P.S. 1 MoMA in New York, one sits on wooden benches in an austere yet quietly elegant room that is suggestive of pared-down nineteenth-century Shaker furniture and spare Protestant chapels. Above, there is the sky, gorgeous and elemental, framed by a rectangular opening cut through the ceiling. While the experience of contemplating that particular rectangle of sky is indeed meditative and cathartic, this piece, like much of Turrell's work, is also precise and controlled, treating the sky as a physical phenomenon, and inviting a close concentration on its appearance. Whatever cosmic or eternal implications the work has remain firmly grounded in an

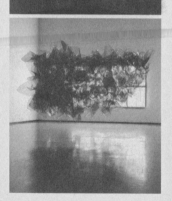

inquisitive rationalism, which has little to do with extra-logical exuberance or gushy emotionalism, but then again the work has an extreme emotional impact. You are contained, but that containment opens up to immensities. You are inside, but looking up, enthralled, at the outside. You are in conditions of exactitude, including the benches, interior lighting, and precisely excised section of ceiling, but that exactitude opens up to vastness. If you want to see a tremendous contemporary rendition of Emerson's "transparent eyeball," the Turrell room at P.S. 1 MoMA is the place to go.

Portions of this essay have previously been published elsewhere.

TOP James Turrell *Meeting* 1986 Photo: Michael Moran

BOTTOM Spencer Finch *Sunlight in an Empty Room (Passing Cloud for Emily Dickinson, Amherst, MA, August 28, 2004)* 2004 Photo: Luke Stettner

THE AESTHETICISTS

An exhibition about the landscape would not be complete without a discussion of aesthetics, for it is in the landscape that the European Romanticists like J.M.W. Turner or Caspar David Friedrich found the sublime, a beauty so great that it evoked the spiritual. The great American landscape painters were as deeply engaged with beauty as the early photographers. The nineteenth-century Transcendentalist writers, like Henry David Thoreau and Ralph Waldo Emerson, talked carefully and exultingly about the inherent beauty in nature, and were deeply rooted in the eighteenth-century writings of Immanuel Kant, the philosophical father of modern aesthetics. These ideas of aesthetics and beauty are political ones as well, especially when it comes to the environment, where beauty is amidst a stream of decline, as well as a history of power and abuse.

The Aestheticists work within the language and history of nature's beauty, by allowing us to really look at the landscape and see it as a social construct. The landscape is in many ways man-made; it is not like nature, though the two are intrinsically entwined. These four artists exploit the sheer physical "beauty" of the natural world, and in doing so, allow us to question its validity and its place within our understanding of the landscape around us.

Most of your work is populated by multiple images of yourself. For the *Landscape* series you remove the figure, yet the works still have a sense of human residue. Can you talk about your decision to shift towards the post-event landscape?

The multiple self-portraits were part of an earlier body of work. While doing the self-portraits, I found myself becoming more interested in building the sets and restaging locations to suit my needs than in the idea of representing the figure. The decision to remove the figure completely came from a desire to reconstruct a narrative in the past tense through the use of leftover props, staged sets and digitally composited landscapes. I was very interested in early American landscape painting at the time and wanted to play with the idea of nature and the sublime as well as the notion of still life. I began to stage performances and interventions within "semi-artificial" locations and then documented the leftover evidence of the actions that had occurred in each location in order to create the idea of a past history/action. Through further manipulation and digital compositing, I was able to create documentation of a past event that never actually took place in a location that never actually existed.

For *Badlands* we chose to focus on a series of snowscapes you made. What was it that drew you to this particular type of landscape?

I was interested in the idea of snow and ice because of their transformative and unifying properties. Snow becomes such a homogenizing element. It blankets an area and transforms it into a unified white surface, which easily records the footprint of any action.

I was hoping we could talk about experience and how the viewer factors into your work. *Snowscape* is a 24-foot long panorama and it seems important that the work functions as an experiential landscape, a photo we can't consume in one glimpse, but rather we have to walk along it as we would in real life.

Snowscape is a flattened out 360° view of seven different winter terrains fused together to create a unified "idea" of an Arctic landscape. Most people read images from left to right and the extreme horizontal format forces the viewer to physically move from left to right (or right to left) along the image which creates an almost interactive sense of narrative. I like the idea of absorbing the viewers into the work and implicating them in the world that is presented to them.

Absence in these environments, the lack of people and of traditional civilization, is particularly poignant given the increased awareness of global warming. Is that something that factored into these works?

I was not necessarily thinking of global warming when creating these works as much as I was just thinking about man's leftover footprint on nature and how human intervention reveals itself in a temporary or long-term way. For me, it is as if the works almost place humanity and nature in competition with each other. There is an underlying sense of imminent danger, although it is not clear from where it stems.

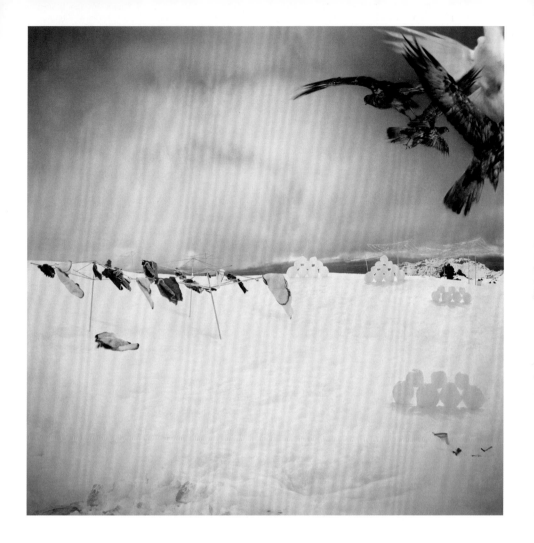

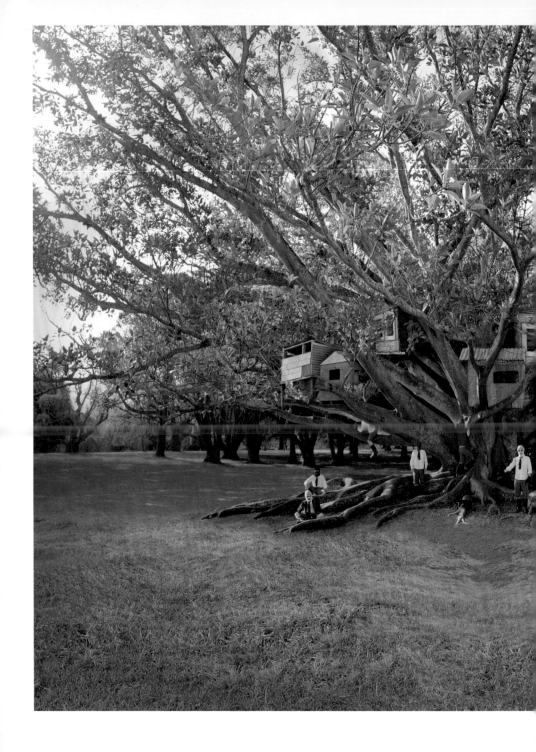

Anthony Goicolea *Tree Dwellers* 2004

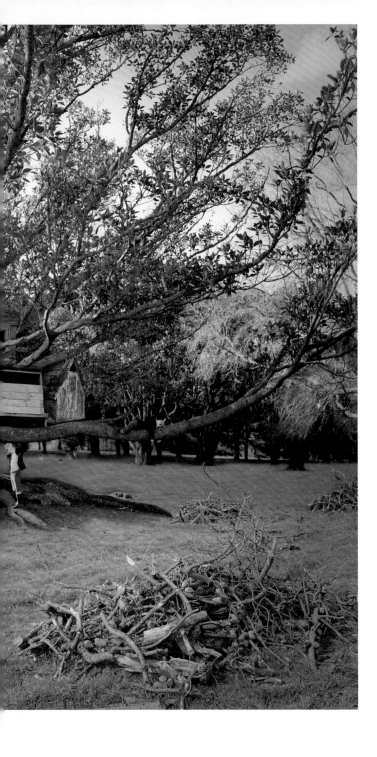

Anthony Goicolea *I'll Show You Yours If You Show Me Mine* 2000

Anthony Goicolea *Snowscape* 2002
TOP Full view BOTTOM details

In your work you often play with systems of nature. I am thinking here of your mending spiderwebs or animal crossdressing. Your work for *Badlands*, though not dealing with the animal kingdom, does subvert certain traditions of nature we come to expect. Can you talk about your relationship to the natural world and your willingness to mess with it?

For a long time I've made work that takes up the human relationship to the natural world, and in the projects such as the ones you mention, this has often involved animals. However, the project for *Badlands* is more about the human relationship to nature as spectacle. We tend to have more fixed ideas about what "natural" means than we are willing to admit, and we seem to put the natural and the unnatural on opposite ends of a continuum. But I'm trying to poke at the way that the spectacularly natural almost turns fake—it's like a loop coming full circle.

The work for *Badlands* is subtle; it rewards its viewer's patience since you are not presented with the project right away but have to search for it outside the realm of the museum. Also, in the fall, the piece will be nearly impossible to see. How do you think about work like this in relation to the audience for it?

It's subtle in one way, because you have to see the piece outside, through the window of the museum, and it's not as easy to immediately locate *art* outside those walls. But on the other hand, the piece is not hard to spot: for most of the year, the fake tree limb stands out like a sore thumb, so to speak. I hope it will almost be embarrassing to see how out of place this one tree branch is, like someone who misunderstood the dress code for a party.

You often make aesthetic leaps with your work; spiderweb mending both fixes the web but is also a visual intervention. For *Badlands* you chose to create a branch in a suspended state of permanent fall, a season that (at least in the Northeast) is considered most beautiful. The work doesn't seem to be about just aesthetics, but rather it becomes a critique on beauty. What relationship do you see between beauty and the natural world?

There is overwhelming beauty in the natural world, of course. Sometimes it's almost comically overwhelming, to the point of inducing doubt. By way of anecdote, I remember the first time I went to Yosemite, and it was almost impossible to believe what I was seeing. I was agog! It was sublime, but also hilarious! Every view was like a Sierra Club calendar picture or an Ansel Adams postcard. At

one point, I became convinced that I had been there before and had just forgotten.

There is a sense of irony or humor in your work, a type of slapstick endurance that always makes me laugh. This work is more subtle; instead of you performing, the viewers take over the role of performer. How does this role reversal function for you?

More often than not, the source for my ideas is the dumb everyday stuff that surrounds us. There may be more there that is of interest to us than we realize. My professor Allan Kaprow once said, quoting his teacher John Cage, that a definition of art could be "paying attention." I have decided to subscribe to this. Maybe this piece is a suggestion to the viewer to do the same thing. Perhaps this one fake branch calls the realness of everything else into question. In peak leaf season, perhaps the viewer will leave the museum and experience the glory of fall with good-natured scrutiny, noticing every branch with a more attentive eye.

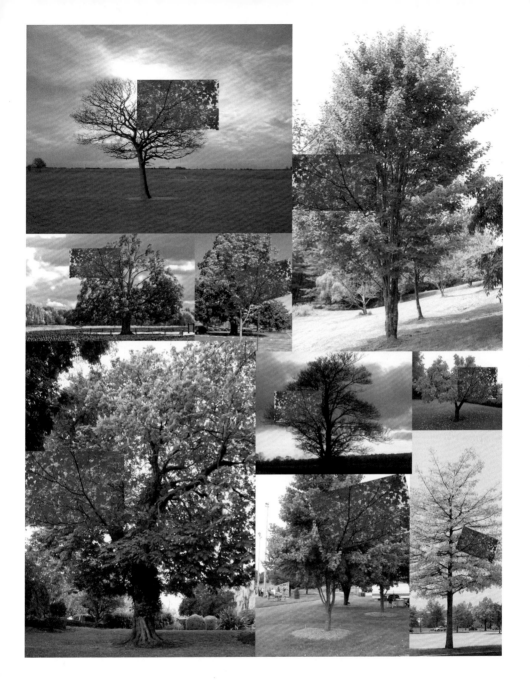

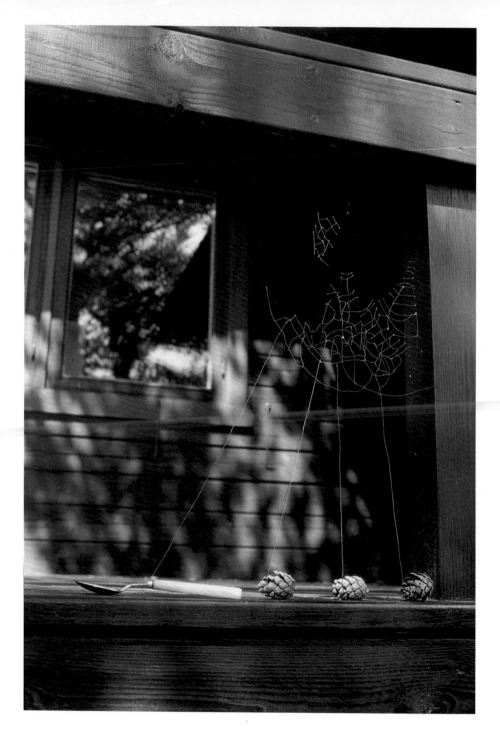

Nina Katchadourian *Mended Spiderweb #14 (Spoon Patch)* 1998

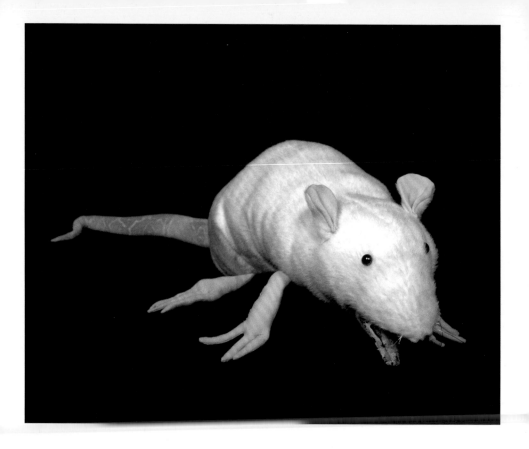

Nina Katchadourian *Crossdressed Snake* 2002

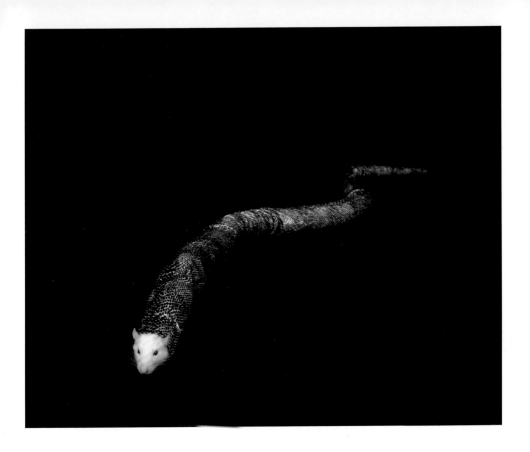

Nina Katchadourian *Barnacle Mixer* 2002

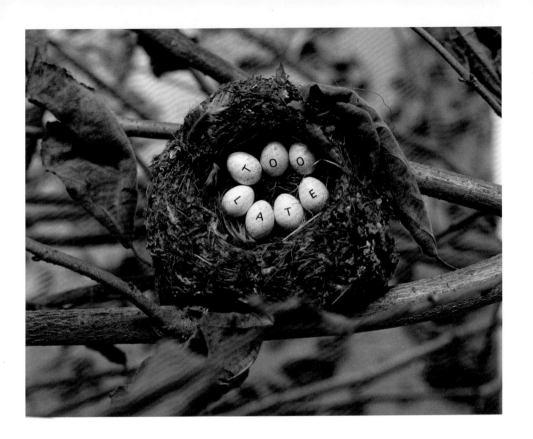

When people first encounter your work, there is an immediate seduction. The movement of your nature seems real while at the same time synthetic. Is it important for you that the trees and flowers you depict don't quite seem natural?

You are right. When I create motion I am striving for a sense of realistic movement while the images I create are less true to life. I prefer to make the images a little more like drawings. The seduction you mention could be an artifact of this type of motion. Our bodies are drawn to motion on a physical and emotional level. It certainly would be easy enough to create motion that alienates the body's senses.

My visual concerns have developed through a deep interest in abstraction. The flowers started as stripes formed out of flowers floating in a current of undulating fluidity for a piece titled *Jimmy Carter*. The work, up until this time, had been installations dealing with architecture, transforming physical space by filling entire walls with synthetic imagery. My more recent artworks, utilizing plants, have liberated me from my past process; some of the projections have become similar to objects rather than fields. It seems I let the objects become more representational while the installations tend to be more abstract.

The words bewitched or enchanted often come up in discussing your work. The large tree projections, more so than the flowers, seem to channel the Brothers Grimm rather than Disney. Can you talk about the unsettling "dark woods" quality to this work?

The first work where I considered enchantment was *Eye Catching*. I had the opportunity to create an installation for an ancient cistern in Istanbul. The building structure uses a couple of Medusa head sculptures for column supports. I decided to create an enchanted environment for the story of Medusa where the limbs of the trees mimicked the writhing snakes in her hair. As you know, if a man gazed upon her eyes he would turn to stone. As a feminist I cannot help reading an explicit sexual metaphor into this transformation.

In 2005 I worked with the Grimm fairytale *Rapunzel* for a work with the same name. This piece is actually a self-portrait of sorts. The story is very dark; it deals with parents giving up their child because of an addiction.

You often title your works after well-known people (*Rosa Parks* or *Jimmy Carter*), books (*The Invisible Man*), and songs (*Hurdy Gurdy Man* and *Ring of Fire*). The title of the series on view in *Badlands* is *Mike Kelley*. What is the relationship for you between the title and the piece?

The piece titled *Mike Kelley* is more of a dedication and a portrait for a teacher and artist I admire. Mike, as a teacher, had a talent for saying things that really stuck with me. I have another piece that was a dedication to another teacher of mine, *Miss Znerold*. She was my first grade teacher. She praised my early art by letting me know I made the best sponge trees in the class. The trees became like figures or people. My childhood memory of the film *The Wizard of Oz*, where the trees argue and throw apples, is quite a profound influence.

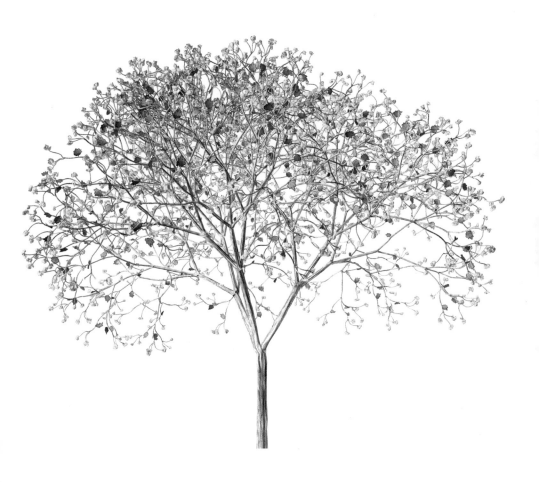

Art Center College of Design
Library
1700 Lida Street
Pasadena, Calif. 91103

Jennifer Steinkamp *Mike Kelley* 2007

Jennifer Steinkamp *Mike Kelley* 2007

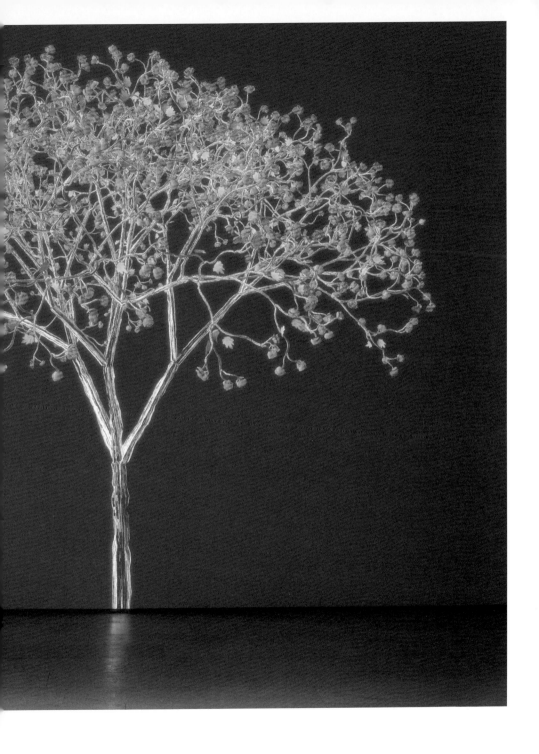

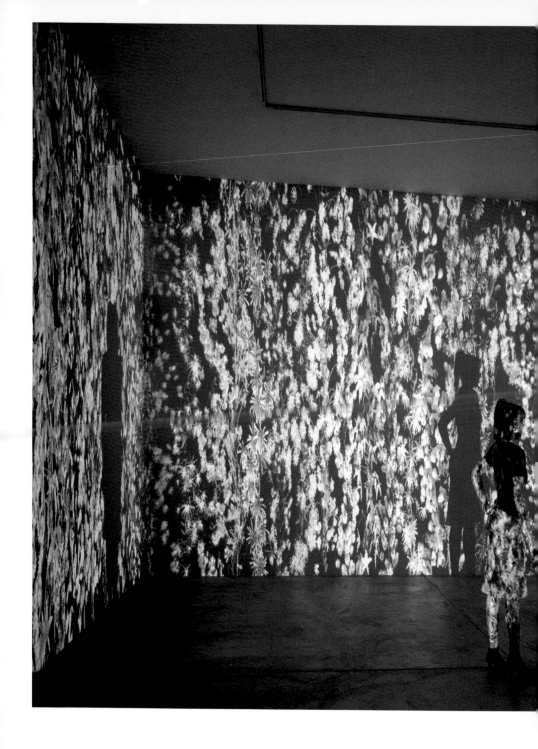

Jennifer Steinkamp *Jimmy Carter* 2002 Photo: Robert Wedemeyer

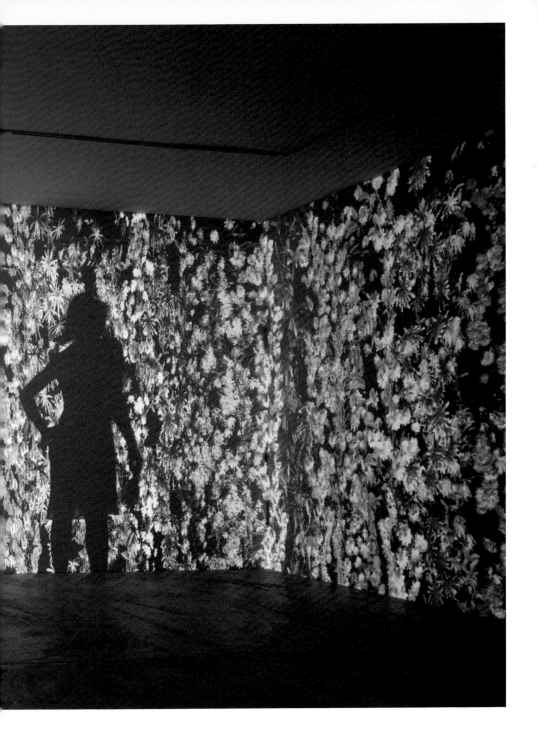

MARY TEMPLE

In a previous conversation we talked about how this body of work did not come from an interest in the landscape but rather a problem of representation in painting. Could you talk about how the work solved that problem and came to involve the landscape?

Yes, well, these pieces depend on two levels of cognition, one being the instantaneous recognition of the visual subject: outdoor light intersecting an interior space. The other is a slower realization that the situation is artificial. What I found in experimenting with painted geometric shards of light was that without the silhouetted plant life within the window shape, there was a greater chance that the image would be misunderstood, that it could be read as a simple geometric shape on the wall, rather than light from a window. So the landscape silhouettes serve to direct the immediate reading—they keep the piece on track.

Once you openly embraced the landscape element of this work, how did you then deal with the vast history of this art historic genre?

Even though my concern is to communicate something about philosophy and doubt, the landscape is specific, and by using it I do want to coax layered responses, in much the same way certain historic landscape painters wanted to

inspire peace, calm, or even awe. And though I'm painting, the approach may have more in common with landscape photography or film, in that I am drawing from actual light and cast shadows to make the painting. The installations then are sort of an amalgam of historic genres—photogram/paintings. So I don't mind these pieces working as a contemporary continuum of landscape-based work, acknowledging that the point of entry is quite different.

What I like about this work is that it plays with perception in a way that traditional painting has trouble with; with the canvas you are always aware of the construct. But here you give in to disbelief. I have seen people experiencing your work, peering around corners and looking for the windows creating the shadows. How important for you is the "ah ha" moment between enchantment and the reveal of truth?

The chance to create and then extend the time between belief and disbelief, when there is only doubt, is my primary reason for making this work. These pieces are made in the service of questions and doubt. Unfortunately the "ah ha" moment can also be regarded as a "gotcha" moment...if I could create that little gap between the two (belief and disbelief), without the "gotcha" moment I would. But another way to think of it

is that the pieces offer a safe environment for viewers to be really wrong—and maybe even to enjoy the idea of "not knowing" in the larger, philosophical sense.

For _Badlands_ I wanted the works on view to range from the beautiful to the frightening, echoing our troubling environmental history. Your work clearly embraces beauty but there is something fleeting and fragile there as well. Is this a relationship you think about often in your work?

By all means, the work forces the question of mortality. Things don't stay the same, and yet in this work I try to fix a moment in time, or at least I'm talking about our sometimes overwhelming desire for things to remain unchanged. Often people tell me that their experience of an installation is bittersweet, and I think that feeling stems from a very human desire to preserve that which we find poignant in our lives.

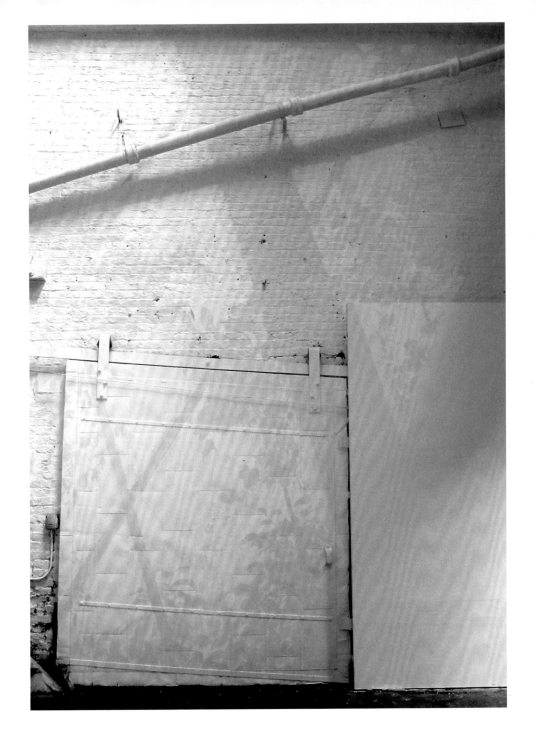

Mary Temple *East Wall, South Skylight* 2003
Installed at Smack Mellon, D.U.M.B.O., Brooklyn, New York

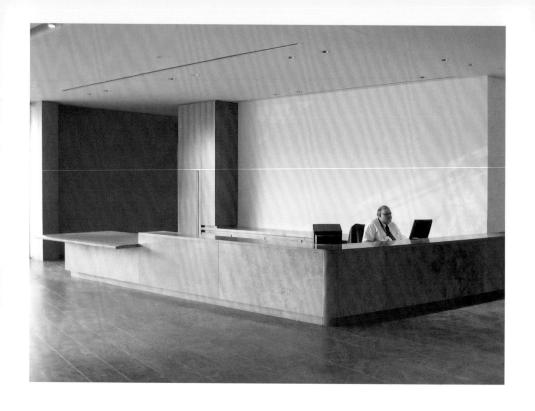

Mary Temple *West Wall, South Light* 2004
Installed at York University, Schulich School of Business, Toronto, Canada

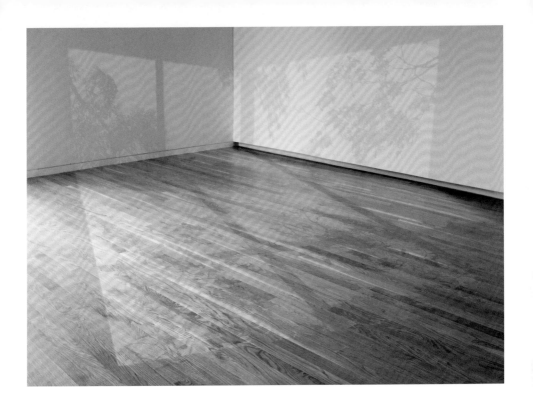

Mary Temple *Extended Afternoon* (detail), Phase III 2006
Installed at The Aldrich Museum of Contemporary Art, Ridgefield, Connecticut

213

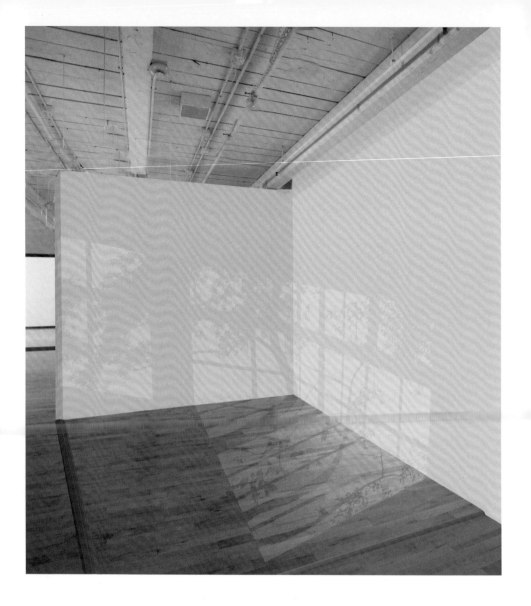

Mary Temple Artist rendering of *Northeast Corner, Southwest Light* at MASS MoCA 2008

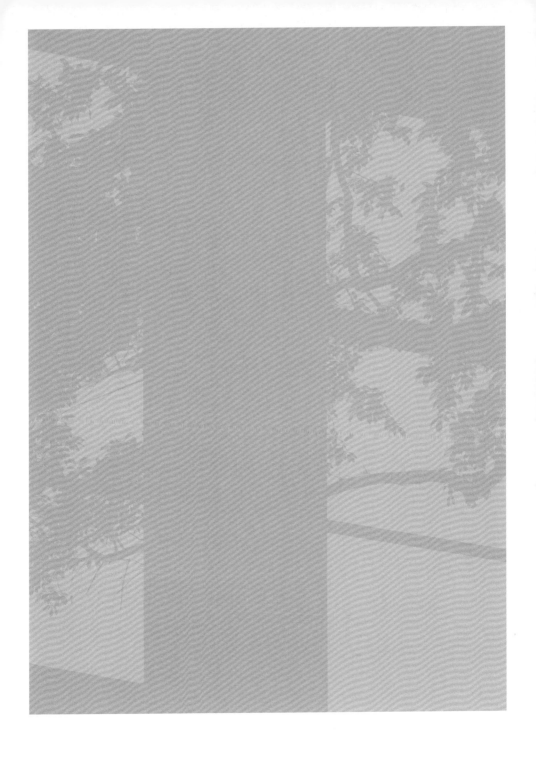

Mary Temple *Southwest Corner with Ladder* 2005
Installed at a private residence

BIOGRAPHIES

Robert Adams (BA University of Redlands, CA; Ph.D. University of Southern California, Los Angeles, CA) lives and works in Astoria, Oregon. Recent solo shows include The Photographer's Gallery, London, England; the J. Paul Getty Museum, Los Angeles, CA; the San Francisco Museum of Modern Art, CA; Haus der Kunst, Munich, Germany; Princeton University Art Museum, Princeton, NJ; Matthew Marks Gallery, New York, NY; and Yale University Art Gallery, New Haven, CT. Recent group exhibitions include *Twilight: Photography in the Magic Hour* at the Victoria and Albert Museum, London, England; *Super Hits of the '70s: Photographs from the Collection* at the Milwaukee Art Museum, WI; *Wide Open Spaces* at P.S. 1 MoMA, New York, NY; and *Cruel and Tender: The Real in Twentieth-Century Photography* at Tate Modern,

London, England. Adams is the recipient of the Spectrum International Prize for Photography, the John D. and Catherine T. MacArthur Foundation Award, a Guggenheim Fellowship, and a National Endowment for the Arts Fellowship.

Vaughn Bell (BA Brown University, Providence, RI; MFA Massachusetts College of Art, Boston, MA) lives and works in Seattle. Bell works in a variety of media, employing installation, performance, and sculpture in an ongoing investigation of the natural world. She has had solo exhibitions at the Disjecta Art Center, Portland, OR, and the NAO Gallery, Boston, MA. Recent group exhibitions include *Wired Forest* at the Kirkland Art Center, Kirkland, WA; *Personally Public* at Crawlspace Gallery, Seattle, WA; *Five We Like* at Allston Skirt Gallery, Boston, MA; and *One is*

Better at Dam Stuhltrager Gallery, Brooklyn, NY. Bell has created public art projects in Seattle, WA; Providence, RI; and Boston, Cambridge, and Somerville, MA. She is currently teaching at Fairhaven College at Western Washington University, Bellingham, WA.

Boyle Family are collaborative artists based in London, comprised of Mark Boyle (1934–2005) and Joan Hills and their children, Sebastian and Georgia. Recent exhibitions include *Teaming* at the Embassy, Edinburgh, Scotland; *Summer of Love* at Tate Liverpool, England, and Schim Kunsthalle Frankfurt, Germany; *Visual Music* at the Museum of Contemporary Art, Los Angeles, CA, and the Hirshhorn Museum and Sculpture Garden, Washington D.C.; *Art and the 60's: This Was Tomorrow* at Tate Britain, London, England; and *Blast to Freeze: British Art in the 20th Century* at the Kunstmuseum, Wolfsburg, Germany, and Les Abattoirs, Toulouse, France. Their work is in collections including the Glasgow Art Gallery and Museum, Scotland; Tate London, England, and the Los Angeles County Museum of Art. (A Boyle Family represented Britain in the 1978 Venice Biennale and the 1987 Sao Paulo Biennale. In addition to sculptural work, Boyle Family has created public projects, performances, films, videos, and installations, collaborating with the likes of Jimi Hendrix and Soft Machine.

Melissa Brown (BFA Rhode Island School of Design, Providence, RI; MFA Yale University, New Haven, CT) is a painter and printmaker living in Brooklyn, NY. Brown has had solo exhibitions at Rove London, England; Bellwether Gallery, New York, NY, and Kravits/Wehby Gallery, New York, NY. Recent group exhibitions have included *Choplogic* at Bellwether Gallery, New York, NY; *Between Mind and Nature* at the Brattleboro Museum, Brattleboro, VT; *New York's Finest* at Canada Gallery, New York, NY; *Visitors from the East* at Billy Shire Fine Art, Los Angeles, CA; and *Where do we come from? What are we? Where are we going?* at Champion Fine Art, Los Angeles, CA. Additionally, Brown was a nominee for the Tiffany Foundation Grant and has twice received the PCS CUNY Research Grant.

The Center for Land Use Interpretation (CLUI) was founded in 1994 and is a research institute devoted to issues of human interaction with the land. CLUI engages current and historical issues relating to the landscape. CLUI has four locations in the United States: Los Angeles, CA; Troy, NY; Wendover, UT; and the Mojave Desert, CA. The Los Angeles and Troy branches serve as offices, archives, and exhibition spaces for temporary shows. The Wendover location is an exhibition space and is home to CLUI's residency program. The Desert Research Station in the Mojave Desert is a satellite of the Los Angeles location and has, as its focus, the desert region it occupies. The CLUI program includes public tours and lectures, a newsletter, an archive, and an online database. Additionally, CLUI Press has published more than ten books.

Leila Daw (BA Wellesley College, Wellesley, MA; MFA Washington University School of Fine Arts, St. Louis, MO) lives and works in Branford, CT, and works in a variety of media. Recent exhibitions include *Art in the Garden 2007* at Wilbur and King, Guilford, CT; *Reconstructed Archaeologies* at Atrium Gallery, St. Louis, MO; *Sense of Site* at A.I.R. Gallery, New York, NY; *There's the Rub* at the Islip Museum, Islip, NY; *Elementum* at City Gallery, New Haven, CT; *Mirror, Mood & Magic* at the DeCordova Museum and Sculpture Park, Lincoln, MA; and *Territories* at Artspace, New Haven, CT, and the Galerie fur Landschaftskunst, Hamburg, Germany. Daw has created public art projects in New Haven and Windsor Locks, CT; Lincoln and Somerville, MA, and St. Louis, MO. Daw was a 2005 recipient of the Berkshire Taconic Community Foundation Artist Resource Trust Grant.

Gregory Euclide (BFA University of Wisconsin, Oshkosh, WI; MFA Minneapolis College of Art and Design, MN) lives and works in the Twin

Cities of Minnesota. Euclide works in a variety of media to explore issues relating to landscape. He has had solo exhibitions at Augsburg College, Minneapolis, MN; OKOK Gallery, Seattle, WA; BLK/MRKT Gallery, Los Angeles, CA; Hotcakes Gallery, Milwaukee, WI; and Receiver Gallery, San Francisco, CA. Recent group exhibitions include *All Star Hustlaz III* at White Walls Gallery, San Francisco, CA; *Spatial Flow* at the Bloomington Art Center, Bloomington, MN; *Extra Credit* at the Minneapolis College of Art and Design, MN; *City Seen* at the Minneapolis Foundation, MN; and *Drawing* at the Katherine Nash Gallery at the University of Minnesota, Minneapolis.

J. Henry Fair (BA in Media Studies, Fordham University, New York, NY) was born in Charleston, SC, and lives and works in New York, NY. Select exhibitions include *Industrial Scars* at Saint Augostino, Tuscan Sun Festival, Cortona, Italy, Wonderland (Klein) Gallery, Köln, Germany, and Art House, Singapore, China; *Special Reconnaissance* at Gigantic Art Space, New York, NY; *Why Look At Animals?* at Artspace, New Haven, CT; and *Radius: Emerging Artists* at the Ridgefield Guild of Artists, Ridgefield, CT. Fair has also been published in *Harper's* magazine and *National Geographic*. In addition to his studio practice, Fair is also the co-founder and director of the Wolf Conservation Center in South Salem, NY, and is involved in numerous organizations that support environmental and social change.

Mike Glier (BA Williams College, Williamstown, MA; MFA Hunter College, New York, NY) is a painter living and working in Hoosick Falls, NY. He is currently the chair of the Williams College Department of Art, Williamstown, MA. His solo exhibitions include the Cambridge Arts Council Gallery, Cambridge, MA; Barbara Krakow Gallery, Boston, MA; Hollins University, Roanoke, VA; P.P.O.W. Gallery, New York, NY; North Dakota Museum of Art, Grand Forks, ND; Williams College Museum of Art, Williamstown, MA; and the Cincinnati Contemporary Art Center, OH.

Recent group exhibitions include *The Flower Show* at Fruitmarket Gallery, Edinburgh, Scotland, and the Aberystwyth Art Centre, Wales; *After Eden: Garden Varieties in Contemporary Art* at the Middlebury College Museum of Art, VT; *Watercolor* at P.P.O.W. Gallery, New York, NY; and *Cultural Economies* at The Drawing Center, New York, NY.

Anthony Goicolea (BFA/BA University of Georgia, Athens, GA; MFA Pratt Institute of Art, Brooklyn, NY) lives and works in Brooklyn, NY. His solo exhibitions include Postmasters, New York, NY; Monte Clark Gallery, Toronto, Canada; Sandroni Rey Gallery, Los Angeles, CA; The Arizona State University Museum of Art, Tempe, AZ; and Galerie Aurel Scheibler Cologne, Germany. Recent group exhibitions include *Global Anxieties* at The College of Wooster Art Museum, OH; *Role Exchange* at Sean Kelly Gallery, New York, NY; *International Video Art Exhibition* at Today Art Museum, Beijing, China; *The Food Show: The Hungry Eye* at the Chelsea Art Museum, New York, NY; *Making a Scene* at the Haifa Museum of Art, Israel; and Representing *Representation VII* at the Arnot Art Museum, Elmira, NY. He has also shown work in film and video screenings nationally and internationally as well as collaborated with fashion designers and various publications on a number of additional projects.

Marine Hugonnier (BA Tolbiac University, Paris, France; MA Nanterre University, Paris, France) is a French artist living and working in London, England. She has had solo exhibitions at the Musée d'art Moderne et Contemporain MAMCO, Geneva, Switzerland; S.M.A.K. Stedlijk Museum voor Actuele Kunst, Ghent, Belgium; The Philadelphia Museum of Art, Philadelphia, PA; Kunsthalle Bern, Switzerland; and the Fondazione Sandretto Re Rebaudengo, Turin, Italy. Recent group exhibitions have included *ECHO ROOM* at Alcalá 31, Madrid, Spain; *Universal Experience: Art, Life, and the Tourist's Eye* at the Museum of Contemporary Art Chicago, IL, Hayward Gallery,

London, England, and MART, Trento, Italy; and *Documentary Creations*, Kunstmuseum Lucerne, Switzerland. Her films have been screened widely at such venues as the International Documentary Film Festival, France; The Copenhagen International Documentary Film Festival, Denmark; and the Mexico City Cinema Festival.

Paul Jacobsen is a painter based in Brooklyn, NY. Jacobsen was born in Boulder, CO, and studied art at the Lorenzo de Medici Institutto D'Arte in Florence, Italy. His work has been featured in a number of group exhibitions. Recent shows include *Into the Woods* at Morsel Gallery in Brooklyn, NY; *Gym Show* at 508 26th Street, New York, NY; *Quixotic* at Slingshot Projects, New York, NY; *Crumbs* at 450 Broadway Gallery, New York, NY; and *Hot and Cold...* at Cornell DeWitt Gallery, New York, NY. Jacobsen's work is in the collection of Max Imgruth, Chairman of the Swiss Institute of Contemporary Art and Harvard Investments, Scottsdale, AZ.

Nina Katchadourian (BA Brown University, Providence, RI; MFA University of California, San Diego) was born in Stanford, CA, and currently lives in Brooklyn, NY. Solo exhibitions have been held at the Frances Young Tang Teaching Museum and Art Gallery at Skidmore College, Saratoga Springs, NY; the Turku Art Museum, Turku, Finland; the Catherine Clark Gallery, San Francisco, CA; and Sara Meltzer Gallery, New York, NY. Recent group shows have included *Un(Natural) Selection* at Pierogi, Brooklyn, NY; *The Powder Room* at Track 16 Gallery, Los Angeles, CA; *The Food Show: The Hungry Eye* at The Chelsea Art Museum, New York, NY; *Welcome Home* at Sara Meltzer Gallery in New York, NY; and *California Sublime* at the Yerba Buena Center for the Arts, San Francisco, CA. She has been the recipient of the Anonymous Was a Woman Foundation Award, the Peter S. Reed Foundation Award, and the Tiffany Foundation for the Arts Award.

Jane D. Marsching (MFA The School of Visual Arts, New York) is a digital media artist working in Roslindale, MA. Recent exhibitions include Institute of Contemporary Arts, Boston, MA; Photographic Resource Center, Boston, MA; Sonoma County Museum of Art, CA; the North Carolina Museum of Art, NC; and Real Art Ways, Hartford, CT. She has received grants from Creative Capital, LEF Foundation, Artadia, The Massachusetts Cultural Council, the Pew Charitable Trust and the Artists Resource Trust. She is currently Assistant Professor at Massachusetts College of Art in Studio Foundation. In addition to her studio practice, Marsching curates and writes about art.

Mitchell Joachim/Terreform (BPS SUNY, Buffalo, NY; M.Arch. Columbia University, NY; MAUD Harvard University, Cambridge, MA; Ph.D. Massachusetts Institute of Technology, Cambridge, MA) is a partner in the non-profit organization Terreform, a philanthropic design collaborative that integrates ecological principles in the urban environment. He is formerly an architect at Gehry Partners, Michael Sorkin Studio, and Pei Cobb Freed & Partners. Joachim is a Moshe Safdie and Assoc. Research Fellow Award and Martin Family Society Fellow for Sustainability at MIT. In 2007 he won the *Time Magazine* Best Invention of The Year for a Compacted Car w/ Smart Cities at MIT. Joachim is on the faculty at Columbia University and Washington University. In his work with Terreform, Joachim addresses green master planning, urban self-sufficiency infrastructures, community development activities, climatic tall buildings, performative material technologies, and smart mobility vehicles for cities. Terreform is a winner of the Infiniti Design Excellence Award—History Channel City of the Future competition.

Alexis Rockman (BFA Rhode Island School of Design, Providence, RI; MFA School of Visual Arts, New York, NY) is a painter living and

working in New York, NY. His work has been widely exhibited both in the United States and abroad. Recent solo projects include The Rose Museum of Brandeis University, Waltham, MA; Leo Koenig Gallery, New York, NY; Galerie Sabine Kunst, Munich, Germany; The Brooklyn Museum of Art, Brooklyn, NY; and Grand Arts, Kansas City, MO. Group exhibitions include *Green Horizons* at the Bates College Museum of Art, ME; *Landscape: Form and Thought* at the Ingrao Gallery, New York, NY; *Failure* at Landes Galerie Linz, Linz, Austria; *Complicit* at the University of Virginia Art Museum, Charlottesville, VA; *Rare Specimen* at The Arsenal Gallery, New York, NY; and *Neo Baroque* at Byblos Fine Arts, Verona, Italy. Rockman's work is in numerous public and private collections and he has been the subject of multiple monographs. He has taught at Columbia University, New York, NY, and Harvard University, Cambridge, MA.

Ed Ruscha (BFA Chouinard Art Institute, Los Angeles, CA) was born in Omaha, NE, and lives and works in Los Angeles, CA. He has shown nationally and internationally for over thirty years. His work has been the subject of a number of museum shows, including the Whitney Museum of American Art, New York, NY; the Museum of Contemporary Art, Los Angeles, CA; the National Gallery of Art, Washington D.C.; the San Francisco Museum of Modern Art, CA; the Hirshhorn Museum and Sculpture Garden, Washington D.C.; the Centre Georges Pompidou, Paris, France; the Museo Nacional Centro de Arte Reina Sofia, Madrid; the Museum of Contemporary Art, Sydney, Australia; the Museo Nazionale delle Arti del XXI Secolo, Rome, Italy; and the Scottish National Gallery of Modern Art. Ruscha's works can be found in the collections of the Museum of Modern Art, New York, NY; The Broad Foundation, CA; the Yale University Art Museum, New Haven, CT; Tate London, England; and the Museum of Contemporary Art, Chicago, IL. Ruscha represented the United States at the 51st Venice Biennale in 2005.

Joseph Smolinski (BFA University of Wisconsin, River Falls, WI; MFA University of Connecticut, Storrs, CT) lives and works in New Haven, CT. Solo exhibitions include Mixed Greens, New York, NY; Real Art Ways, Hartford, CT; Creative Arts Workshop, New Haven, CT; Albany Academy, Albany, NY; Phipps Center for the Arts, Hudson, WI; and Gus Lucky's Gallery, Minneapolis, MN. Group exhibitions include *Road Trip* at Mixed Greens, New York, NY; *Landscape vs. Netscape* at Unit B (Gallery), San Antonio, TX; *The Contemporary Landscape* at Tower Fine Arts Gallery, SUNY Brockport, NY; *Modeling the Photographic: The Ends of Photography* at the McDonough Museum of Art, Youngstown, OH; and *Dreaming of a More Better Future* at The Cleveland Institute of Art, OH.

Yutaka Sone (BFA/MA Tokyo Geijutsu University, Tokyo, Japan) was born in Shizuoka, Japan, and lives in Los Angeles, CA. Solo exhibitions include David Zwirner Gallery, New York, NY; Gallery Side 2, Tokyo, Japan; the Foundation for Contemporary Art, London, England; Kunsthalle Bern, Bern, Switzerland; Aspen Museum of Art, CO, and Museum of Contemporary Art, Los Angeles, CA. Selected group exhibitions include *Temptations of Space* at Espace Louis Vuitton, Paris, France; *Red Eye* at the Rubell Family Collection, Miami, FL; *Untitled Folly* at Bowie Van Valen, Amsterdam, The Netherlands; *Monuments for the USA* at the CCA Wattis Institute for Contemporary Arts, San Francisco, CA; the *Whitney Biennial 2004* at the Whitney Museum of American Art, New York, NY; and *100 Artists See God* organized by Independent Curators International, New York, NY. Sone represented Japan at the 2003 Venice Biennial.

Jennifer Steinkamp (BFA/MFA Art Center College of Design, Pasadena, CA) is an installation artist living and working in Los Angeles, CA. Recent solo exhibitions include Albright-Knox Art Gallery, Buffalo, NY; greengrassi Gallery, London, England; Kemper Museum of

Contemporary Art, Kansas City, MO; Lehmann Maupin, New York, NY; San Jose Museum of Art, CA; ACME, Los Angeles, CA; and Soledad Lorenzo Gallery, Madrid, Spain. Selected group exhibitions include *Garden Eden—The Garden in Art Since 1900* at Kunstahlle in Emden, Germany; *Time Present Time Past* at Istanbul Modern, Turkey; *Orbigo 07*, Leon, Spain; *SIX* at Williamson Gallery, Pasadena, CA; *Taipei Biennial*, Taipei, China; *redefined* at the Corcoran Gallery of Art, Washington DC; and *Again + Again* at the Austin Museum of Art, TX. Steinkamp is a professor in the Design Department at the University of California, Los Angeles, CA.

Mary Temple (BFA/MFA Arizona State University, Tempe, AZ) is a multimedia artist living and working in Brooklyn, NY. Solo exhibitions include Trois Gallery, Savannah College of Art and Design, Atlanta, GA; Sandroni Rey, Los Angeles, CA; Smack Mellon, Brooklyn, NY; Mixed Greens, New York, NY; Aldrich Museum of Contemporary Art, Ridgefield, CT; and the Martin Museum of Art, Baylor University, Waco, TX. Selected group exhibitions include *New Prints Autumn* at the International Print Center, New York, NY; *Double-Take: The Poetics of Illusion and Light, Mary Temple, Alexandra A. Grant and Bernhard Hildebrandt* at The Contemporary Museum, Baltimore, MD; *New Prints* at Reynolds Gallery, Richmond, VA; *Thoreau Reconsidered* at the Wave Hill Glyndor Gallery, Bronx, NY; and *Light x 8: Light in Contemporary Art* at the Jewish Museum, New York, NY.

Denise Markonish (BA, Brandeis University; MA, Center for Curatorial Studies, Bard College) is the curator at MASS MoCA. Previous to her position at the Museum, Markonish was the Gallery Director/Curator at Artspace in New Haven, CT, where she curated exhibitions such as *50,000 Beds: A Project by Chris Doyle*, a collaboration with the Aldrich Museum, Ridgefield, CT, and Real Art Ways, Hartford, CT; *Don't Know Much About History*; *Why Look at Animals?*; and *Factory Direct: New Haven*. Markonish has published catalogues for *50,000 Beds*, *Factory Direct*, *Past Presence: Contemporary Reflections on the Main Line*, and *Mark Dion: New England Digs*. In addition to her work as a curator, Markonish has taught at the University of New Haven and the Rhode Island School of Design.

Ginger Strand grew up in Texas, Missouri, Illinois, Wisconsin, and Michigan. Her fiction and essays have appeared in many places, including *Harper's*, *The Believer*, *Orion*, *The Iowa Review*, *The Gettysburg Review*, *Swink*, *Raritan*, *The New England Review*, and *Carolina Quarterly*. She has received residency grants from The MacDowell Colony, Yaddo, the Virginia Center for the Creative Arts, and the American Antiquarian Society, as well as a Tennessee Williams scholarship in fiction from the Sewanee Writers' Conference. She lives in New York City, where she teaches environmental criticism at Fordham and recently completed *Inventing Niagara*, a cultural history of natural wonder at America's waterfall, due out in April 2008 from Simon & Schuster.

Gregory Volk (BA Colgate University; MA Columbia University) is a New York-based art critic and freelance curator. He writes regularly for *Art in America*, and his articles and reviews have also appeared in publications including *Parkett* and *Sculpture*. Among his recent contributions to exhibition catalogues are essays on Joan Jonas (Museu d'Art Contemprani de Barcelona, 2007) and Bruce Nauman (Milwaukee Art Museum, 2006). Together with Sabine Russ, Volk has curated numerous exhibitions, including *Agitation and Repose* at Tanya Bonakdar Gallery, NY; and *Public Notice: Paintings in Laumeier Sculpture Park* in Saint Louis, MO. Volk had taught at the State University of New York, Albany, NY, and currently teaches in the Sculpture and Extended Media department at Virginia Commonwealth University, Richmond, VA.

Tensie Whelan (BA, New York University; MA American University's School of International Service) is the Executive Director of the Rainforest Alliance. She has been involved with the Rainforest Alliance since 1990, first as a board member, and then as a consultant, becoming the executive director in 2000. In addition to her work with the Rainforest Alliance, Whelan served as the executive director of the New York League of Conservation Voters from 1992 until 1997, prior to which she was Vice President of Conservation Information at the National Audubon Society. Whelan also worked as a journalist and environmental communications consultant in Costa Rica. Whelan's published work includes one of the first books on eco-friendly tourism, *Nature Tourism: Managing for the Environment* (1991, Island Press).

CHECKLIST

1.–3.
Robert Adams
Longmont, Colorado
Longmont, Colorado
Boulder County, Colorado
From *Listening to the River*, 1987
Three gelatin silver prints
5⅛ × 7¾ inches each
Yale University Art Gallery,
New Haven, Connecticut
Purchased with a gift from Saundra B.
Lane, a grant from Trellis Fund and the
Janet and Simeon Braguin Fund

4.–7.
Robert Adams
Longmont, Colorado
From *Listening to the River*, 1987
Four gelatin silver prints
5⅛ × 7¾ inches each
Yale University Art Gallery,
New Haven, Connecticut
Purchased with a gift from Saundra B.
Lane, a grant from Trellis Fund and the
Janet and Simeon Braguin Fund

8.–10.
Robert Adams
South Denver, Colorado
Saguache, Colorado
Saguache, Colorado
From *Listening to the River*, 1987
Three gelatin silver prints
5⅛ × 7¾ inches each
Yale University Art Gallery,
New Haven, Connecticut
Purchased with a gift from Saundra B.
Lane, a grant from Trellis Fund and the
Janet and Simeon Braguin Fund

11.–15.
Robert Adams
Saguache County, Colorado
From *Listening to the River*, 1987
Five gelatin silver prints
5⅛ × 7¾ inches each
Yale University Art Gallery,
New Haven, Connecticut
Purchased with a gift from Saundra B.
Lane, a grant from Trellis Fund and the
Janet and Simeon Braguin Fund

16.–17.
Robert Adams
Larimer County, Colorado
From *Notes for Friends*, 1987
Two gelatin silver prints
5⅛ × 7¾ inches each
Yale University Art Gallery,
New Haven, Connecticut
Purchased with a gift from Saundra B.
Lane, a grant from Trellis Fund and the
Janet and Simeon Braguin Fund

18.–19.
Robert Adams
Longmont, Colorado
Along I-25, Weld County, Colorado
From *Notes for Friends*, 1987
Two gelatin silver prints
5⅛ × 7¾ inches each
Yale University Art Gallery,
New Haven, Connecticut
Purchased with a gift from Saundra B.
Lane, a grant from Trellis Fund and the
Janet and Simeon Braguin Fund

20.
Vaughn Bell
Village Green, 2008
Acrylic, hardware, plants
Dimensions variable
Courtesy of the artist

21.
Melissa Brown
New Valdez, 2007
Oil on aluminum panel
120 × 60 inches
Courtesy of the artist

22.
Melissa Brown
Pond Scum, 2007
Oil on aluminum panel
48 × 48 inches
Courtesy of the artist

23.
Melissa Brown
Forest Fire, 2004
Oil on aluminum panel
108 × 60 inches
Courtesy of the artist

24.
Boyle Family
Ploughed Field Study, Kent, 1986
72 × 144 inches
Mixed media, resin, fiberglass
Courtesy of Boyle Family

25.
Boyle Family
*World Series, Barra. Elemental Study
(Rippled Sand with Worm casts)*, 1992–3
48 × 72 inches
Mixed media, resin, fiberglass
Courtesy of Boyle Family

26.
Boyle Family
*Study of Brown Mudcracks with Tyre
Tracks and Coal Dust, Portishead*, 2006
48 × 48 inches
Mixed media, resin, fiberglass
Courtesy of Boyle Family

27.
CLUI
Massachusetts Monuments:
Images of Points of Interest in
the Bay State from the Center for
Land Use Interpretation, 2008
Digital photographs
14 × 11 inches each
Courtesy of CLUI

28.
Leila Daw
Volcano to the Sea, 2006
Mixed media
45 × 112 inches
Courtesy of the artist

29.
Leila Daw
Wiping the Slate, 2008
Mixed media
43 × 110 inches
Courtesy of the artist

30.
Gregory Euclide
I Was Only the Land Because I Liked
the Predictable Stillness, 2008
Acrylic, pencil, resin,
paper, waxed thread
6 × 4 × 3 feet
Courtesy of the artist

31.
Gregory Euclide
Something More Than
My Ribcage Because Several
Treelines Are There, 2008
Acrylic, pencil, paper,
bees wax, lead, PETG, wood
24 × 36 × 16 inches
Courtesy of the artist

32.
Gregory Euclide
A White Plane of Light
Pushing Forward Again, 2008
Acrylic, pencil, paper,
bees wax, lead, PETG, wood
24 × 36 × 16 inches
Courtesy of the artist

33.
J. Henry Fair
Paintbox
Coal Fired Power Plant
Niagara Falls, NY, 2002
C-print
75 × 50 inches
Courtesy of the artist

34.
J. Henry Fair
Cover-Up
Hydroseeding after Mountaintop
Removal around Kayford Mountain, WV,
2005
C-print
75 × 50 inches
Courtesy of the artist

35.
J. Henry Fair
Pilings
Wharf pilings, Sulfur and
water at abandoned facility.
Port Sulfur, LA, 2005
C-prints
75 × 50 inches
Courtesy of the artist

36.
J. Henry Fair
Dividing Line
Aeration tanks at sugar mill
Gramercy, LA, 2005
C-print
75 × 50 inches
Courtesy of the artist

37.
J. Henry Fair
Expectoration
Bauxite waste from aluminum processing
Darrow, LA, 2005
C-print
75 × 50 inches
Courtesy of the artist

38.
J. Henry Fair
Outlet
Phospho-Gypsum Fertilizer Waste
Geismar, LA, 2005
C-print
75 × 50 inches
Courtesy of the artist

39.
Mike Glier
September 27, 2006,
56°, N42° 52.551, W73° 20.792
(The Creek in the Hedgerow)
From the *Latitudes* series, 2006/7
Oil on aluminum panel
30 × 24 inches
Courtesy of the artist

40.
Mike Glier
August 30, 2006,
64°F, N42° 52.638, W73° 20.654
(Front Pond)
From the *Latitudes* series, 2006/7
Oil on aluminum panel
30 × 24 inches
Courtesy of the artist

41.
Mike Glier
December 1, 2006,
53°F, N42° 52.649, W73° 20.742
(The Studio Yard)
From the *Latitudes* series, 2006/7
Oil on aluminum panel
30 × 24 inches
Courtesy of the artist

42.
Mike Glier
February 25, 2006,
24.5°F, N42° 52.649, W73° 20.742
(The Studio Yard)
From the *Latitudes* series, 2006/7
Oil on aluminum panel
30 × 24 inches
Courtesy of the artist

43.
Mike Glier
July 31, 2006,
74.5°F, N42° 52.631, W73° 20.689
(Under the locust)
From the *Latitudes* series, 2006/7
Oil on aluminum panel
30 × 24 inches
Courtesy of the artist

44.
Mike Glier
June 5, 2006,
59.5°F, N42° 52.796, W73° 20.756
(The Back Pasture)
From the *Latitudes* series, 2006/7
Oil on aluminum panel
30 × 24 inches
Courtesy of the artist

45.
Mike Glier
June 9, 2006,
62°F, N42° 52.640, W 73° 20.697
(By the Hemlocks)
From the *Latitudes* series, 2006/7
Oil on aluminum panel
30 × 24 inches
Courtesy of the artist

46.
Mike Glier
March 10, 2006,
45°F, N42° 52.551, W73° 20.792
(The creek in the Hedgerow)
From the *Latitudes* series, 2006/7
Oil on aluminum panel
30 × 24 inches
Courtesy of the artist

47.
Mike Glier
March 31, 2007,
41°F, N42° 52.588, W 73° 20.667
(Back Pond)
From the *Latitudes* series, 2006/7
Oil on aluminum panel
30 × 24 inches
Courtesy of the artist

48.
Mike Glier
May 23, 2006,
49°F, N42° 52.635, W73° 20.717
(The Garden)
From the *Latitudes* series, 2006/7
Oil on aluminum panel
30 × 24 inches
Courtesy of the artist

49.
Mike Glier
November 4, 2006,
35°F, N42° 52.638, W73° 20.559
(Lower Wild Spot)
From the *Latitudes* series, 2006/7
Oil on aluminum panel
30 × 24 inches
Courtesy of the artist

50.
Mike Glier
October 13, 2006,
42°F, N42° 52.588, W73° 20.667
(Back Pond)
From the *Latitudes* series, 2006/7
Oil on aluminum panel
30 × 24 inches
Courtesy of the artist

51.
Mike Glier
Latitude: Williamstown, MA, 2007
From the *Latitudes* series
Oil on 12 aluminum panels
15 × 12 inches each
Collection of Carol and Bob Stegeman

52.
Anthony Goicolea
Snowscape, 2002
288 × 40 inches
C-print
Courtesy of the artist and
Postmasters Gallery, New York

53.
Anthony Goicolea
Glacier, 2002
C-print
30 × 30 inches
Courtesy of the artist and
Postmasters Gallery, New York

54.
Anthony Goicolea
Snowscape with Owls, 2003
30 × 30 inches
C-Print
Courtesy of the artist and
Postmasters Gallery, New York

55.
Anthony Goicolea
Tree Dwellers, 2004
C-print
98 × 72 inches
21C Museum Foundation,
Louisville, Kentucky

56.
Marine Hugonnier
Ariana, 2003
Super 16mm film transferred
to DVD with sound
Duration: 18:36
Courtesy of the artist, Max Wigram
Gallery, London and Film Video Umbrella

57.
Paul Jacobsen
*The Final Record of the
Last Moment of History,* 2007
Oil on linen
119 × 72 inches
Courtesy of the artist

58.
Paul Jacobsen
*Metaphorical Investigation of
Metaphysical Reunion,* 2007
Oil on linen
119 × 72 inches
Courtesy of the artist

59.
Nina Katchadourian
Fall's Colors, 2008
Mixed media
Dimensions variable
Courtesy of the artist and
Sara Meltzer Gallery, New York

60.
Jane D. Marsching and Terreform
Future North: Ecotarium, 2008
Video: 9 minutes
Courtesy of the artists

61.
Jane D. Marsching and Terreform
*Ecotarium: An Observatory of
Nature's Collapse,* 2008
Digital print
60 × 40 inches
Dimensions variable
Courtesy of the artists

62.
Jane D. Marsching
Rising North, 2007
Video
Courtesy of the artist and
Allston Skirt Gallery, Boston

63.
Alexis Rockman
South, 2008
Oil on gessoed paper
358¾ × 75 inches
Courtesy of the artist
and Leo Koenig, Inc., New York

64.–69.
Ed Ruscha
*Be Careful Else We Be Bangin On You
You Hear Me?*
Do As Told or Suffer
It's Payback Time
Noose Around Your Neck
You Will Eat Hot Lead
Your A Dead Man
From the *Country Cityscapes* series,
2001
Set of six photogravures
with screen printed text
13½ × 17½ inches each
Edition of 60
Courtesy Graphic studio/University
of Southern Florida, Tampa, and
Barbara Krakow Gallery, Boston

70.
Joseph Smolinski
Tree Turbine, 2007
High definition digital animation
Yale University Art Gallery,
New Haven, Connecticut
Leonard C. Hanna, Jr., B.A. 1913, Fund

71.
Joseph Smolinski
Spinning Tree for Spent Oil, 2008
Watercolor and graphite on paper
15 × 22 inches
Courtesy of the artist and
Mixed Greens, New York

72.
Joseph Smolinski
Biosphere, 2007
Graphite on paper
44 × 32 inches
Courtesy of the West Collection,
Pennsylvania

73.
Joseph Smolinski
Virus, 2008
Graphite on paper
11 × 14 inches
Courtesy of the artist and
Mixed Greens, New York

74.
Joseph Smolinski
Temple, 2007
Graphite on paper
11 × 14 inches
Courtesy of the West Collection,
Pennsylvania

75.
Joseph Smolinski
*Tree Turbine Study Model
for Prototype #1*, 2008
Mixed media
Courtesy of the artist and
Mixed Greens, New York
The *Tree Turbine* research and
development was funded in part by
the University of New Haven College
of Arts and Sciences and supported by
the Tagliatela College of Engineering.
Research engineering teams led by
Dr. Ali Montazer and Dr. Konstantine
Lambrakis included Naresh Babu, Ali
Alhamdan, Jatin Vij, and Prashanth
Allu that made this project possible.
Laura Cote and Jill Latella designed the
website and support documentation
materials. Special thanks to Dean Ron
Nowaczyk for supporting this project.

76.
Joseph Smolinski
Tree Turbine Prototype #1, 2008
Mixed media
Courtesy of the artist and
Mixed Greens, New York

77.
Yutaka Sone
Highway Junction 405-10, 2003
Carved marble
63½ × 46½ × 8⅞ inches
Courtesy of the artist and
David Zwirner, New York

78.
Yutaka Sone
Highway Junction 110-105, 2002
Carved marble
59⅛ × 57½ × 10⅛ inches
Courtesy of the artist and
David Zwirner, New York

79.
Jennifer Steinkamp
Mike Kelley, 2007
Multimedia installation
Dimensions variable
Courtesy of the artist and
Lehman Maupin Gallery, New York

80.
Mary Temple
Northeast Corner, Southwest Light, 2008
Mixed media
12 × 10 × 9 feet
Courtesy of the artist

ADDITIONAL CREDITS

The following works are featured in this catalogue, but not in the *Badlands* exhibition.
All works are courtesy of the artist unless otherwise noted.

PAGES 6 & 203
Nina Katchadourian
Too Late, 2003
C-print
43 × 34 inches
Courtesy of the artist and
Sara Meltzer Gallery, New York

PAGE 16
Alexis Rockman
Tropical Mudslide, 2006
Oil and acrylic on wood panel
39 × 58½ inches
Collection of Chuck Rosenzweig,
Greenwich, CT

PAGE 18
Alexis Rockman
Manifest Destiny, 2004
Oil and acrylic on wood panel
24 × 8 feet
Courtesy of the artist and
Leo Koenig, Inc., New York

PAGE 20
Ed Ruscha
Blue Collar Tires, 1992
Acrylic on canvas
120 × 54 inches
Gagosian Gallery, New York

PAGES 45 & 49
Vaughn Bell
Biosphere Built for Two, 2006
Acrylic, soil, plants, organic materials
and tiny organisms, water
52 × 24 × 30 inches

PAGE 47
Vaughn Bell
Personal Home Biospheres, 2004
acrylic, soil, different plants and
organic matter according to the
specific environment of the biosphere:
tropics, forest floor, herb garden
Dimensions variable

PAGES 56 & 57
Boyle Family
pm 2/11/1969
pm 4/11/1969
From *Sand, Wind and Tide Series*, 1969
Mixed media, resin, fibreglass
59 × 59 inches each
Compton Verney House Trust, England

PAGE 59
Paul Jacobsen
Sky Phenomenon, 2005
Oil on canvas
68 × 80 inches

PAGES 60–61
Paul Jacobsen
Post Industrial Collapse, 2005
Oil on canvas
100 × 62 inches

PAGE 83
Ansel Adams
The Tetons—Snake River, Wyoming, 1942
National Archives

PAGE 86
Thomas Cole
View in the White Mountains, 1827
Oil on canvas
35³⁄₁₆ × 25³⁄₈ inches
Wadsworth Atheneum Museum of Art,
Hartford, CT
Bequest of Daniel Wadsworth, 1848.1

PAGES 110–111
Marine Hugonnier
The Last Tour, 2004
Super 16mm film transferred
onto DVD with sound
Duration 14:17
Courtesy of the artist and
Max Wigram Gallery, London

PAGES 112–113
Marine Hugonnier
Travelling Amazonia, 2006
Super 16mm film transferred
onto DVD with sound
Duration 23:52
Courtesy of the artist and
Max Wigram Gallery, London

PAGE 115
Jane D. Marsching
Arctic Then: Deb questing,
McCall Glacier, Alaska (DEM 1956;
Glaciologist: Matthew Nolan), 2006
Lightjet print on Fuji Crystal Archive
48 × 36 inches

PAGE 116
Jane D. Marsching with Justin C. Knapp
and Christopher Wawrinofsky
Climate Commons Lounge, 2006
Mixed media upcycled
from construction of ICA Boston
108 × 108 × 29 inches

PAGE 117
Jane D. Marsching
Arctic Then: Bonnie and Tim,
Columbia Glacier, 2006
Lightjet print on Fuji Crystal Archive
48 × 36 inches

PAGE 118
Jane D. Marsching
Arctic Then: Martini Hatchshell,
Devon Ice Cap, Canada, 2006
Lightjet print on Fuji Crystal Archive
60 × 45 inches

PAGE 119
Jane D. Marsching
Arctic Then: Mike supervising Naomi
building an umiak, Austfonna Glacier,
Svalbard, Norway, 2006
Lightjet print on Fuji Crystal Archive
48 × 36 inches

Credits

PAGE 123
J. Henry Fair
Coal Fired Power Plant
Barker, NY, 2002

PAGE 124
J. Henry Fair
Magnum Mine
Kayford Mountain, WV, 2005

PAGE 128
J. Henry Fair
Vehicle tracks in fallow field
Baton Rouge, LA, 2007

PAGE 135
Melissa Brown
Niagara at Dawn, 2005
Oil on aluminum panel
72 × 48 inches

PAGE 135
Melissa Brown
Pollination Station, 2003
Oil on aluminum panel
108 × 60 inches

PAGE 150
Leila Daw
Weather Starscape
From *Planetary Conditions*, 2004
Mixed media installation for
Bradley International Airport
Windsor Locks, Connecticut

PAGE 151
Leila Daw
**** *Site*, 2006
Mixed media on paper,
welded aluminum, wood
108 × 49 inches

PAGE 171
Yutaka Sone
Highway Junction 14-5, 2002
Carved marble
44½ × 46⅝ × 13⅜ inches
Edition of 3
Courtesy of David Zwirner, New York

PAGE 172-173
Yutaka Sone
Highway Junction 110-10, 2002
Carved marble
52½ × 51⅜ × 10½ inches
The Museum of Contemporary Art,
Los Angeles
Partial and promised gift of David Teiger

PAGE 176
Yutaka Sone
It Seems Like Snow
Leopard Island, 2002-6
Island: paper, wood, sponge,
paper mache, polyurethane, paint,
pump, live plants, soil
Pedestal: wood
372 × 342 × 146 inches
Courtesy of David Zwirner, New York

PAGE 178
Fitz Henry Lane
Brace's Rock, Eastern Point,
Gloucester, c. 1864
Oil on canvas
15 × 10 inches
National Gallery of Art, Washington
John Wilmerding Collection

Martin Johnson Heade
Sunlight and Shadow:
The Newbury Marshes, 1871-5
Oil on canvas
26½ × 12 inches
National Gallery of Art, Washington
John Wilmerding Collection

PAGE 179
Robert Smithson
Spiral Jetty, April 1970
Great Salt Lake, Utah
Black rock, salt crystals,
earth, red water (algae)
3½ × 15 × 1,500 feet
DIA Center for the Arts, New York

PAGE 180
Donald Judd
100 untitled works in
mill aluminum, 1982-6
Permanent collection, Chinati
Foundation, Marfa, Texas

Donald Judd
15 untitled works in concrete, 1980-4
Permanent collection, Chinati
Foundation, Marfa, Texas

PAGE 181
Teresita Fernández
Fire, 2005
Silk yarn, steel armature, epoxy
96 × 144 (diameter) inches
In collaboration with The Fabric
Workshop and Museum, Philadelphia
Courtesy of the artist and
Lehmann Maupin Gallery, New York

PAGE 182
Fred Tomaselli
Hang Over, 2005
Leaves, pills, acrylic, resin on wood panel
120 × 84 inches
Courtesy of the artist and
James Cohan Gallery, New York

Joan Jonas
Volcano Saga, 1985-9
Courtesy of the artist and
Yvon Lambert, Paris and New York

PAGE 183
Roni Horn
Limit of the Twilight, 1991/2000
Solid aluminium and white plastic
8 × 56 × 9 inches
Courtesy of the artist and
Hauser & Wirth, Zürich and London

PAGE 183
Roxy Paine
Conjoined, 2007
Stainless steel
45 × 40 feet
Installed: Madison Square Park, NYC
Courtesy of the artist and
James Cohan Gallery, New York

PAGE 184
James Turrell
Meeting, 1986
Courtesy of PS1 Contemporary Art
Center, New York

Spencer Finch
Sunlight in an Empty Room
(Passing Cloud for Emily Dickinson,
Amherst, MA, August 28, 2004), 2004
One hundred fluorescent light fixtures
and lamps, filters, monofilament, and
clothespins
Dimensions variable
Museum für Moderne Kunst,
Frankfurt am Main
Purchased with the generous support of
the partners of the Museum für Moderne
Kunst: DekaBank Deutsche Girozentrale,
DELTON AG, Deutsche Bank AG,
Eurohypo AG, Helaba Landesbank
Hessen-Thüringen, KfW Banking Group
and UBS Deutschland AG, and the City
of Frankfurt au Main

It takes a whole ecosystem to make any exhibition and publication a success. I would like to begin by thanking the artists for participating in this project, from those who came here to create new works to those who loaned existing pieces. Thank you to the following galleries, museums and collectors who loaned work or otherwise helped with the exhibition: Hanna Schouwink and Courtney Treut at David Zwirner Gallery; Paul Schimmel and George Davis at LA MoCA; Magda Sawon at Postmasters Gallery; Heather Darcy Bhandari at Mixed Greens; Sara Meltzer Gallery; Leo Koenig Gallery, NY; Mariska Nietzman at Lehman Maupin Gallery, NY; Allston Skirt Gallery, Boston, MA; Yale University Art Gallery (especially Joshua Chuang for igniting my love of Robert Adams' work and to Jock Reynolds for his continuous support); Andrew Witkin at the Barbara Krakow Gallery, Boston; Kristin Soderqvist at Graphic Studios and Peter Foe and David Reuter at the Contemporary Art Museum, all at the University of South Florida, Tampa; William Morrow at the 21 C Museum, Louisville, KY; Rachal Bradley at Marine Hugonnier's studio; Lynn Richardson at Mike Glier's studio; Dan Langston; Bob and Carol Stegeman; and The West Collection.

This exhibition could not have happened without Joe Thompson and the dedicated staff at MASS MoCA, and without my two fantastic interns, Lauren Wolk and Diana Nawi (you guys kept me sane and on track). I would also like to thank Malcolm Nichols and Michael Oatman for their artist suggestions and enthusiasm, Keith Sklar for reading many versions of my essay, Bill Greenwald for his help in making the turbine run, and Milgo/Bufkin in Brooklyn for its fabrication. I also thank Pawel Wojtasik for his continued and generous support; you are always willing to serve as a sounding board or sparring partner for my ideas, my writing and anything else that comes along.

Last, but certainly not least, those who made this catalogue a reality, from the terrific writers who provided illuminating texts (Gregory Volk, Ginger Strand, and Tensie Whelan), to Dan McKinley, graphic designer extraordinaire, and Steve Van Natta, an excellent editor as always. And many thanks also go to Roger Conover, Marc Lowenthal, and everyone at MIT Press.

MASS MoCA
BOARD OF TRUSTEES

Duncan Brown, *Chairman*
Hans Morris, *Vice Chairman*
George Ahl
Ella Baff
Daniel Becker
Joyce Bernstein
Ben Binswanger
G. Donald Chandler
Stacy Cochran
Michael Conforti
Lisa Corrin
Gregory Crewdson
Bobbie Crosby
John B. DeRosa
Nancy Fitzpatrick
Timur Galen
Robert Gold
Francis Greenburger
Carmela Haklisch
James Hunter
Elizabeth Roche Wilmers
Philip Scaturro
Morton Schapiro
Jay Tarses
Susy Wadsworth

Sandra Burton, *Trustee Emeritus*
Robert Collins, *Trustee Emeritus*
Foster Devereux, *Trustee Emeritus*
Meyer Frucher, *Chairman Emeritus*
Allan Fulkerson, *Chairman Emeritus*
Francis Oakley, *Trustee Emeritus*
Else Steiner, *Trustee Emeritus*

MASS MoCA
DIRECTOR'S ADVISORY COUNCIL

Jane Eckert, *Chairman*
Ellen J. Bernstein
Ellen Bowman
Melva Bucksbaum
Henry Eckert
Susan Gold
Donald Gummer
Agnes Gund
Holly Angell Hardman
Kristen Johanson
Lorie Peters Lauthier
Raymond Learsy
Barry Levinson
Diana Levinson
Dorothy Lichtenstein
Susan Bay Nimoy
Carol Stegeman
Robert Stegeman
Meryl Streep
David M. Tobey
Julie Tobey

Art Center College of Design
Library
1700 Lida Street
Pasadena, Calif. 91103